SOCIALIST REALISM

SOCIALIST REALISM

Trisha Low

COFFEE HOUSE PRESS
An Emily Books Original
Minneapolis and Brooklyn
2019

Coffee House Press books are available to the trade through our
primary distributor, Consortium Book Sales & Distribution, cbsd.com
or (800) 283-3572. For personal orders, catalogs, or other information,
write to info@coffeehousepress.org.

Coffee House Press is a nonprofit literary publishing house. Support
from private foundations, corporate giving programs, government
programs, and generous individuals helps make the publication of
our books possible. We gratefully acknowledge their support in detail
in the back of this book.

LIBRARY OF CONGRESS CATALOGING-IN-PUBLICATION DATA

Names: Low, Trisha, author.
Title: Socialist realism / Trisha Low.
Description: Minneapolis : Coffee House Press, 2019. | "An Emily
 Books Original." | Includes bibliographical references.
Identifiers: LCCN 2018054100 (print) | LCCN 2018059281 (ebook) |
 ISBN 9781566895590 (e-book) | ISBN 9781566895514 (trade paper)
Subjects: LCSH: Low, Trisha. | Authors, America—21st century—
 Biography. | Gender identity.
Classification: LCC PS3612.O879 (ebook) | LCC PS3612.O879 Z46
 2019 (print) | DDC 813/.6—dc23
LC record available at https://lccn.loc.gov/2018054100

PRINTED IN THE UNITED STATES OF AMERICA

28 27 26 25 24 23 22 21 4 5 6 7 8 9 10 11

for my family

&

those who, braver than me,
sacrifice

Some names have been changed.
Some facts may have succumbed to recollection.

"A man who gives a good account of himself is probably lying, since any life when viewed from the inside is simply a series of defeats."

—George Orwell, *All Art Is Propaganda: Critical Essays*

"What I understand by realism goes beyond reality."

—Maurice Pialat, interviewed in *Cahiers du cinéma* (2000)

SOCIALIST REALISM

In the 1949 romantic comedy *Adam's Rib,* Judy Holliday plays Doris Attinger, a woman who is arrested for firing several clumsy gunshots at her cheating husband and his lover. Katharine Hepburn plays Amanda, the sleek and capable defense attorney who plans to make her a feminist example, a political cause. To do so, she needs to find out more: about the situation, about Doris's intent in shooting her husband. "Now, let's start with the day of the *accident,*" Amanda says pointedly. "No accident," Doris says. "I wanted to shoot him . . . So I sent the kids to school and I went and bought a gun . . . So then I got very hungry." "When?" Amanda asks. "When I bought the gun," Doris replies. "Yeah?" says Amanda. "So I went in this hamburger place and I ate two rare—and one lemon meringue pie," Doris continues. "And then?" Amanda prompts. "And then I was still hungry," Doris says. "Think of that," the paralegal says drily.

People continue to buy the promise of California as a land of abstract and eternal desire—charged with possibility, yet devoid of satisfaction. A hollow final destination.

I'm in the car, my cheek resting on the seat belt. Blues and browns of the earthy landscape whirring by. I'm looking out the window, and I can almost hear the chants of the gold rush echoing in my ears, hopeful and pure. *We'll be home soon, here in the West.* Who wouldn't want that? But I'm in denial. Finding any place to call home seems impossible, it's both fantasy and threat. Christopher Isherwood writes, "There is no security in your mansions or your fortresses, your family vaults or

your banks or your double beds. Understand this fact, and you will be free. Accept it, and you will be happy."[1] Accept hunger, that is. How the dream is made from it and no place you reach can stave it off.

Even after you've arrived, California offers no home to moor yourself to, apart from the rattle of the next optimistic caravan. "I bought some chocolate nut bars and I went outside of his office and I waited the whole afternoon and I kept eatin' the candy bars and waitin' until he come out. And then I followed him, and then I shot him," Doris says. Amanda: "And after you shot him, how did you feel then?" "Hungry," Doris says.

It's a year later. I came to California. I lost the love I moved here for, but I found another. It's a year ago. Is it? I'm in New York, listening to Black Flag. I'm staring at the walls, thinking about sunny California. It's home to me now, but it's no utopia. It's just the closet space of my own fantasy; it's just another prayer. Do I know that? LOL. Maybe not. Maybe I'm just like all the other girls after all.

I take a trip. We go to L.A. because that's what you do. You have to leave a place to figure out if it's where you really live—whether or not it's home. It's hot. The sky is a wall of blue. I want to press my fingers into its glossy weight. We're driving back to Oakland, and when I look up and breathe, it's heavy; as though fiction and reality have blurred through the translucent backs of one another. A double landscape that could swallow me whole. Vacation is always a too-fragile boundary. It leaves its psychic residue everywhere. The fantasy of the good life and the reality of the lived one, jumbled into useless, staticky lint.

It's a year ago. Friday night at home, and I'm watching *Rosemary's Baby* with Staiti. Mia Farrow's living the dream: she's the perfect housewife, sliding her perfect sofa into her perfect apartment. Perfect, apart from the fact that a satanic cult has commandeered her building, and its members have managed to drug and impregnate her with some rapey demon's child. "Great," I mumble to myself. Who doesn't love a horror-movie metaphor about a woman's grim and inevitable enslavement to domestic labor for the rest of supernatural time? It's too real, but I don't heed the warning. I lie in my bed, wearing a fake-organza robe and not much else.

I mimic Mia's housewifely glamour. The apartment she and her husband have purchased seems, for lack of a better word, damp? It's stately and wooden. Mia, on the other hand, is young and fresh. Her eyelids are caked with pastel makeup. She wants to keep her husband happy and her unborn baby safe. She is able to make her commitment to these duties seem classic and cosmopolitan and not the least bit wretched. I am envious. I watch Mia compartmentalize her life. She turns her apartment into a final stronghold of intimacy and personal comfort. She keeps her creepy neighbors at bay. She glosses the walls white and daffodil yellow. She coaxes it into modernity with a record player and chartreuse couches.

But each decorative alteration she makes to the apartment begins to mirror itself in her body. As the French windows of the living room yawn and gape with the light, they become grotesque reflections of Mia's own eyes, growing wider and wider in her gaunt face. Satanic cult or no, the building she's moved into has a soul. It exercises its own uncanny power upon her, remains an obstinate repository for centuries of memory and tradition. It's as though Mia is being consumed from the inside out, leached of her contemporary vitality. The demon child in her belly is probably the culprit, but the camera draws closer with each shot; it seems as though the apartment itself is feeding off of her, closing her in. Let's face it: Mia's a modern woman, but she can't possibly outstrip architecture with something as flimsy as decor.

Watching *Rosemary's Baby* with Staiti, I run the edge of my big toe absently along the windowsill. I press into it as if it were the dense California sky. They stroke the ridge of tendon running along my neck. My eyes roll back, I lean into the touch. It makes me feel solid. Is this person my home?

In the car, Lindsey and I sing songs about being abject and unloved. Patsy Cline's "Crazy" and Bonnie Raitt's "I Can't Make You Love Me" play all the way home while Staiti rolls their eyes in the back seat and groans. As banal as it is to drive from L.A. to Oakland, with a friend and a lover, the journey home's become some slow, apprehensive torment. It makes me fidget. It feels like danger.

"I'm bored," I whine, my clammy thighs sticking to the car-seat vinyl.

Lindsey playfully smacks the side of my head.

I shriek, melodramatically, "I don't want to go!"

Home, what even is it? I'm not sure, but I know I want it—because home is a chronic matter of wanting. Of forcing desire, despite itself, into a shape—one with a beginning, middle, and end. It's about futurity. "Going home" is necessarily a journey, but it's also the security of destination. It's knowing you have a place to rest after all your time spent wandering, even if you have to trick yourself into believing it exists.

I'm standing on a street corner. What time is it? I know I'm close to home, but I don't remember what it looks like. I don't know how it'll feel once I get there. Childishly, my synapses connect the noun *home* to the adjective *good,* but my gut turns. It's not so simple. I don't move. I eat a bag of Ruffles to stave the nausea off instead.

At the end of *Rosemary's Baby,* Mia decides to stay in the building to raise her demon child. I watch her body go slack, her limp hand rocking the cradle. She might be wearing pale blue, but it's dark inside, and the cradle's draped in black. She's disappearing into it, inch by inch—her home. She's the one that wants it; no, I mean, she's the one it really wants.

Seven p.m. at home in California, and I'm cooking salmon with the back door open. It's a warm day, but the sun's set early, and there's a breeze. I see the decidedly indoor cat run into the kitchen from the garden, looking startled and harried. I hadn't noticed her escape. It's the first time she's been outside in over a decade. I wonder if the fresh air was a shock to her. If encountering the limitless expanse of the outdoors had terrified her, forcing her to retreat. Either way, she doesn't look pleased—not about having been outside, and certainly not about being back home. She meows voicelessly at me. The porcelain saltshaker I keep on a ledge over the stove falls as I turn to look at her; shatters delicately with her return.

It's years later, December 31. New Year's Eve. I'm back home in Singapore from the u.s., visiting family, fulfilling obligations as every good daughter

should. I'm at a dinner party with some old friends. The hosts have put us all at a kids' table even though the youngest person in the room is twenty-five, because that's what Asian parents do. Segregation by age is customary; it's usually best for the safety and comfort of both generations. I'm sitting at the kids' table with a bunch of twenty- to forty-year-old Asian "kids" who have been sent West, who have all worked or studied abroad. Jacob, my pseudo older brother, lives in San Francisco, across the bay from me. He gifted me my first Sleater-Kinney CD when I was thirteen. His brother, Justin, lives in New York, along with his cousin Kat and her family. They run a modern Chinese eatery in Gowanus. My little sister, Marsha, sits across the table from them; she's lived in London since she graduated college and got a job at a bank there. Tonight, it's a loving, bizarre mix of real and made kinships and we're talking about, to name a few parent-friendly topics: the difference between gender identity and expression ("Where do we even begin?"), politics and religion ("Let's agree to disagree, OK?"), poly relationships ("Honestly, at this point having an affair is just so retro."), Klonopin versus Vicodin versus Xanax ("If I asked your mom for a Xanax right now would she have one? Would she give one to me? I'm thinking about having a C-section for my next kid because then Zain and I would be swimming in Vicodin, you know, honestly I think it'll be worth it, it's just . . . so nice."), anyway, you get the idea.

Kat asks me if I'm dating anyone and I say yes. She asks me how my parents feel about my person not being a man. I shrug and say medium. They don't particularly like it, but they don't particularly like a lot of my other choices either—how much I love cheese, how I went abroad to America, how I decided to stay there. But I try a little and they try a little; I scream a little and they scream a little. These days, we hear each other more easily, so it turns out OK. It's parents, I say. So as long as everyone's trying, what more can you ask for? At least every year I come home.

My dad tells a story about when he was a young professional living in New York in the eighties. Before that, he had been a student in London, so the cold weather was familiar. Even so, he was unprepared for the

intensity of the winters that come with East Coast American living, the way the cold seeps into the dark, how it cuts you along the cheeks and into the bone. Unlike in London, there was no murky rain or fog to diminish the chill. The days got shorter and you could hardly tell when night ended and began. My dad tells me how he lived in a small apartment in Battery Park with subpar heating. One morning, he woke up to an unfamiliar sensation: sunlight was streaming through the windows. It reminded him of home. He threw off the blankets and turned toward the sky, warmth beating down on his face. He ran out of his apartment wearing only boxers and a thin T-shirt. He ran West deliriously, toward the sun. The doorman chased after him, waving his arms, shouting that he was crazy and to get back inside, for fuck's sake.

This was the day my father learned that sunny winter days in New York can in fact be much colder than the dark ones. It was twenty degrees when he made a break for it.

I loved this story. I was a child shrouded in the warmth of Singapore. I was awed by the forces of winter. I was rapt with the visceral image of my father's sacrifice and suffering. My father, chasing the imprecise comfort of a memory—so suddenly and miraculously attainable. My father, senselessly sprinting toward a familiar sunny warmth, longing to feel, for just one moment, as though he were home. That morning, he couldn't. It pained me. Then, I grew older and quickly learned the narrative of "make-it-or-break-it" New York from bad movies and books. After that, I mostly teased him about not being tough enough to stick it out in the big city. But what did I know about the cold? And the truth is, when my turn came, I wasn't tough enough to make it either.

People say you get soft when you move to California. I might have gotten soft, but three years later, I'm still not sure I belong. I'm not sure why I moved to New York five years before that, either, but looking back, it might have been because of the paranoia it offered me—how I never jigsawed smoothly into the city, how I'd always have to be fighting to stay. New York is supposed to be every artist's dream, but it's a city of precarity. It might snow, your landlord might double your rent, someone might come to your performance or hate your poem and it's

just as likely none of this will ever happen. But that's not the hard part. The hard part is that all this *could* happen, and no one could care less.

It's years ago, and in New York, representation's so sharp it could slice. Sitting on a bench in Union Square, I watch an array of superegos parade down the street. Head-to-toe athleisure, sleek chignons, and pencil skirts. *Vogue*'s clutch of the month in one flawlessly manicured grasp and the perfectly satirical art-fair tote bag in another—it's a dazzling mélange of self-consciousness. I get up and put my cigarette out in the street. I'm going through a breakup. I'm an anomaly here, wearing a housedress in public; I'm sloppy, but I don't care. I'm walking to a movie, a blockbuster entitled *Snow White and the Huntsman*. Josef always says movie theaters are the best part of New York City summers: they're the only places in the city guaranteed to be stone cold, kept at freezing twenty-four hours a day. The movie stars Kristen Stewart, and she's cute, but I'm not really there to watch; I'm not paying attention. I'm there because I want to cry, but I don't want to be home. I want to be alone, but I don't *not* want to feel the soft, ambient heat of other bodies around me. A movie theater is like a double negative. It's not-*not* comfortable, I'm not-*not* interested in the on-screen explosions or the bland, blond femme fatale, I can lose myself in another world even as I treasure the knowledge that life is not like any filmic representation of it. Kristen Stewart looks alluringly up at the camera and bites into the poisoned apple. I feel a visceral tug in my lower belly. I know that this desire is forced and constructed. It's this unreality that is delicious to me.

The story is simple enough. She moves to New York for Art. She is young. She isn't beautiful, but she has a nice ass. She attends graduate school. She eats cheese in white-walled galleries and jokes often with her friends about how stealing catered food will keep them full. This is a lie. She is hungry in almost every respect but has no problem actually keeping food in her belly. When she's not in class, her time is empty. She goes to readings and talks about Art. It is not uncommon for her to make friends by sleeping with them first. She shares her bed with boys who are not beautiful but who she believes have beautiful thoughts. She tells

them they are not allowed to stay the night but then gifts them other intimacies instead. She memorizes the beautiful thoughts of these boys. She regurgitates their thoughts back to them at bars and on the weekends. She reads. She sits in Washington Square Park and eats banh mi with an extra egg on it. She plots the location of every good place to buy ice cream in the Lower East Side. She begins to garnish these thoughts she has memorized with ones of her own. She smokes cigarettes and puts them out on the sole of her shoe. She gets good at balancing on a single leg. She buys a latex skirt. She thinks of herself as one of the selected few. At readings, she heckles poets whose work she thinks is bad. She goes to a party where she helps dismantle a sculpture made of potatoes then watches her friend chase someone around the room with an electric drill in a misguided attempt to kiss them. She criticizes an ignorant majority jostling for popularity and normalcy. She reveres Form. She differentiates between Art that is "weird" and art that is "I-pandered-to-the-Art-World-Zeitgeist kind of weird." She makes declarative statements about how Net Art is over. One night, she watches her friends steal car keys from a fancy apartment where a reading is being held because they think the host is rich. Her friends think rich people shouldn't be poets. At this point, she comes clean about the fact that she has rich parents.

They all fight. When they reach an impasse, they all make out. They all agree that any type of writing that has already been established is uninteresting and inferior. Even then, she loves melodrama but reviles "feelings" in Art. She believes all representations of "feelings" inevitably render them inauthentic and trite. Only she knows how to manipulate Art so it reveals the worst of humanity, no matter what anyone believes. No matter what anyone believes, only she knows that Art cannot save a whale but can ruin someone's personal life. She writes a poem that will ruin someone's personal life—her own. She knows what matters most is Art's deep and unparalleled ability to torture its audience. She wants to drag every reader's heart through the mud and hand their dissected guilt to them on a platter. She wants to push appropriate behavior to its edge. She does this with everyone around her. She sleeps with one half of a pair of best friends, then the other. She says she is in love. Poets love each other. No, these poets are in love with each other. She can't

tell the difference. They can't either. Because of this, these poets band together. After all, they are well versed in Godard and have all seen *Bande à part*. Together, they believe that the other poets are old and in the way. Together, they condemn positivity. Only they know how to carry the promise of a contentless genre to its logical conclusion. Only they know how to use the internet. This gang has a score to settle. They believe the types of writing they're doing have never been done before. She believes it too. She wants every word to be a blade in a machine of representational revenge. She wants every book to be a testament to the fact that even Art cannot mend a soul. She is so naïve and yet she alone knows that Art is a sham. It can do nothing at all.

Most of all, she believes that Art is proof no one is exceptional. She believes this most of all about herself. She murmurs to herself, "You're not special," even while believing the Art she makes is the be-all and end-all of any value she might have upon this earth. She reads *The Piano Teacher*. She begins to think of it as her bible. "No art can possibly comfort HER then, even though art is credited with so many things, especially an ability to offer solace."[2] Solace, she learns, is lazy. She is not lazy. She makes rigorous, cruel Art. She refuses to take responsibility for any unforeseen consequences this may cause. She is in pain, so she believes Art's ultimate purpose is to cause this pain in others, without reason or redemption.

She forgets how "sometimes, of course, art creates the suffering in the first place."[3]

She may have left New York, but she was not acquitted of these charges. They happened. It is just as unpleasant for a woman to have her clothing damaged or soiled. She begins to suffer from bouts of excitement and insomnia. She gets headaches, perspires freely, breathes heavily, etc. Even if she was in the field for four full years and fought in twenty-seven battles, it is fair to say that these symptoms indicate cowardice, even feeblemindedness.

It's cold, and I'm at the Whitney, the contemporary concrete of the walls pressing me within. I'm standing in front of a Diane Arbus print with a long name: *Carroll Baker on Screen in "Baby Doll" with Passing Silhouette,*

N.Y.C., 1956; Arbus sets a beautiful scene. In a cinema, a man and a woman embrace in the soft glow of the studio lights, their mouths agape. An audience member stands in relief, a middle-aged man small against the screen. He's edging his way out toward the end of the row. His nose is crooked, his other features invisible, but it's the sharpness of his silhouette that's poignant. Against the dreamy romance, you can't miss him, but in the hustle of a busy street, he'd go unnoticed. He's normal. He's just some guy. Within the artifice of the photograph and the fantasy of the big screen, it's his tiny reality that's so painful. The inconsequentiality of his life dwarfed by the movie's big-picture destiny.

I'm at the movies, a Kristen Stewart blockbuster, and two high-school girls sit a row in front of me. They can't stop snickering. "I can't believe Lizzie McGuire was wearing Vivienne Westwood when she fell into her bathtub singing 'Atomic Kitten,'" one of them scoffs. It's cold in here, but I'm warm. I feel the icy snot and sweat drip down the side of my face. I look away from the screen. I'm not missing anything, that's for sure. But nothing's quite sunk in yet—teeth, or wet, cold nails, or otherwise. I'm in New York, and here, it's starting to feel as though everything's already lost. It burns.

Middle row, dead center. I set the scene. No, the scene set me, but the images keep disappearing. I'm sorry, what's the score?

My parents named me after the girl they thought was the prettiest Miss America contestant in 1988.[4] She didn't win the pageant, but they do remember that she wanted to be a housewife. Home—it's always been the dream. But what composes it? Wanting to belong somewhere, to feel comfortable returning to a place. *Home* is conceptual, immaterial. Architecture, then, is its manifestation: it's what we build in response to our desire for place, how we design the structures that hold us. Some place so delicious we can only dare imagine how it might one day arrive. I hate to admit it, but the truth is, I'm waiting. Come home to me.

It's Monday night, I'm waiting for Staiti to return. What's the worst that could happen? I ask myself in an effort to keep calm. It's pointless.

13

I've moved on to imagining who I'll call first when I find out that, yes, they've been in a car accident, shorn apart by metal; yes, they were jumped by strangers and beaten to a pulp; yes, that's why they're gone, all better reasons than them not wanting to come to me. I feel loose and unmoored; I can't find the ground. I try to eat a sandwich, but I can't bear the taste. I tear the tip of my fingernail delicately with my teeth.

It's twenty years ago. I'm seven. I go to bed, but I have a nightmare anyway, and I scream as though I'm dying. My dad comes to calm me down. "What's the worst that could happen?" he asks reasonably, stroking my hair. "A monster under the bed? I'll kill it with my magic sword. An evil wizard in the closet? We'll say a spell to wish him away. The worst thing that could happen, well, I promise you, it's not so bad after all." It's twenty years later. I check my phone because my hands feel restless. Liz posts on Tumblr—Chantal Akerman has died. What's the worst that could happen? The truth is, while I sit here idle and expectant, someone I love could leave me.

It's late. I haven't done anything but this morning's potatoes. I buy a three-dollar robe made of fake organza and wear it around the house. I let Staiti fuck me in it after I make them dinner. I notice that my kitchen counters are just the right height for a 5'2" woman with a knife to leverage her weight for efficient slicing. These activities loosely compose a home. It seems natural. I like these drapes. I mean, my housewifery's just aesthetic, right? Or that's what I tell myself, my Miss America name an impotent omen. I'm filled with so much hate for any impetus to fit my life within a form, but feeling like I'm filling a role turns me on regardless, so I embrace it. I slacken myself. I'm tame. I soak the dishes. I slice an apple. So many women have fought for better than this for me, and yet it seems the question remains: Can we have the war without being soldiers in it? In the battle for women's rights, so many have taken a side—in the first, or second, or third, or fourth waves of the feminist movement. It continues. I want to fight—there's so much to fight for— but I don't like taking sides, especially when there are only two. I don't like the vagueness of choosing Choice either, its flip-flop flimsiness akin to Mia Farrow's seventies pastel decor, or the watery taste of bad soup.

Some choices are wrong. I want to be good. I take out the trash. I make pancakes to share with Staiti. I whisk the batter with an automatic efficiency. Rinse and repeat. I note a dark and demonic presence guiding my hand from the oppressive structures below.

I don't know if I have vertigo, but I have trouble with repetitive motion. When I was little, I would wake up screaming because I felt a sensation that was what I now recognize as dizziness but back then could only describe as "being afraid of the floor." "I'm afraid of the floor," I would yell, clutching at anything nearby to anchor myself so the world would stop spinning, so I would feel once again like someone who belonged to it rather than an object it was trying to expel, a disgusting piece of gristle in its seamless series of cogs. The doctors later figure out that it's low blood pressure. But since then, anything that moves repetitively has sent me into a panic. Being in the ocean is bad. Being on a carousel is my worst nightmare, the gold and gilt and cotton-candy pink spinning me into a sobbing mass of flesh. I remember being trapped in a Snoopy-shaped bouncy castle, hyperventilating and clawing at the walls. They won't let me out. I retreat into a catatonic state. I'm pressed paper-thin by a vast expanse of space. I've been released from the world; I'm the grime at the bottom of a centrifuge. When I come to, my mother is clutching an ice cream sandwich to my head like a makeshift ice pack. "You're back," she says, "finally." "Oh," I reply. "Do you want to go home?" she asks. "What do you mean?" I say. "Am I back on the ground?"

The last time we were hanging out, Alli said something about how the best part of being in a relationship is that it's like the ground. The world can shift, but you know it's still there. You can always find your feet.

Late at night, I'm fighting on Gchat with Staiti, and I'm sobbing so hard I have to leave the computer. I can't stop. My body, fragile and sloping. I call the suicide hotline, more out of curiosity than anything else. The disembodied voice at the other end of the phone says, "It just seems like you're really depressed, honey," and I'm overcome by the materiality of the snot leaking from my nose, the tears dripping over

and around my fingers. I can't get clean, I can't leave home, I'm dissolving into a puddle of misery and filth.

"Thank you for talking to me," I say into the phone between sobs, "I think I'm going to be ok," but I choke and hang up before I can finish the sentence. I run to the bathroom but throw up before I can make it, clots of bodily fluid littering the floor. I can't find the rigid inside parts of myself that remind me I'll be fine, so I lie down where I am. I rub the gluey mess into the wood.

In the morning, I find a splinter in my cheek. It doesn't come out for days. I carry it around with me, as if it might possess some gravitational pull. Because at some point, when I wasn't looking, you became it; you became the ground.

I want to chart all the ways you make me dizzy, the way you shift with the graceful momentum of what's changing around me.

So I choose the home team. I wonder what it would be like to pick out wallpaper together. To make breakfast in an apron every morning. I think about screen doors cutting their way through torqued hallways, decorative porcelain ducklings scattered across a field. An unforgiving wall of pink roses in bloom. Full community view. There's a part of me that still believes the perfect home means unquestioned happiness. But as Marcel Proust once wrote, happiness is impossible: "There can be no peace of mind in love, since the advantage one has secured is never anything but a fresh starting-point for further desires."[5]

Someone once told me that Proust would jerk off all over his papers as he was writing. He'd let come seep obscenely into every page, a spoiling, splotchy constellation. They were probably just fucking with me, but I like the degradation of it, the recurring libidinal stain of impossible fulfillment. I think about shared air-conditioning units, the same tired gas cycling through each pair of wheezing lungs, leaving the bitter tang of codependence, of never being separate or alone. Nuclear colonies of ranch housing raised procedurally by game engine. Still, I can't help it. What if I want it all? A happy marriage. A loving family. A beautiful home. There's no denying that this fabricated tableau could

be utopic. But how can you tell if your desires are real, with TVs and movie screens, with the occasional relative blaring at you about how this life is obviously what you've always dreamed of? I'm looking out my pretty French windows. They gape like Rosemary's wide, unblinking eyes. Yeah, sure, I want it, but home is fucking out to get you.

Are you hungry? I put the chicken in the oven.

Staiti and I are fighting, but in the middle of it I get hungry. I'm a nightmare, I'm crying and railing and collapsing into the weight of anxiety. The familiar soupy feeling. It's back. It's infiltrated my bones. I've lost my form. I can't find the ground. Staiti holds me and tells me to settle, as if I'm a cat. But I'm sharp and defensive like a razor; I turn my head away. "I'm hungry," I say and leave the room. I eat granola, but it's not what I'm hungry for. I think about Chantal Akerman, whose women are always hungry. "I'm hungry," one of a pair of girls says in *J'ai faim, j'ai froid;* they careen through the city and take what they want. The two of them careless, oblivious to any other cost. "I'm hungry," the woman says in *Je tu il elle,* when she visits her ex-lover after days of lingering alone in her room, eating a bag of sugar. "More," she says, after she eats a piece of bread spread with Nutella in big, consuming bites. I cry while I shred rotisserie chicken for salad, thinking about how I need to get fucked. Is there a gender politics of buying rotisserie chicken? I scoff at myself. It's so typical, so Freudian, so Dark Continent of Unknown Female Sexuality of me. I lick sugar off my spoon. Kathy Acker once wrote, "If we keep on fucking, I'm not gonna die,"[6] which, as desperate as it sounds, is still my favorite method of emotional blackmail. It's another way of saying, I will end my life if you leave. One step out the door and my body will collapse as though its skeleton were excised. A slack sack of meat and liquid pooling on the floor. I'm pouting: "You wouldn't do that to me, would you?" Not so much a plea as a guarantee that you will be held responsible for any bodily harm that I inflict upon myself. Yes, I will make sure of it.

Formlessness has something to do with unhappiness; unhappiness and desire. The urge to make it all go away by finding a structure that

could hold you. When I was little, I didn't know what shape my desire should take, I only knew I wanted to be loved. I didn't know what it was like to really love another human who wasn't family, and I certainly didn't know what it felt like to be fucked. My mother had told me that you should only fuck someone if you love them. I had a puppy I loved. Because of what my mother said, I conflated everything. I thought fucking someone might mean loving them in the same way my puppy loved me. I lay naked, my back to the cold bathroom floor, my puppy licking my face. I imagined what it would be like to fuck my dog, its rough, rapid tongue moving between my legs. I made it lie on top of me, panting and confused, so I could try to understand the weight of a lover, how it would feel to have someone pressing down upon on my body. I didn't understand my desire so I transposed it. I tried to squeeze it into a familiar form, however inappropriate, however strange. In my twisted mind, I created a pleasurable fantasy from the information I had, out of what I already knew. In other words, I built a home. As Judith Fryer writes, "the structures that contain—or fail to contain—women are the houses in which they live."[7]

When I was a very little girl, I lived in a house that looked like a ship, sleek and beautiful. In it, my father told me stories about what he built. Restaurants, cars, businesses—he had built them all for me. The lives of fathers; what they do for their daughters. According to him, this was just how it was supposed to be. The house I lived in was full of rounded corners and smooth steel; it had porthole windows and giant panes of curved glass that I liked to rest my cheek against. Daddy built lots of other things. A career that meant he was often away. Meant he got home late from work, 10:30 p.m. or later. I had a strict schedule grow-ing up, the days segmented into one- or two-hour increments. I took naps so I could stay up late to greet him, his return a looming figure on my childish horizon. My life was good, everyone told me. They were right. It was. People gave me books about children who gave up their jackets in the winter to keep their aging parents warm. About students who braided their thick black hair and tied it tautly to the rafters. Who studied late into the night, by candlelight, their chins drooping with

sleep, their hair painfully jerking their heads back. They pushed pins under their fingernails to stay awake. I wanted to be good like them. If I was good, I was told, and got grades that were as good as I was, one day I'd get to go to the West. There, I would learn to build houses and businesses like my father did, better ones than they had at home. That way, when I grew up and returned and Daddy was tired, he could stop building them himself. I would take his place. I would continue into the future. No one knew specifically what kind of future I'd build upon my return. But they were certain of one thing: whatever I learned to build in the West would already be better than what I would have built if I'd stayed. I was a good girl. It was an irresistible and predetermined course of events. It had a shape. It was a destiny. Back then, I didn't know what destiny was. I was grateful for it nonetheless.

When I was a very little girl, I didn't know much about the West as Americans know it. This bloody slice of history that some people delusionally call great, that others go so far as to call epic. To me, the West was never a place of immigrants and cowboys, of gold mining and wagons. And even now, what little of the American West I do know, I learned from Laura Ingalls Wilder's series of children's books *Little House on the Prairie,* which chronicles the life and travels of the Ingalls family on the frontier. I don't remember much of the plot, or what eventually happened to the clan. But tiny, happy moments from their pioneer life stand out in my memory. Maple syrup on the fresh snow. A pink hair ribbon purchased for chestnut hair. Re-reading the books as an adult though, I'm surprised to find all this set against a backdrop of disaster. No wood, no food. There's scarlet fever for Mary, the eldest sister, then lifelong blindness. The Ingalls don't find a permanent home; instead, they have to keep moving—u.s. soldiers are sent to remove white settlers from Native land, later they leave to accommodate demolition for a railroad track. A terrible fire destroys the house that adult Laura Ingalls and her husband, Almanzo Wilder, have painstakingly built together. The thing about the Ingalls is, despite all this, they never complain. Whatever hardship manifests, we become convinced that they will always overcome. We believe they'll stubbornly

savor the taste of maple candy on their tongues for as long as they can make it last. Nine books in the series, and they always just build another home.

Really though, has the concept of the West ever been anything but a diorama of survival porn? I suppose its abstract myth has always been the same, that if you survive whatever is happening now—typically at the expense of another—you will one day arrive somewhere else. A place where "something wonderful is always about to happen."[8] Where a destiny is always about to unfold.

It's Sunday and I'm on vacation in L.A., the city of angels or hallucinations—Sophie's choice. I'm sweaty at LACMA, staring at a Chris Burden sculpture, a tiny tinsel town of model roads and silvery condos swelling into the embrace of a fully equipped miniature city. Titled *Metropolis II,* it's detailed and lifelike, little whirring engines propelling hundreds of cars, each into their rightful place. The piece is mesmerizing, but I roll my eyes. I look away. Burden has managed to build the most intricate shrine to infantile masculinity I've ever seen. I hate it.

My favorite Chris Burden performance piece is called *Doomed.* It took place in April 1975 at the Museum of Contemporary Art in Chicago. From beneath a slanted pane of glass, Burden started a clock, then lay there for the next forty-five hours and ten minutes without food or water. When a museum employee finally placed a glass of life-sustaining water within his reach, he got up, smashed the clock, and left. When asked about the performance, he said that on the first night, he was impressed that the museum didn't interfere and respected the integrity of the piece. But by the time he reached the second, all he could think was, "My God . . . are they going to leave me here to die?"[9]

I love Chris Burden's early work. Back then, he was a master of calibrating scenarios that expose the arbitrary structures that hold us and force us to arrive at a crux of institutional fallacy. In one performance, Burden shoots single shots from a revolver at an airplane as it takes off. In another, he lies facedown in the middle of a busy street until he is arrested by police. He convinces a friend to shoot him with a .22 caliber

rifle. The bullet's meant only to graze him but it penetrates his arm instead and leaves a smoking hole. For Chris Burden, we can work hard, chase our dreams, build our lives with blood, sweat, and what have you, but like Bartleby, he would prefer not to. He would prefer to point out that any human action can only barely graze the world. What may feel like a huge effort or accomplishment in fact makes little difference, because for Burden, any effort we make is ultimately futile, destined to be absorbed back into the systems in which we exist. And given all that, why bother building anything at all?

The cars in *Metropolis II* run silkily, endlessly, a vapid insult to his name.

It's years ago, and I am a sickly, chubby child. I study hard, but no one would call me clever. I'm not yet at the age where there appears to be no difference between the two. On my first day of school, another child tells me I'm fat, like an ugly plum. I decide other people are no longer worth my time, yet I seek out ways to impress them in order to appear superior. I droop my eyes whenever my parents' own seek me out. I feel vile and unclean. I ask my mother if being fat is bad. I bring home a slip for her to sign. As part of the Ministry of Education's Trim and Fit program to target childhood obesity, my school decides that children who are overweight must exercise during break instead of eating. My mother remains stone-faced. She signs the form. She spends the summers feeding me broccoli salad with low-fat mayonnaise. She no longer wants me to have to endure this lunchtime torture. She is helpless. I limp through laps around the playground. I raise my hand in class every time. The other children carve graffiti into my desk. I read books. I like English lessons. I like the pretty sentences. I pride myself on speaking the same pretty words as I read in the books about blond girls with blue eyes and candy-pink skin. Sweet Valley High. I stop speaking in the same Singlish pidgin the rest of my classmates use, even outside of class. My elocution means I become a model child for the new government Speak Good English Movement. Since my sister's birth, my nickname at home has always been Jie Jie, Cantonese for *older sister,* but one day, my extended family starts calling me by the far

less flattering nickname Potato. I'm confused. My uncle, who is rough with me because he wishes I had been a boy and insists on treating me as though I were, scuffs my ear. He tells me that like a white person, I would rather eat potatoes than rice. This, he tells me, is why I'm fat and soft, not brown and lean like the other children. When I run crying to my father, he sighs. He tells me to fetch him a lighter from his study. "The people who are mean to you are so stupid," he says. "One day you'll go West. You'll be just like everybody else there. Reading and eating potatoes." "But I'll miss you," I tell him. "It's OK," he says. "I want the best for you. I went West too. It was hard. I was poor. I ate eggs and spam every day. But you won't have to. I made sure of it. It's why I learned to build things. And then, I came back. You will too," he says. "I will too," I repeat sleepily while he holds me, smoking a Mild Seven. It haunts me. I didn't.

I'm at LACMA, thinking about Chris Burden. Sure, he spent most of his career destroying artistic convention, but late in life, he built art objects instead. Built the perfect city, spun from his misplaced nostalgia for living: *Metropolis II*. I'm standing in front of it, its fairy lights tedious and piercing, and all I can think is, "Is this what it's like to make art before you die?"

It's 2015 and Chris Burden is dead. On Facebook, I write that wherever he is, heaven or hell, I bet he still believes in not believing. In the stunning futility of human repetition. I post a picture of him crucified on a Volkswagen. He's young, belly up and pale against the steely background, a self-annihilating martyr in striped cloth sneakers.

I can't deny that Burden's work is adolescent. It's a calculated flirtation with the limits of cruelty and destruction. His self-inflicted injury has no real-world stakes, it doesn't take much risk. Sure, he might get shot in the arm, but it's not like he's going to lose his job. I like Chris Burden, but even I'm willing to admit that it's easy to brush at the limits when you are assured an art-world payoff and relatively certain of your physical safety. It's easy to be Chris Burden. It's even easier for Chris Burden to be willing to get hurt, or maybe even die, when it's uncertain whether he knows what that really means. Whether he

understands how hard others have to actually fight to live. Like all the other white boys, Chris Burden seems incapable of dealing with any impending threat of *senseless death*—death without the glory of transgression or the deluded heroism of doom. And maybe that's part of his aggressive polemic, but it doesn't make it any less annoying.

Anyway, I can never get past that moment in his performance of *Doomed,* when the museum employee makes the tiny action of offering Burden a glass of water—a gesture that decisively ends the piece and arguably saves his life. Without the water, it's possible Burden would have remained under the pane of glass for days, until he died. *Doomed* is my favorite Chris Burden piece because it's not purely nihilistic, but rather demonstrates the dual absurdity and potential of human action, human ambition.

When I finally do make it West, it's to an all-girls British boarding school where, my first night, I learn two important lessons. The first is how to give a blow job to a baby carrot. I have a housemother, a girl who's been assigned to take care of me, to make me feel at home. I have to ask her what a blow job is. "It's when you get a dick and you suck it," she snaps. The second is that despite my perfect grammar and my pretty vocabulary, I have an accent. "It's *three,* not *tree.*" My housemother's eyebrow arches. "Can't you pronounce your *h*? *Tree,*" she mimics, calmly, cruelly.

A year later, at the airport on my way home to Singapore: "Sorry, are you from here?" a British woman asks me in the bathroom. "No," I say, "why?" She picks up her handbag, clumsily; she's evidently flustered. "Oh, nothing," she says. "It's just that you'd never know. I mean, your accent's just so classically British. So posh, like you grew up riding horses." I find myself nodding dumbly. I'm unable to parse my ambivalence. *Remarkable,* I think, *how adeptly and unquestionably I took to my assimilation.*

As I get older, I get better at finding comfort in my identity. I study Mandarin by watching the melodramatic martial-arts dramas I loved as a kid. I make friends with the aunties selling dumplings in Chinatown. I complain with them in Cantonese with ease, about white girls wearing qipaos and the new hipster pizza joint encroaching on their block. But still I see the strength of my urge to pass as a sign of my own hypocrisy.

And when it arises, along with the guilt, it seems truly laughable I would preach any kind of ideological purity to the world.

T. H. Watkins says, "The West is not any one thing. It is a tremendous collection of stories. But no intelligent person can look at it without feeling a mix of both pride and shame."[10]

Years ago, I graduate from elementary school. There is a ceremony. Each girl wears a dowdy skirt suit bearing the insignia of the secondary school she will attend. Since they're only worn once, these suits are rented and oversized. The hall is swarming with girlish frames swamped by cheap polyester. I leave for a school that doesn't have an insignia anyone in this country will recognize. It's far away, in the West. Faced with my difference, I don't know what to do. I ask the principal what I should wear, and she tells me to opt for something neutral. A white dress, she suggests. When I watch the home video, it's easy to spot me amidst darkly colored blazers and shoulder pads. I look bloated, beached and chubby. Slouching and uncertain in pale cotton lace.

What I remember: floating up on stage, somehow made light.

These memories, verifiable? I came to the West with a desire to reinvent myself even if I didn't know how. I wasn't expecting much of this destiny, but I did expect to find some kind of home. What I found was a sobering lesson instead—a thin and sweet delusion, doomed.

This is not a protest poem, but I live in California now, so. It's May Day. I'm at the march, but something's wrong. It felt wrong when I left my house. The march is moving fast, there are kids in large gray hoodies flanking the crowd. One kid is dragging along a shovel that seems larger than he is, its metal edge making an unbearable screech against the sidewalk. I can't see much through the sea of bodies and backpacks, the dull colors of my friends' sweatshirts bobbing in front of me like somber guiding lights. A palpable intensity in the humidity between bodies, the sweat between clasped hands. We're walking fast. We're tired and uncomfortable. We're pissed off—about minimum wage, about police

brutality, about the murder of trans women of color, about so much more. The psychic tissue of our want turns the crowd into one fleshy mass. A bottle shatters. I can't see. We're trying to get forward, but we're trapped. I feel the pressure from the crowd behind me. We're infinitely demanding, but there's too much for us to even name—what we want or can't live without, what we won't admit, what we can't reconcile ourselves to. Some of us are idealists, others are nihilists; we're teen serial killers or punks or academics. We're a mess. Some of us are armed. Some of us aren't but don't know it, or are and don't want to be.

I'm at the march and honestly, I want to fight, but I don't want to be a soldier. I mean, what's the deal with having to exist as a decipherable subject anyway? What's the deal with *We fought for it together, so it has to mean something*? Yeah, we fought for it, but sometimes the fight is all there is, which is another way of saying, well, nothing.

Should I go home?

"There is no home here,"[11] wrote the novelist and transplant Christopher Isherwood of his adopted Golden State. Its horizon split open by the sun, its ground lurching with rolling yellow dunes. California is a strange harmony of desolation and hope, a paradox of signifying garbage and pristine landscape. The streets of Berkeley are lined with hippy-spiritual hookah stores, and across the bay, in San Francisco, are swarms of tech-boom man buns and telecommuting laptops. The soil upon which all this is built: quietly soaked in indigenous genocide, a bloodstained project that continues into the present, gently mutating into gentrification and the forced displacement of black and brown people from their homes.

And yet, because we're in California, everything remains edged with bursting flora by the wayside and its eternal succulence. From the student protests of the sixties and seventies to antifascism today, the Golden State spans decades of generational hope, even if you can't tell which way it's marked. Fading community murals, graffiti deriding cis-hetero-patriarchal capitalism, everything spun into oblivion by the yearlong sunshine—it's a jumble of radical promise, both emerging and obsolete. "California Dreamin'."

It's May Day. We're hungry. We're marching because we want just-not-this, or literally-anything-else. José Esteban Muñoz was my teacher, and he liked those extremes. He taught me that it was OK to be a punk and still believe in believing. He taught me that it was OK for my nihilism to be utopic, for my politics to also be a sensibility. "Queerness is not yet here," he cautioned us at the beginning of *Cruising Utopia*. "The here and now is a prison house. We must strive, in the face of the here and now's totalizing rendering of reality, to think and feel a *then and there.* Some will say that all we have are the pleasures of this moment, but we must never settle for that minimal transport; we must dream and enact new and better pleasures, other ways of being in the world, and ultimately new worlds."[12]

It's May Day and we're marching. Are we peering into the then and there? A portal to the imagined possibilities of shared utopia? But my eagerness fades as the protest reaches First Friday, Oakland's monthly hipster street fair. It becomes impossible to tell who's one of us and who's just a tech bro in plaid, trying to get an artisanal lamb burger for his girlfriend in the ironic cowboy boots. We hit a corner, speeding along, and the cops give a dispersal order, but we charge anyway. Someone's started a fire, but it's feeble. I fall and someone else catches my ankle, pulling me back, but Claire drags me to a side street by the strap of my overalls. I'm on a stoop, I can't breathe, my body's insides are slopping sickly against it. What I wanted to be a "there and then" feels so claustrophobically, resolutely now. We go to the hospital because there are globules of fat and blood spilling out of a hole in my knee. I feel embarrassed. I apologize. I do it again and again. I can't stop. There's a circle of cop cars surrounding the hospital. They'll only let me in alone, but Grace and Claire bully their way into the ER anyway, past the cops and hospital bureaucrats. They're clutching chocolate and Doritos from the vending machine. I find a Twix in my bloody pocket. In the ward, we meet Brian, an ER tech. Like me, Brian is a Scorpio. He keeps a pair of gardening shears in his cargo pants for cutting clothing off injured limbs or god knows what else. He gives Claire and Grace surgical masks with clear plastic visors to protect their faces from any squirting blood before sticking

an anesthetic needle deep into my knee. There's a cop two beds down from me with the same injury. He's loud and red and demands an x-ray. I get four stitches. Claire drives us home. It's one in the morning, so we order a pizza. We eat it in my apartment, until our talking turns into falling asleep around and across each other. It feels like we're building a fortress, but that's silly. I mean, it's just *home,* some weird little apartment somewhere. Still, tonight, it feels far outside the world. It feels, in its own way, like more of a utopia than the one we were marching to live.

I'm lying in bed, very still. I don't want to go to work, so I'm trying to detect any symptoms of possible sickness. If I'm sick of anything, it's the weight of revolution. I want the promise of something better, sure, but I also want the minor. I want the weak underbelly, our routine deficiencies. I want every symptom of hard-lined ideological fantasy—of burn-the-banks communism, or formal aesthetics, or queer separatism. I want it alongside the real and fateful knowledge that we will necessarily fail to live it.

It's now. It's a year later. I see that Jenny Holzer piece on the internet all the time, white text on a black background that says, "In a dream you saw a way to survive and you were full of joy."[13] I can't actually think of many ways to survive late capitalism, so it feels ill fitting, a little like consulting WebMD—how every diagnosis is cancer. I'm in the kitchen, eating eggs with Claire. She tells me another friend of hers is thinking of planning an action to take over a space—to quietly craft or arrange flowers together within it, a tender form of protest. They're tired of holding signs and stalking angrily around the lake. I'm weary of it too. I say, "Sometimes I think it's funny how the aspirations of what we call *full communism* are so much gentler than what everyone likes to remember. I mean, what is it anyway? It's subsistence farming, right?" "Are you hungry?" I ask Claire. I say, "Let's face it, the end goal of revolution is just everybody eating salad in a field together." I'm lying on my couch, wrapped in a pink fleece blanket, wondering what would happen if the austerity of smash-the-state revolution were a little bit more like the gentleness of coming home.

I know, I know, that's fucked up. For any revolution to be a revolution, you have to burn it all to the ground. And after that, what even is salad anymore? Wanting the end goal of revolution to feel cozy and familiar would likely end in some reformist compromise—a "central-heated, air-conditioned, strip-lighted Paradise,"[14] as Orwell imagined.

It'd be a little like wanting to kill yourself but not wanting to die.

For that impertinent impossibility, though, José would have liked it.

"California Dreamin'." We're driving and it's on the radio. Is it the Mamas and the Papas, or the Carpenters?

It's strange, how our visions of a better life are barely ever new.

It's, what, four years ago? I'm back in London, a place that gradually, since boarding school, has become another home. I'm tired, jet-lagged, and the world starts to black out around the edges of my vision. I stop by the Tate Modern to catch my breath. I'm sitting dead center in the Kazimir Malevich exhibition, in front of his *Black Square,* thinking about how much I love art that is a simple gesture of refusal. Refusal to give you any explanation for a deeply arbitrary world. When I look at Malevich's best-known painting, sneering within its uneven white borders, I know he wasn't interested in discovering some new aesthetic form that could sustain a common language. No. He was interested in the dissolution of communication, in negating every possibility. He was interested in how refusal, stark and unadorned, has an elegance all of its own.

I'm sitting in the last room of the exhibition, and because it's a retrospective, I have to contend with the horror of watching an artist degenerate into his own sentimentality. For some artists, it's a return to the scaffolding of a more conservative form. For others, it's complacency: a softening of what they've already accomplished into what's weaker, nostalgic, pinker (literally pinker, I like to think, in Henri Matisse's case). But the change in Malevich's later work is less personal, less emotional. The conservatism of his final portraits suggests he's succumbed to a state-mandated socialist realism.

A style of representational art that glorified communist values and romanticized the lives of a heroic proletariat class, socialist realism was the

only form of art sanctioned by the Soviet government after the rise of the Soviet Union in 1932. In drastic contrast to the Russian futurism of artists like Malevich, who wanted to enact a complete refusal of bourgeois values by breaking with traditional aesthetic representation, socialist realism was communist ideology made material, meant to inspire the masses to become the kinds of citizens the Soviet Union needed most: strong, healthy, and unquestionably optimistic about the future of their country.

In line with the state's demands, Malevich was forced to relinquish his avant-garde refusal in favor of propaganda. He was made to take part in the compulsory artistic commemoration of glorious revolution—something "to be transmitted over distance, preserved as history, viewed as models, enjoyed as sources of pleasure,"[15] as Robert Bird and his co-editors describe in *Vision and Communism*. Because of this, Malevich's final paintings are a "celebration" of idyllic post-revolution everyday life—abstractly pastoral portraits of workers in fields, in factories, their natural habitats. In the distance, rainbow paths lead across the rolling hills. But just one thing stands in the way of theses portraits' total realism—each person wears a blank colored circle instead of a face.

I'm at the Tate Modern, and I need to pee. It's starting to hurt. I can't find the bathroom, so I peer into the blank, sky-blue oval of a farmer's head. I twist one leg around the other. There's a slight remnant of refusal in its glossy, abstract indifference, its suggestion of homogeneity. A mild hint that the communist haven he's depicting might not be all it's cracked up to. There's something uncanny that remains in Malevich's portraits, a sardonic refrain that we, the people, have made it! That the revolution has been won! The perfect homeland has finally arrived! These late portraits suggest that in life under Soviet communism, everyone is equal, and therefore equally content. There is no longer any reason to want or hope for anything different; no reason to yearn for a house, or think about how we might build one differently. Instead, each painting bestows a rainbow-colored halo around the pissy reality of life in the Soviet Union. Each painting a restrained shorthand for a bizarre political situation in which communism has failed, and yet its state-mandated "paradise" has robotically continued.

Malevich's socialist realism suggests, however subtly, that if we choose to believe that revolution is already over, the perfect home already built, things may, in fact, turn sinister.

Home might be, as Naguib Mahfouz says, "where all your attempts to escape cease."[16]

I don't think it's strange to want revolution, just as I don't think it's strange to desire utopia (how could we not?), but to embrace this desire is also to recognize its emptiness. First used by Sir Thomas More in 1516 in the book of the same name, *utopia* has come to mean a perfect place where everyone has what they need and nothing needs to change—someplace better than the one we know. But the word comes from the Greek *ou,* for *not,* and *topos,* for *place,* meaning *no-place.* In other words, it refers to somewhere impossible. I think this is apt. I don't believe any utopia we imagine can ever come into being. Such perfection is, by definition, beyond what our reality is capable of.

But maybe the value in utopia is not in serving as *place*—as structural blueprint for an imminent future—but as the *impetus* behind it. Maybe utopia is imagining life beyond what we know is possible. For *striving to create* new ways to exist in the world and in relation to one another, ways that do not depend on our society's current flawed foundations. From unexpected intimacies in the mosh pit at the queer hardcore show to the one-time grace of a dancer's incomplete gesture, José taught me how it's these small and numerous acts of *imagining utopia* that have the deepest implications for our lives—even if their direct results are not a perfect revolution.

I'm home, but I can't sleep. My parents are away, so my grandmother is babysitting. We're sharing a room, and she's snoring loud and hard. I'm only seven, but I'm a serious child, awake with anxiety. I'm pondering my fate. I wake her and she tells me a tale about a woman who becomes the first great empress of China. Her name is Wu Zetian. She first enters the palace at age fourteen as a lowly concubine, a common path for girls of her breeding and stature. She's smart and educated, but pretty girls in the palace are a dime a dozen. She doesn't quite manage to catch the

emperor's eye, so she spends her time reading instead, about government and politics, literature and music. She is admired by many other men of the court. When the emperor dies unexpectedly, she is sent to a nunnery to serve out the remainder of her life, a customary fate for concubines who have not yet produced children. It's a waste, but it could have been worse. My grandma tells me that when an emperor died, many of his wives and servants were entombed with him—alive—so they could continue serving him in the afterlife. It was considered their destiny. Rows and rows of women, wearing gauzy white gowns, sealed into a beautiful tomb. The lucky ones were gifted a length of cotton and a footstool so they could hang themselves once the doors were shut. Others were given a fast-acting poison. Others simply had to starve to death. They were supposed to consider this final act a privilege. But this Wu Zetian, my grandma exclaims, is wily. When the emperor's heir, his son by another concubine, visits her in the nunnery, she promptly seduces him. He commands that she be allowed to leave and return to the palace. She births his first son, the crown prince, and becomes the queen consort of China. And when her second husband (conveniently) dies, she becomes the child's regent. She ascends to the throne. It is a long and scandalous journey, peppered with vicious scheming and cruelty. She puts two rival concubines to death. She chops off their arms and legs and places the bleeding stumps of their bodies in giant vats of fermented vinegar while they are still alive. I'm fascinated, I beg for more, but my grandma makes me go back to sleep. "You're lucky," she tells me matter-of-factly. "If you had been born a century ago, that could have been your destiny, even if you were a good girl. Starving to death in someone else's tomb. Cheating your way into a better life." She shakes her head. I frown. It seems to me that this empress fought to become exactly who she was.

After all, in all the books I've read, about the West or otherwise, you can only fulfill your destiny once you overcome many terrible dangers.

Is destiny just what you call living despite being doomed?

I'm sixteen, a girl on the internet. I'm locked in a school in the faraway West; it has iron gates and a dress code that's long, one whole sheet, double

sided. It's my destiny even if I don't know how I'll survive it. I wear my hair in pigtails. I double knot my tie and tuck it into my kilt. Between classes I read stories about gay teen hustlers working in the porno theaters of Times Square when New York was a different city. I write fan fiction in long, sticky trails on LiveJournal. Comment by comment, I develop a vocabulary of orgasmic expressions. I can describe any florid sex act with starry-eyed detail, even though no one has ever made me come. I let my boyfriend touch me between my legs at the movies, popcorn stagnant on his breath. I imagine myself as a boy, like him, on my knees in a filthy theater with someone else's cock in my mouth, blue jeans slipping easily off my slim hips. I'm in the laundry room at school, letting another girl feel up my thigh, her face in my neck, her tinny breath catching in my ear.

I'm in Philadelphia with a friend who works at an x-rated movie theater, the Forum. (It's out of business now, its doors shuttered with a bashful, ladylike wheeze.) On Wednesdays, after everyone's left the theater, he tells me he finds a small pile of fried chicken bones underneath the same seat. Carefully balanced on top of it, there's a smaller, neat, even stack of acrylic nails. He's never been able to figure out which patron it is. Is it a ghost? A vicious teen queen? We delight in conjuring identities. My favorite: a construction worker too embarrassed to publicly indulge his fetish for donning acrylic nails. He gets manicures once a week and admires his flawless cuticles for an hour and a half before slowly destroying them in a blur of white meat and grease.

I've always thought the French expression for *orgasm* is apt even if overly precious—*la petite mort*. It's a singular moment in which you cease to be yourself. You manage to find, in someone else's meat, a portal to somewhere distant, a place severed from reality. An orgasm is the perfect disassociation. The little death: a temporary respite from the horror of your big-picture destiny. I'll take any freedom I can get.

I look up. I'm at the movies. The woman on the screen clutches a purple dildo with her curled and precise red talons, her face looming large. She scoffs at my tiny, sharp silhouette, my crooked and wrinkled nose.

It's years later and I've moved to California. I'm not yet assimilated. I'm itchy and uncomfortable. I don't yet feel at home. Back in New York,

Joey's started calling me Rainbow and threatens to mail me a bunch of hemp bracelets and weed paraphernalia. Back in New York, there are decadent karaoke sessions at Sing Sing that end with the bartenders giving out free shots and Holly performing air guitar to her epic rendition of Heart's "Magic Man." I tell Joey that I'm sorry. I miss everyone, but I was miserable and unhealthy, and I wanted to live; I moved to California to work on my life.

Joey tells me that back in New York, friends and enemies alike can't stop joking about how I moved to the West, where they're always seeking revolution. I still don't know what that means. Maybe seeking revolution is a way to make the world livable when it feels complicated, when there are so many moving parts. Bodies joined in protest can literally embody our collective vision of the future. Fantasy can be an imperfect solution; it's why we have the cinema.

But it's all a story we tell ourselves nonetheless. Something imaginary.

Shamefully, I did not come to Patricia Highsmith by way of Literature. I came to Patricia Highsmith by way of Homosexuality. The first work of hers I encountered was *The Talented Mr. Ripley,* initially the 1999 film based on the book of the same name, then later the book itself. In this story of a stolen identity, Tom Ripley (played by Matt Damon) is an unremarkable young man and occasional con artist who befriends Dickie Greenleaf (played by Jude Law) at the behest of Dickie's father, in an attempt to get him on the right path. Dickie is a spoiled, wealthy playboy Tom is envious of. It does not hurt anyone that both of these actors are extremely easy on the eyes. Tom and Dickie forge a tumultuous and deeply homoerotic friendship. Eventually Tom murders Dickie and impersonates him, taking over his glamorous and affluent life—he merges the two of them forever into one.

In 1999, Singapore is a place where homosexuality is still socially unacceptable and any act of "gross indecency" between two men is technically punishable by law, even if this is rarely enforced.[17] My friends and I watch movies every week because that is how nerdy children conspire together to learn more about the world. We are children of questionable, and flexible, sexuality. One of us does not get aroused by anything except

pristine sound engineering—specifically, the gun-related sound effects in the blockbuster movie *Once Upon a Time in Mexico.* Discovering *The Talented Mr. Ripley,* a charming tale of homoerotic friendship turned murder, felt, to us, like a beacon. Obviously, we did not wish to murder and impersonate our future lovers. But this narrative felt affirming nonetheless. It was the first gay romance we encountered in which the romantic element wasn't melodramatic or overblown. In which eroticism was not a revelation, but repressive, so latent it could only sublimate into fatality. *The Talented Mr. Ripley* was a manifestation of the forbidden longing we each felt consumingly, but for which we were too afraid to find a form.

In Highsmith's pulp lesbian novel, *The Price of Salt,* the way Carol and Therese fall in love is painfully casual. It's not graceful or fortuitous. It just happens the way life happens, for no reason at all. They spend time together because of senseless, mundane events. One woman sends the other a Christmas card for no particular reason, the other happens to respond. They drive to Utah because it's literally just something to do. I love how haphazard the narrative is, the way it seems as though they can't ever remember why they're doing what they are. Nothing fits. They can't help the way they gravitate toward one another; it happens as a simple consequence of going about their lives. In Carol and Therese's romance, nothing seems new even though they both know everything will now have to change. And as strange as it is, their love becomes the reason anything makes sense anymore. It becomes the ground.

I'm falling asleep, dreaming, I can't remember about what. When I wake, my nose is bleeding. No surprise, since I am a defective and sickly child. Alongside my asthma and vertigo, I have inherited weak blood vessels in my nose. My mother had hers cauterized, a red-hot rod prodded deep into her nostrils so the delicate, veiny frills would flatten and cease to bleed. I was a replicative mistake, the blood gushing out of my nostrils. I'm kicking and screaming. My grandma's pulling my head back by my hair, her pudgy fingers strong against my scalp. I remember projectile vomiting, miles and miles of red. I'm dying. I swear it. I pass out from the panic. The next morning, my grandma shows me the basin

I remember choking the contents of my body out into. On the pink plastic, there sits only a single tiny blood clot, shriveling in the morning air. I can hardly believe I'm still alive, or how wrong my own experience can be. I can barely believe the lesson I've just learned—that what I'm certain I know will rarely be perceived by others as real.

Hannah Arendt once wrote that "storytelling reveals meaning without committing the error of defining it."[18] There's no better way to describe the way homoeroticism functions in Patricia Highsmith's work. Sexuality is not a defining quality for her characters—the way someone is described as cruel for kicking a cat to the curb, or kind for taking it in. Homoeroticism in a Highsmith narrative happens nonchalantly. It's a *product* of a precise and fortuitous series of events, part of a character's unfolding response to a given situation rather than a permanent obstacle to overcome. Sexuality is woven into the fabric of how each person chooses to negotiate the world. Tom Ripley is a charming people pleaser known for his accurate impersonations of others. His desperation for Dickie's love turns uncontrollable and murderous because of his class anxiety. Whether or not Tom is gay is basically irrelevant, but the quality of his desire for Dickie is relevant and highly so—it reveals the nuances of the resentments that drive him.

Indeed, there are no "classically tragic" or "gleefully punishable" gay clichés in Highsmith—make a list, and in comparison to her work, each seems more gauche and conspicuous than the last. Instead, she leaves us with a staunch refusal to let sexuality, or any identity, dictate the story of a given life. And without this prescriptive weight, we are forced to free-fall into the fickle human psyche, the arbitrariness of the material conditions it finds itself in. We're moved beyond assumptions we would otherwise be tempted to make. It's a better story. Most of the time, to describe a Highsmith character as "gay" is such a gross reduction of their circumstances as to almost be a lie. Sexuality, for Highsmith, is more character development than it is identity politics, and honestly? It seems to do more that way.

Like, I'm at home, reading Patricia Highsmith's biography, when I learn she had a love for snails. She raised a large colony of them in her

garden when she was living in France. When it came time to go home, she discovered customs laws prohibited bringing the snails back to the u.s., so she ended up smuggling a large number of them across the border. She hid the snails under her shirt, along the underside of her braless breasts. Sure, that's not an identity, but it's the most lesbian thing I've ever heard.

"What a strange girl you are."

"Why?"

"Flung out of space," Carol said.[19]

In 1970, a forty-five-foot, eight-ton dead whale is blown up on a beach in Florence, Oregon. Whale flesh and blubber raining down from the sky in large, dangerous chunks. People falling to the ground, stunned by the stench of briny, decomposing entrails. Do you know how big a whale is? Have you ever wondered about whale skeletons and where they come from?

I'm at a talk by curator Hamza Walker at The Lab. He's telling us about a piece he once acquired, *Leviathan Edge,* by the artist Lucy Skaer. The piece consists of a single whale skull, mounted against a white background and enclosed within a long, narrow hallway. The bone is delicate and hollow, translucent under the staging lights. Along this hallway, freestanding walls block the visitor's sight line, meaning there's no angle from which one can get a full view of the skull. Instead, there are only slithers of visibility as one gets closer and closer—an eye socket, a mandible, part of the maxilla. A poignant comment upon man's relationship to nature, the restricted vision of *Leviathan Edge* suggests our inability to grasp the extent of humanity's impact upon the environment, its diffuse cruelty. We cannot fully comprehend the gentle dignity of the whale's almost-extinction, even if we can recognize the skull for what it is.

Walker tells a story about obtaining this piece for the show. He calls the artist on the telephone. "Great," she says, when he extols the virtues of the piece, puts forward a proposal for him to show it in Chicago. "Great," he says, in return. There is a pause. "Great," he says, "and how shall we arrange for transport for the piece?" "Oh," she says. There is a

pause. "Well, I'm happy for you to show the piece, but obtaining the piece, that's your job. It's all part of the artwork. You have to want to show it enough to find one. You know, your own whale skull?" Pause.

Walker goes to great lengths in order to obtain this item. He calls several different whale specialists, a profession he previously did not know existed. As purveyors of aquatic mammal specimens, whale specialists are not simply merchants who sell and rent weird skeletons. Their profession also involves carcass removal, which allows them to more easily obtain and preserve the rare and specialized bones. When a beached whale dies and rots away on the shore, its body ballooning with carbon monoxide, you can call a whale specialist to properly dispose of it.

There are many ways to dispose of a whale carcass. You can drag it back into the ocean and let it decompose in its natural habitat. You can bury it until all its flesh melts away. You can cut it up and burn pieces of the flesh, strip by strip. You can blow it up, but after Florence most whale specialists disavow that method of disposal for the sake of the surrounding township. For the sake of a more tourist-friendly "beach aesthetic."

Either way, I'm not in Chicago. I've never seen a whale skull up close. But to me, what's stunning about *Leviathan Edge* is not the rarity of the near-translucent object. It's not even that the piece contains within itself a long and arduous quest that must be undertaken by the curator. To me, the beauty of *Leviathan Edge* is that no matter how much you long to, you can never see this sought-after skeleton, its contours and edges, in its entirety. Rather, like any identity, it has to be believed in order to be seen.

I'm thirteen. I want to be loved, but I don't know how to ask for it. I solve this problem with simple solutions, anorexia and cutting, because I am a fairly simple girl who finds it satisfying when she does what's expected of her—even when it comes to the forms her rebellion takes. I shred the flesh on my arm and hide it under the neat silence of a single Band-Aid because I am unhappy. Leslie Jamison, in her essay "Grand Unified Theory of Female Pain," tells it best: "I cut because my

unhappiness felt nebulous and elusive, and I thought it could perhaps hold the shape of a line across my ankle. I cut because I was curious what it would feel like to cut. I cut because I needed very badly to ratify a shaky sense of self, and embodied unhappiness felt like an architectural plan."[20] I buy pink Band-Aids with Hello Kitties printed on them instead of the ordinary flesh-colored strips. They loudly announce my injury while obscuring and aestheticizing it, the pastel stars and smiling flowers cheerfully informing the world that I am hurt, hi, I cut myself, while all the time sanitizing the wound, making it affable, feminine, and pretty.

It's a Monday in late 2016, and my mom calls. The last book of the New Testament, Revelation, promises seven years of hell and worldwide disaster before the Second Coming of Christ. I don't believe in the Rapture anymore, but given the state of the world, we could be in the Great Tribulation nonetheless. If you've been a Christian, you know what this means. I'm thinking about the Antichrist. He's supposed to be a baby, but with his bad hair and orange tan, President Trump kind of looks like one. My mom is a Christian psychic who speaks in tongues and sometimes has visions. She believes she instinctively knew the results of the election long before it occurred. Now, the worst has happened even though she had hoped her visions wouldn't come true. And now that it's happened, she tells me, it must be God's will—and God's will be done.

Curious, I ask her why she thinks He made this happen. She says that He probably just wanted to "shake things up." I laugh, I can't help myself, but I groan, too, because often, her visions do come true. Sometimes though, they're more like "visions"—her way of expressing a strongly negative opinion about something in my life without having to attribute it to herself. "I'm not sure I see that that's the right path for you," she'll say. "It's not God's path." I look away, but I still hear her. I mumble to myself that her special talent would be so much cooler if she wasn't my mom.

Sometimes, she tells me I have the power, like she does, to move people. When I hear this at home, nestled next to her arm, sentiment rises

in the back of my throat. The taut magnetism of our affinity. Today, my mother tells me not to think too negatively. She tells me it's dangerous. That I might accidentally will something wicked into existence if I believe it. I think about all the people I love, the people I visualize, dying in car crashes, because of how I manifest and repel my fear. Staiti trips over a crack in the sidewalk. I'm sorry, was that me?

Sometimes, when I go to church with my mother, I feel as if I'm on the outside. I'm not aligned, I'm not in faith. I reach into my pocket and find a half-melted Twix. It's my favorite chocolate, but my stomach turns. I curl my body deep into the back of a pew. Around me, people fall to the floor. They raise their hands to the heavens, eyes closed, tears streaming down their faces. Sometimes, they call out. These are invocations.

When I think about church, I think about belonging. But here, I'm not quite in it. I don't feel at home. I'm moved, nonetheless, by the affective force of everyone around me. I'm singing along to the minor chords. It is a transient psychic disturbance. Belief. When it happens, it's a moment when all the ingrained inhibitions of my upbringing, embarrassment, education, and social behavior are simply cast overboard, and natural impulse, like a mountain torrent, sweeps everything before it away with nostalgic force. Tears are welling up from somewhere, I don't know.

Even now, my impulse when I'm bored is still to put a blade to my skin. I believe in discretion, so I keep a supply of Band-Aids in the kitchen. It's only polite. I google "history of the Band-Aid," and one of the search results that comes up is the Great Idea Finder page. It tells me that Earle Dickson, inventor of the Band-Aid, was inspired by the fact that his wife, Josephine, often met with kitchen-knife accidents during the preparation of meals. The unfortunate phrasing of the internet article reads, "During the first week that she was married to Earle Dickson, she cut herself twice with the kitchen knife. After that, it just went from bad to worse. It seemed that Josephine was always cutting herself."[21] I smile. The idea that Josephine intentionally inflicted harm upon herself in order to

escape the banality of her domestic chores amuses me. But like every smart-ass man, Earle Dickson invented the compact and convenient "Band-Aid solution" so she could continue her work despite any messy injury, despite any blood. Poor Josephine Dickson, foiled. Just like all the other girls.

I've always enjoyed the myth of the Band-Aid. Flesh-colored and waxy, it's designed specifically to blend into the rest of a body's surface area. A Band-Aid will simulate the fantasy of healed flesh so we forget the actual wound. Contemporary Band-Aids and other newer brands of adhesive bandages even use popular cartoon characters and fantasy animals to extend this myth of recovery, to help neutralize the threatening presence of a wound and make it more innocuous. "Made with Unicorn tears for extra healing power!" one box even exclaims. A bandage obscures any unnecessary gore. It makes it easy to believe in the wholesome goodness of a smooth, unruptured surface. It's what allows us to forget not only the wound, but the root of the problem. What caused the hurt in the first place. The real suffering. I press my nails viciously into Hello Kitty's mouthless, pretty little face and send a twinge up my arm.

I'm thirteen, and what stops me from destroying myself is going to church. I hear a pastor speak about parables. You know, the prodigal son, the good Samaritan, all the stories Jesus would tell his followers, all the stuff I learned in Sunday school as a kid. The pastor says something interesting. He believes that what's significant about parables is not their content, but the counterintuitive form they take. In other words: a parable is not a story designed to convert someone to Christianity. In fact, it is rather the opposite. It is made to affirm one's faith—a parable can only be truly understood by an actual believer. Mark 4:11–12: "To you has been given the secret of the kingdom of God, but for those outside, everything comes in parables; in order that 'they may indeed look, but not perceive, and may indeed listen, but not understand; so that they may not turn again and be forgiven.'" A parable is code. It is designed to be obtuse so its lesson remains obscured to those who do not believe but clear to those who do. And like a parable, the pastor tells us, God's

unconditional love is not to be *discovered*. It can only be experienced if we first believe it exists—if we first believe that we are worthy of it. If we do not, it will forever remain unseen; we will be blind to it. But if we simply believe, we will feel His love. It will flood over us in waves.

After I hear this, I begin to believe that God loves me unconditionally. I believe that He will love me no matter how much I weigh. He will love me whether or not I am wounding myself; He will love me despite this pain that I feel. I begin to pray every day. I take comfort in the idea that I have no control over what will happen in the future, but I trust that God's will shall be done. Somehow, I want for nothing. Somehow, the pain is gone. I begin to eat again, especially food that's sweet. I stop wearing Band-Aids. I wear leg warmers on my forearms to hide my red and healing scars, the synthetic wool soft and comforting against the keloids on my skin.

When I start eating again, my mother is delighted and relieved. She buys me pain aux raisins from the bakery near my school, greasy and sweet, with crème pâtissière baked into its spiral. When I stuff the soft pastry into my mouth, I think about how much God loves me. When I lick the orange glaze from my fingers, I think about how even when I look disgusting to everyone else, He will still love me. When I savor the pain aux raisins, one minuscule bite after another, when I hide even the last crumbs inside my standard-issue school desk, I think about how much God still loves me. So much. I believe it.

Years later, I'm at church with my mother, crying as the music swells. The communion wafer sticks to the roof of my mouth. I imagine my mouth engorged with raisins. I lick my molars. I feel the weight of a doughy ghost on my tongue. The chord changes cheesily, but my heart lifts along with it. I'm falling back in faith. And as much as I hate to admit it, church is not-*not* home, I guess.

In theorizing the recurrent anxiety we recognize as the uncanny, Sigmund Freud used the German term *unheimlich,* which, can be translated according to its historic usage to "the not-home," or the "unhomely." He writes,

"[The] uncanny is in reality nothing new or foreign, but something familiar and old—established in the mind that has been estranged only by the process of repression."[22] In other words, the uncanny is no fresh fear. It's the jarring feeling of recognizing what's in front of you, yet not being able to place it. It's what makes us shudder.

Don't laugh, but I'm in New Jersey. It's Halloween. I'm with friends at a triple haunted house extravaganza. For the low price of forty-five dollars, you get to experience a haunted hayride, a haunted corn maze, and finally (you guessed it), a haunted replica of the Bates Motel. The lines are long, but it's usually worth it, and I pass the time licking a candy apple, trying to keep caramel from dripping down my arm. Kirsten spikes the hot chocolate with vodka. None of us scare that easily. We don't flinch at the girl sawn in half or the zombie hands that grab at us through the corn stalks. But unluckily for me, I went to Catholic kindergarten. I learned the alphabet while gazing upon bloody murals of Jesus being crucified at Golgotha. When I see a woman who looks like a witch being crucified upside down, I scream and scream, my fear spewing from a distant memory I didn't think I could remember. "Dude, but I thought you were into BDSM," someone hisses next to me, irritated. A sudden retreading of an unpleasant memory we've chosen to forget, the uncanny can be a reminder that what we repress usually comes to define us. It's an unexpected return home.

At boarding school, I kept a can of store-bought pea soup in a cabinet. I ate pasta with ketchup, cheese, and butter. I reheated baked beans and school-rationed sausages. I wanted to make certain I was just like all the other girls, so I ate like them. I thought it would help. But in the back of the freezer, I hid a box of Chinese barbecued pork buns. I cut them into precious quarters and microwaved them when no one was looking. I savored the sweet, yeasty taste of bread, the red, braised meat spilling onto my fingers like a crime. The weight of the steam in the air. Home, or heaven—I can't escape how I return when there's familiar food at the table. Charcoal-grilled toast slathered with butter and coconut jam alongside soft-boiled eggs so undercooked they're like soup. Condensed milk in coffee brewed all morning, the beans first

fried in butter. Food imbued with the decadence of lost time, food that reminds me how the hours stretched in childhood, simple and unending. I'm somewhere, eating noodles. The shopkeeper is brusque, and when I inhale the familiar broth, I burn my tongue. I tear up just a little. Perhaps the uncanny is a denial of home too—a refusal to acknowledge our ever-present desire for it.

I decide to give in. I decide to avail myself of all repression and denial. I'm in Chicago, where the light spills in. I glimpse the whale skull through the cracks. Finally, I decide to believe in the story of identity. Like in *Leviathan Edge,* I let its unknown completeness engulf me. I will write about the wisdom of my elders. My confused and divided feelings will culminate in an enlightened state combining a contemporary sensibility with my embedded heritage. Like the parable of the prodigal daughter returning, I will experience an emotional climax, with my mother washing the mud off my feet despite all my wrongdoing. I will reach the pinnacle of erudite humility. I will return with a contrite spirit. I decide I'm going home.

I'm back in Hong Kong, visiting my grandmother. It's 2016, and she is ninety-four years old. I love my grandmother because she is one of the toughest people I have ever met. She pours me tea out of a plastic thermos in her sitting room. I ask her about her life, what it was like living in a British colony as a child, and how she survived World War II. About the years she spent in an orphanage, the only thing that earned her a reasonable education as a girl child. What it was like to be the daughter of parents who had to abandon her because they were too poor to feed her. My grandmother has a bad leg. It keeps her from going too many places. But her mind is incredibly sharp. Her favorite activity is sitting in her easy chair and listening to the stock market radio show, because she's still aggressively trading stocks and bonds. When I ask her why she doesn't watch the stock market on TV or the internet, she shrugs and says she likes her habits the way they are. When I ask her about the British, she says, "They treated us like pigs." When I ask her about the orphanage, she tells me there were a lot of lice there. When

I ask her about the war, she says, "It could have been worse." When I ask for more, she shrugs and says, "That's the reality of life, what do you want me to say?"

The truth is, my grandmother likes to talk about money. It's the fifties in Hong Kong, and even though it's unusual, she is the bread-winner of the family. My grandfather is soft spoken and intellectual, a nighttime English-to-Cantonese translator and photographer at the *Daily*. He brings home four hundred Hong Kong dollars to my grand-mother every week. It's not much, so it's she who handles the finances. She does it with an iron fist. I ask her about her marriage, about when she met my grandfather. I try to extract some romance out of the situa-tion. She shrugs and says that she loved him but he never helped her do much. He never helped her out around the house, even after she became the landlady of the three apartments in Hong Kong—apartments she still keeps up to code and rents out. I try to deduce her childhood ambitions. I ask her what she wanted to grow up to be. She laughs and says she can't remember. My mom is sitting on the sofa with her headphones in, watching a Korean drama as we talk. She looks up to interrupt in Cantonese, teasingly, "You can't remember? You didn't care! You just wanted to make money!" My grandmother laughs, but as a realist, she agrees. "Money will always be able to make things happen in this world," she says. "It makes you independent. You should only work for money. Nothing else is worth it."

Sometimes, when my father is annoyed at my mother and me for act-ing too similarly—you know, too anxious or whatever—he complains, "God, you know, you buy one, you get one free."

I'm nine. I'm at my grandmother's house, and I'm helping my mother dig all the expired food out of the fridge and cabinets. We do this at least once a year. Because my grandmother had very little as a child, she hates wasting any kind of food. My sister and I know her suffering is "not funny" but in this situation, it kind of is. "Well, this expired like twenty-five years ago," Marsha yells, waving a tin of fermented beans and fried sardines from the back of the cabinet like a trophy. After we

finish, we're bored, so my mother puts on Japanese *Sailor Moon* cartoons dubbed in Cantonese for us to watch. I love the animated pink backgrounds, the sailor blouses, and adorable short skirts. The protagonist, Usagi, is a normal schoolgirl whose life changes forever when she discovers she can transform upon command into Sailor Moon, an incarnation of Princess Serenity of the Moon Kingdom, who once watched over the earth. Even with this extraterrestrial pedigree and the weighty responsibility of having to protect our present-day earth from dark forces, Usagi cries a lot, has unrealistic expectations about romantic love, and is constantly terrified of becoming fat. I identify strongly with her.

I expand my repertoire of cartoons. I become obsessed with Japanese anime. I buy trading cards featuring anime characters with money I've painstakingly saved. I carefully frame each one in plastic laminate to keep its sparkly, holographic surface clean. I place each sheet of perfect cards in a binder that I bring to school every day. I admire the cards at break time, sitting on the grass, away from the playground. I do not play catch with the other children. I want to watch my shows undubbed, in the original Japanese, so I try to learn the language. Subconsciously, I wonder what my grandfather would think.

My grandmother might not want to talk about the war, but before he died, my paternal grandfather sometimes did. The story was simple because it was true: When the Japanese came to Singapore, they drove trucks around the neighborhood. They knocked on every door. They rounded up every Chinese man above the age of fourteen and under the age of twenty-one. The men got into trucks. They never came back. "Why live in the past?" my grandma would lament, throwing up her hands, but my grandfather would never buy anything made by the Japanese, not even a rice cooker.

It's 2017, and 209 protestors who attended demonstrations during Trump's inauguration are slapped with multiple charges for felony rioting and face up to sixty years in prison. In this moment, when it's harder and harder to live in the present, I fall prey to historical

decadence. I watch a Maggie Cheung movie. I swipe matte red lipstick over my lower lip. I put on a fifties-style cream blouse. I'm thinking about nostalgia. A strange muddling of temporalities, nostalgia seems to me like the desire to simultaneously romanticize our past and create our future in its image—to return to a utopic golden age when everything was "simpler," a time "before the world changed."

In her book *The Future of Nostalgia,* Svetlana Boym sees nostalgia as the by-product of a capitalist world in which progress is fetishized. According to Boym, humans were once allowed a "space of experience"[23]—a span of psychic time that allowed us to assimilate the recent past into the present, and to reconcile it with the unknown horizon of the future. But capitalism's centralized, often nationalistic ideal of a better future is inextricably tied with rapid spatial expansion, colonization, and renewal. Speed becomes essential. In order to survive, we can no longer live in the present. We are forced to dwell in a compulsive and never-ending race toward the future. And in this new normal, there is no longer any psychic space for synthesizing our experiences. We suffer a sense of constant displacement. Exhausted, we desire a place to rest. We mourn the comfort of the vanished past, made all the more glamorous by our inability to wholly assimilate it into our present, our inability to process its flaws. We begin to long for home. Nostalgia, therefore, is a symptom of our ever-encroaching capitalist future. A future that promises us everything but the solace for which we long.

Growing older, I tire of anime, but my curiosity about Japan remains. At boarding school, I drape my cubicle with a peculiar mix of tweenily earnest friendship photos and anachronistic black lace. I start listening to visual kei, a baroque blend of Japanese heavy metal, glam, and punk rock known more for its playfulness of performance than the strength of its craft. Aptly, I like it less for the thrashing music than for the antiquated gothic costumes that its practitioners wear, rock stars in pancaked white makeup and faux-Victorian lace garb, writhing around the stage. The first time I put on a petticoat, lace shirt, and corset is the first time I look into a mirror and like myself. I paint wide black circles in

kohl around my eyes and glue long tinsel lashes to my lids. I subscribe to a magazine entitled *Gothic & Lolita Bible.* I buy the overpriced black lace, the teetering platforms, the cutesy embellished knee socks. The girls I see in these Japanese magazines are uncanny—they're not-*not* like me, with their almond-shaped eyes and yellow skin, these physical characteristics I also possess.

I pin their cutouts to my mirror. My attainable ideals. I am a shapeless mass of emotion, and I scaffold myself with these Japanese cultural forms. I carve them out as templates. Each one just alien enough to fascinate me, just distant enough from myself to be fetishized. Because of my obsession with these fashions, I become nostalgic for an imaginary homeland I feel I know but that isn't mine. And in these illusions, I find the comfort I need to weather a painfully Chinese adolescence, one in which the weight of Confucian filial piety and its obligation is beginning to crush me.

"The danger of nostalgia," Svetlana Boym writes, "is that it tends to confuse the actual home and the imaginary one. In extreme cases it can create a phantom homeland, for the sake of which one is ready to die or kill."[24] For Boym, the nostalgic desire to return to an imaginary and untainted homeland is the foundation upon which nationalist movements—from xenophobic fascism to white supremacy—are built. Obviously, I did not become a Japanese nationalist, and perhaps it seems extreme to suggest that that may have been a possibility. But I did find another Asianness to come into when I could not understand my own. When I was grasping desperately at ways to belong. Perhaps it's troubling to think that because of something as unremarkable as adolescent isolation, I, too, succumbed to the lure of a phantom homeland. I, too, found relief in an imagined identity. I buried my race by eliding it into the illusion of another. I found myself; I rejected myself. I was not-*not* me. Somewhere, my grandfather turns at least once in his grave.

I'm back in New York, but what the fuck. I'm trapped in the Paul McCarthy show at the Park Avenue Armory. I can't bring myself to leave. Titled *WS* for White Snow, this extravagant multimedia installation is as

nostalgic as it is perverse. It's an 8,800-square-foot artificial enchanted forest snaking across the entirety of the armory hall. A literal live-action Disney set, complete with foam trees, glittering cobwebs, underfoot shrubbery, and fake woodland creatures clinging to its shiny branches, *WS* is a place that would be magical to your average six-year-old, if not for the sinister cottage embedded within it. This is no ordinary cottage, nor does it house your clichéd fairy-tale witch. Rather, it's a re-creation of McCarthy's ramshackle Salt Lake City childhood ranch home at three-quarters' scale, reconstructed by the artist himself entirely from memory. Just the idea of it is fucking terrifying.

I'm looking up at the fluorescent lights in the vinyl ceiling. I'm wandering down the enchanted forest path, the yellow brick road to wherever. I discover that the only obvious tell that the house is a replica is the fact that it has tiny glass rectangles embedded in every wall and door so you can peer voyeuristically within. And when I bend down to take a look, its interior is absolutely trashed. A mannequin half-dressed in a Snow White costume is covered in what appear to be the remnants of food fights; there are knives embedded in the mantelpiece, blood is splattering the surfaces—sorry, no, it's ketchup. I realize the panoramic screens on each end of the hall are playing a seven-hour film on loop, one in which the artist, McCarthy, dressed in a suit and prosthetics to look like Walt Disney himself, is on a pornographic rampage with three seminude Snow Whites and seven trouserless dwarves.

That's right. On screen, Walt Disney, Snow White, and her dwarves are systematically destroying McCarthy's childhood home with as much and as many kinds of debauchery as it is possible to imagine. The camera careens around its characters as though it's rolling off the dolly; it's nauseating. The never-ceasing laughter as characters grope and fondle and stick their dicks in whipped cream and sexually asphyxiate each other with strings of raw sausage is a squealing ambient soundtrack. But my favorite parts of the exhibition are smaller: numerous enclaves in which related video works are shown, hours and hours of footage. McCarthy, as Walt Disney, is on his hands and knees, scrubbing the floor with a toothbrush. He is impossibly slow.

He behaves like a four-year-old child. He blubbers and snots and spits. Snow White dons a white apron. She's suddenly cast in the role of Walt Disney's mother. She forces him to perform various household chores in the tone of an especially skilled dominatrix. She forces him to clean out his filthy mouth with soap. He cajoles and whines and begs in a stuttering baby voice. He wants affection. He wants to be loved. He cannot ever become a clean or good enough boy for mommy Snow White. Unlike her, he will never be pure. It's an intolerable scene that's luscious with coded s-m eroticism even though the actual childhood trauma it's sublimating is not sexy at all.

WS is not only the total obliteration of any sentimental feeling that one might have for one's childhood. It goes one step further. It catalogs all the fairy-tale stories our psyches have manufactured to make our childhood traumas tolerable, palatable. It turns them revolting. It makes them unforgivable. It is a gleeful evisceration of nostalgia.

I'm back in Hong Kong, at my grandmother's home. It's a warm fall day, but I drape myself in a pink floral blanket anyway, the same one I hid under as a child. I breathe its familiar mothball smell. The colorful plastic vinyl laid out over the glass coffee table is sun-faded but sports the same cheerful checkered pattern as it did twelve years ago—red and white speckled with the odd yellow lemon. Across from me, steam rises from a thermos. It's a comfortable room. I'm listening to my grandma tell her story, and despite my best efforts, I begin to fall asleep. I pinch the crook of my elbow discreetly. I nod and smile. I spread my eyelids extra wide into their sockets. I try to stay awake.

After all, I have decided to give in to the wisdom imparted by my elders. I want to immerse myself in the dynastic stream of knowledge. I want it to wash over me and endow me with existential clarity. But because my grandmother, like most elderly folks, tends to be long-winded, what I'm hearing is a haphazardly thorough rundown of the events that make up a reality. I'm hearing the story of her life, sifted through damningly human priorities—the murk that class and war and Confucianism and gender have produced over ninety-four years. I'm hearing it translated into everything that seems petty—a grievance about

her tenants, some grudge with her brother-in-law, all of it entwined with family and sentiment. It's a jumbled ball of contradictory threads. And sitting in front of my grandmother, quite frankly, I'm bored.

I wanted to believe in the story of identity. I should have found myself in the mirror, but it was hazy with industrial smog. My expedition failed. The reality of my grandma's tale was not a narrative any reader would enjoy. In my excavation, I found no exotic, ancestral knowledge to impart to you. There were no guiding motifs to be found, no clarifying reflections, not enough historical coherence to paint a vivid picture of my oriental past. I did not find the guiding light I was seeking for myself. I did not fill the black hole of my own stupid identity crisis. Instead, I found so many minutiae I could hardly see the events within the narrative.

But of course, that's how events are made. Knitted together from our glossy projections, our selfish, uneven retellings, they don't just turn out large; they're small and ordinary first, like lives. And like any other small, real life, my grandma's cannot be smoothed or saved from its flaws: not by representational politics nor by romanticized heritage. But I love her. She is the toughest person I know.

I don't remember when I first heard the term *heritage,* but I remember not understanding what it meant. My school had a rigorous educational program when it came to racial equality, and we schoolchildren often went on "heritage tours"—day-long tours of each of the city's ethnic precincts, from Chinatown to Little India to Kampong Glam. Instead of having lessons in school, we'd visit religious buildings, eat local food, and learn about rituals, cultural events, traditional businesses, and trades. Because of this, I thought *heritage* meant having fun, something a little more like *vacation.* I thought it was worth celebrating. "That's right, Trisha, it certainly is!" the sari-clad tour guide chirps at me, pointedly on script. "I'm happy to be celebrating my heritage with you!" I'm eavesdropping on my classmates, who are ruthlessly making fun of the length of a Sikh girl's arm hair. The tour guide hands me a traditional Deepavali treat. I eat the sweet dessert. Gently,

but firmly, I am interpolated. I respect all heritages. I see the invisible line ahead of me. I toe it.

Boym writes, "When nostalgia turns political, romance is connected to nation building and native songs are purified. . . . The past [is] no longer unknown or unknowable. The past [becomes] 'heritage.'"[25] Traditionally, heritage has meant the preservation of an ethnic community's history. But more insidious than nationalism, heritage, when wielded by the state, suggests that by simply commemorating our racial identities, we can address the inequalities we suffered on account of them. These days in the u.s., heritage is mobilized as an individualistic, institutional myth. It would have us believe that by reviving our family narratives and traditions, by demanding representational equity, indeed, by raising "awareness" of our ethnic differences, we can address, even eradicate, the scourge of racial inequality.

Heritage would have us believe that if we receive truly equal opportunities, we can finally excel and secure the better futures we seek. From best-of Asian American lists, governmental grants, and foundation awards to affirmative action, heritage works best when it's visible, and often presents as progress toward a miraculous meritocracy. But, as Stuart Hall famously wrote, "race is . . . the modality in which class is 'lived.'"[26] In truth, heritage, as part of a societal belief in the narrative of "it gets better," would have us look away. It would proclaim that racial equality alone can eradicate everything from poverty to violence, when in fact it's nothing but part of a Band-Aid solution to the problems of late-stage capitalism. A false tangent, built out of cardboard and painted red.

Identity—we worship at its shrine even as it keeps us docile, all the while declaring itself infallible because of its authenticity.

Being made aware of my difference is no novelty to me, but boarding school is the first place where I am made aware that my heritage is undesirable. My dad still thinks everyone who is mean to me is stupid. It's a blanket accusation, but this time, when I complain about my classmates on the phone with him, he's quieter. After a long pause, he says, "You just

have to work harder than them. Work hard and you can have anything you want." Yeah, I've heard it before. I almost get annoyed at how tinny the aphorism sounds. Nonetheless, it was easier to dismiss when it was just what I'd heard people say, not what felt real. I nod, but my dad can't see me, so he adds, "And white people drink too much." I laugh.

It's easy to believe in the essential goodness of your heritage. It's even easier to believe your identity will save you. My grandfather used to bring me to Haw Par Villa, an Asian cultural park in Singapore famous for its gorily realistic tableaux of the Chinese afterlife. The Buddhism he taught me there had no Zen in it. It was no sanitized, whitewashed myth. It had the Ten Courts of Judgment and the Eighteen Levels of Hell. At the last stony gate before reincarnation, a decrepit old woman made you suck on her bitter tits to forget your past life. Heritage may have mimed what my family taught me, but it was an institutionalized delusion. What I learned was no *Joy Luck Club*. It was specific and ordinary. It composed me, loosely and imperfectly. I'm embedded in its tangle, but I have no belief in its salvation. Thank god.

A story about my grandmother: She is young. Maybe six? Her parents have gone to work. She is hungry. There is nothing to eat in the house. She paces around. She searches the cabinets. She looks on the stove for any leftover rice. There is none. In the kitchen, she finds a plastic bucket. It is filled with water. Swimming in it is a giant live eel. There is nothing to eat in the house. She is barely four feet tall. She dips her hand into the bucket and tries to grab hold of the eel. It is slick. It struggles. The bucket falls over with the force of the eel's body, a single lean muscle. It thrashes from side to side. The water swamps the kitchen floor, a deluge. The eel throws itself upon my grandmother and they become a monstrous, flailing whole. Its gills and mouth open and close. It is gasping for breath. My grandmother can't get a foothold. She throws her arms out for anything she can find. Miraculously, she grabs the rice cooker. She finds enough strength to crush the eel's head deep inside it. She crams the rest of its body into the pot. She locks the lid. The pot is heavy, but she manages to get it onto the stove. My

grandmother boils the shit out of that eel. She feels like a winner. Her parents arrive home as she finally opens the pot. The eel is inedible. Everyone knows you have to skin an eel before you cook it. Otherwise, it's impenetrable leather. Her mother throws the eel out and scolds her, but my grandma smiles. Both of them are hungry, so together they make rice. They eat dinner as they do every day. Later, my grandmother picks a piece of eel out of the trash and eats it furtively. To her, it tastes sweet. It's a great parable, don't you think?

It's years later. I'm having trouble sleeping at Staiti's house. The radiator's blowing steam but not heat. It's a little too cold, but I don't like using the flat sheet. I'm a brat and I find its surface too smooth to be cozy. But Staiti is sweet and they buy me a blanket identical to the one I have at my apartment: blue with a waffle weave. The West Coast isn't cold enough to have updated central heating systems like the aggressive ones in the East, so I swaddle myself in the blanket every chance I get—it's over my toes when they hang off the edge of the couch, snug under the heavy down comforter when our bodies wrap around each other at night. My swath of blue fabric, like the dense California sky, sprawling across the floor, trailing from one piece of furniture to the next. In bed, our body parts spill out from under it like a partially concealed jigsaw, a fortress of our own. We don't live together, but it's still home—a tiny utopia in an apartment somewhere. Instinctively, I slacken, I lean into it, but its beauty is suspect, so I tense. We're too far outside the world. It's too far from reality.

After all, home isn't perfect. Home sweet home is a void even if it remains the center of everything, the point from which a heartbeat radiates. The point to which breath inevitably returns, and then it stops.

Home—it's just something to contain our misplaced desires for a better world.

How can we willingly long for that?

Chantal Akerman's last film is called *No Home Movie.* We like to assume that everybody wants one—a home—or should. But this film is a bleak

documentary, chronicling Akerman's last conversations with her mother, who passed away shortly after filming concluded. Cycling through the myriad endearments and resentments that sustained their relationship, it finds the bitter complexity at the maternal heart of loving home. *No Home Movie.* Say its title out loud, short and curt, and you'll hear the contempt in it. Home. I don't want it.

Chantal Akerman's first film is titled *Saute ma ville,* which literally means *blow up my town.* It taught me how to breathe. A young woman, played by Chantal, arrives home. At first, she seems to be accomplishing a number of ordinary household tasks. She drags flowers haphazardly through the door by their stems. She methodically gets out a number of cleaning items, as though she's about to put them to use. It seems she might be preparing for some kind of event, but quickly, her actions become absurd. She tries cleaning her leg with a shoe shine, she duct tapes the edges of her door. She throws a bucket of water, along with several pots and pans, on the floor and then tries to mop it up. When that doesn't work, she takes a towel and starts cleaning the walls. The scene grows tense and suspect, if only because we can't tell if her actions are supposed to be comic. As she works, she hums, a sharp, unpleasant sound.

The young woman grows frenzied; she looks in the mirror and tries to write something on it, but it doesn't materialize. She starts laughing or crying joyously at herself, you can't tell which. The emotional pitch becomes unsustainable, but you get the sinking feeling that the only person who isn't sure what's about to unfold is you. The protagonist has a secret. What it is, we don't know. You can tell from the brusqueness of her gestures, their increasing speed. No home. The young woman lights a match. She sets a piece of paper near the stove on fire. She turns on the gas. She leans over the stove. There's a bang, then black. *No Home Movie.*

What might we dream in place of the familiar security of home? Sometimes, when you are falling asleep with your arm splayed across my ribcage and your knees nestled into my back, I think about what shapes we're making with our bodies. I think about the little extrusions that

don't fit into the good, sensible shapes, the way we can itch them like wounds. The way we hold each other anyway, make spaces between ourselves in an effort to find new geometries. I think about this line in *The Price of Salt:* "She wished the tunnel might cave in and kill them both, that their bodies might be dragged out together."[27]

I write Staiti. I ask, weak and pathetic and soft, "What do you remember about us falling in love?"—that instant when the world seems it can be molten and reformed.

I'm at home, scrolling Tumblr, and I discover that while I wasn't looking, Chantal Akerman has died. I re-watch the classics. I make toast with Nutella and eat it in large bites—an homage to *Je tu il elle.* I sit in the kitchen with *Jeanne Dielman, 23 quai du Commerce, 1080 Bruxelles.* At three hours, it's a meticulous record of a housewife's regimented schedule of domestic tasks, taking place over three days. I watch Jeanne pound schnitzel. She peels the potatoes. She does the dishes. At the same time every day, she receives a male visitor in the bedroom in exchange for money. She deposits the cash in a blue china urn on the dining room table. She is underappreciated by her son. She colors within the lines of life; it's a rigid template. One day, she overcooks the potatoes, and her practiced chores start to slip. Minute incidents accumulate into a pile of out-of-place matter. When at the end of the third day she has an unexpected orgasm with her client, something snaps. The even striations of her life give way to a landslide of psychic chaos, and in the throes of her own little death, she murders her client with a knife.

 In the last long shot of *Jeanne Dielman, 23 quai du Commerce, 1080 Bruxelles,* Jeanne sits at the kitchen table in the dark. She's gotten dressed, a single drip of blood visible on the breast pocket of her cream blouse. Cars pass outside the window, the light from the road playing across her face. Anesthetized to all emotion, stripped of the rigorous scaffolding of home, she's motionless, but not bereft. She's calm, but not satiated. She's present, but limp. She's somewhere we can't access. Watching her, I'm overcome with need. I'm tearful and starving but

sitting at the kitchen table, tight-lipped, in some compartmentalized stasis, Jeanne wants for nothing. Jeanne is not home.

In *Close to the Knives: A Memoir of Disintegration,* the artist David Wojnarowicz writes, "Destination means death to me. If I could figure out a way to remain forever in transition, in the disconnected and unfamiliar, I could remain in a state of perpetual freedom."[28]

Chantal Akerman's women might be hungry, but they aren't searching for a destination. They don't cater to the viewer's desire for a frame or a narrative. Often fixed in position, and affectively glacial, the camera in Akerman's films follows its subjects at a calculated distance, revealing with precision what is haunted in the resolute now, the architecture of their routine living. An elliptical formalism that allows shadowy empathy to percolate through the negative space.

When we see the two women make love in *Je tu il elle,* it's abrasive, they're kneading at each other, fighting, and pressing and slotting into where they can't. They're pulling against the sharp, urgent melding of their bodies; they refuse to yield. They make it *difficult.* And what they are building isn't so commonplace as to be merely erotic or romantic. Rather, they shape and reshape themselves with each other's hunger and loss, memory and desire. Fusing what's individual with what's ages old, together they become not-home. The nowhere to which we could belong.

I'm hungry, but I refuse to believe the world could give me any form that could cure me.

It's what, nine years ago? I'm at the Royal Academy of Arts in London, at the Anish Kapoor exhibition with a boy. His name is Thomson. I'm visiting him from far away because I'm young enough to believe our love transcends the past and the future. It's naïve. His dreams of me are very poorly colorized, like the fake-organza robe that hangs against my mirror, resplendent in its yellowing lace glory. I'm wearing lipstick, my mouth a smear of dark red. I'm carrying my cruelest handbag, a vintage clutch made entirely out of taxidermied deer skin,

its fur formaldehyde sleek. Most of the exhibition is guts and tubes, the sculptures stacked and weaving. Parts feel contained, but the centerpiece snakes everywhere. Titled with a Sanskrit word that means *self-generated, Svayambh* is a gigantic block of red wax, roughly twenty-two feet long and fifteen feet high, mounted on a set of tracks. Slowly, so softly as to be almost barely visible, it moves across the length of the exhibition hall. Every time it reaches a doorway, it's forced to squeeze itself through, leaving sticky, wet, red smears on the white interiors of the Royal Academy's historically ornate arches, slathering itself over the etched mountings and pillars. Crowds are gathered around each doorway, filling the space almost to bursting. Everybody has brought their friends and family, watching this great wet hulk that just keeps mechanically pressing through each hole. We stand there. We might watch it forever. He reaches for my hand, our fingertips barely touching, and we stay there like that for a long time, so long that I think tiny capillaries might start to grow out of our skin and web themselves together into new flesh. We stay there so long that it feels as though our veins have started rooting into the glossy wood floor, tethering our bodies to the looming red solid in front of us. We are plastering ourselves like a malleable, meaty massacre, inch by inch, across the Royal Academy's walls and windows.

I don't want to escape. I don't want to find a correct shape, a cure, or a form. I don't want a home. I want a new paradigm of interaction. "I want to build an architecture to inhabit with you," Jeanne posts on Tumblr. "I yearn for such a structure in which we could hold each other across our incommensurability. Free to move and be recognized and feel separate."[29]

Thomson is a dead end, like all the rest of the boys are. I have no illusions for our romance, but I like the meaty structure we might conjure together. Afterward, he writes me. He says, "I didn't realize how much I had missed you until I saw you and you left. You make all this seem less wooden. When I'm not thinking about Batman or Minor Threat, I'm thinking about what we might do together in the future."

The future. I want it too. I want the unknown. I want the there and then, with I don't know who and maybe so many. In our emails together, we've already ruled out so many of these ideas. We can't share a circulatory system (whatever that means), we can't actually be strangers (but we can pretend), we can't put tracking devices in our teeth and hunt each other down with radio scanners (even though that would be fun), and I can't get my tongue tattooed with a red star to represent the discourse that informs my thinking when we're kissing, because the ink just wouldn't take.

These impossible futures I would die for. The futures that will inevitably peter out, in the trying humanness of them, that seem possible but are merely unreal.

Dreams, I guess. Dead ends.

I fall asleep, and I'm dreaming. I can't remember what, but I wake up and it's morning. No, afternoon? I roll over, and reality hurts. I can't remember how many cigarettes I smoked the night before, but I wake up, and I'm wheezing so hard I can't breathe. I wake up in New York, where I'm visiting, and when I take a hit from my inhaler, Joey calls me a nerd, laughs like a hyena, then asks me what it's like to forsake the city and live in "health-food California"—all in one breath.

Cheerfully, I retaliate. I tell him that I'm suffering only mildly from what one might call the "post-cult letdown." New York, Jonestown, what's the difference? It doesn't matter. New York's still the greatest place on earth for everyone who lives there, the city and its supposedly endless possibilities. But that's not always how it is. These days, it's getting harder and harder to live in the present, and perhaps it seems lazy, or stubborn—or both—to only consider what's directly in front of you rather than fantasize about the vast expanse of the future, about how we might be able to change it for the better.

But in New York, it's freezing in the morning. When you get up, you have to make coffee right away, or you can't leave the house. You have to wear a cute outfit, or you won't be able to get on the subway

without shriveling into a ball of inadequacy and shame. You have to get to work on time, or you won't be able to afford the salmon you impulse-bought from Whole Foods. You have to get on the R train before midnight or it'll turn into the D, and so on and on it goes. It's hard enough to wade through time. It's difficult to face what's real.

At the end of the day, we're all just trying to get through it.

And so, things pass.

It's evening. I'm tired. Staiti goes to the corner store to get a bottle of wine, but I don't drink, so I go to the Carl's Jr. instead. It's dingy. A stuttering white man in a cheap suit stands in front of me trying to decide what soda he wants, and four kids loiter at the counter eyeing the chocolate chip cookies. Staiti walks in, and it's corny, but behind them the background fades.

At the Carl's Jr., it's Ash Wednesday. The cashiers are two South Asian women wearing plasticky uniforms. Giant ashy crosses are smeared on their foreheads, austere and odd amidst the kitschy fast-food Americana. One of them touches her wrist to her ashen forehead with fatigue, a graceful pinprick of belief in the smog of reality. I stroke my hair to offset the waiting. I wonder how these women feel. When I was little, I always found it odd to emerge from the dark ritual of church into sunny Sunday life. From communion to the Carl's Jr.—it just feels irreconcilable; it's a decisive letdown. Now I know that each is just one side of the same coin. One makes the other bearable by throwing it into sharp relief—the longing for an imaginary spiritual heaven entwined smoothly with a capitalist fantasy of the American dream. I leave the restaurant. Before we walk out the door, I turn back for a second, and in what seems like slow motion, I watch each delicate icon dissolving into the viscous cloud of skin and oil and powdered seasoning that is each woman's face.

Sometimes I think about how plain fantasy, or blind belief, no matter how senseless, is the only thing that makes it possible for us to continue seeking utopia. The only way we can keep things moving anymore.

Things pass. They do because they do.

It's what, 2002? I'm still in Singapore? Have I left? It doesn't matter. I fall in love with someone. We smoke cigarettes together outside an ugly shopping mall built out of red marble and brick. There's a giant bookstore inside. We wander around it. We avoid each other in the stacks and stationery displays. Avoiding what makes you nervous is another way to brush past it, to briefly touch, to indicate a desire to get closer. We buy snacks and lean against the pillars outside. People pass us by for hours. We don't notice. They do. They're upset because we are both girls. We don't care. We're young; we talk about Shakespeare and Pablo Neruda. Our appreciation is heartfelt but naïve. We touch fingers. When we kiss, it's soft, and her mouth is small. She tastes like grape juice and smoke. It doesn't seem like much. It's like any other teen romance, but it clips at my heart in a different way. Like we stretch our two skins over each other with our too-too sameness. But I'm fifteen. My feelings are simple because they are real. A week later, I leave for boarding school. I buy phone cards so I can talk to her for hours on the pay phone because cell phones are not allowed. For her birthday, I make her a hand-bound chapbook with collages I've put together with a glue stick, a Xerox machine, and handwritten transcriptions of poems I think she'll like. Carol Ann Duffy is involved. It's woefully adolescent. My mother finds out eventually. When she confronts me, she is upset. She tells me that rumors have been flying around, that she's heard about it from so many of her friends, so many concerned parents. She tells me that the other girls are telling tall tales about me. She emphasizes *tales*. At this moment, I come out to her. I mean, I try to. I kind of do? My memory of that moment is vague and blotted out. Either way, we don't talk about it anymore. As if it never happened. Like it has never been said.

In any case, I take my mother's cue. I excise the girl from my life. I tell her it's too hard. I excise the possibilities that come along with her. From this moment on, I like boys instead. It's for the good of my family. I think very little of it.

Things pass. They do because they do. This is hard for me. You can't stop it, or tweak it, or guide it. There will always be an unknown constant. There is no way to see what's coming. This is even harder.

I'm at a bar in the East Village with Ariel, because I'm about to move out West, to Oakland, California, and I don't really know anyone there. I don't really know the person who's going to be my new roommate, but Ariel does, so I'm trying to get the scoop. We get udon and a drink and gossip about everyone we know in Oakland because that's what poets do. Ariel and I talk about Alli, this mutual friend we have. She's recalcitrant, but it's sexy. I think she has nice tits. Ariel agrees. They say they couldn't stop staring at her one time at a reading, and their girlfriend at the time got really annoyed. "Aren't you moving to California to be with a dude?" Ariel asks. "Yeah," I reply, shrugging.

A few days later, when Ariel talks on the phone to my future roommate, they tell them that I am not as straight as I seem, as though queerness is a guarantee that I am a more ethical or principled or, I don't know, cooler person than I would be if I were a dedicated heterosexual. I'm not sure how to feel about this, maybe it's true? My soon-to-be roommate isn't a man, but from what I know of them from friends, sometimes they're not unlike one. They dabble in masculinity. Predictably, I find this charming rather than annoying. They laugh at Ariel on the phone. "You know I love straight girls. Why would I care?"

I'm in the East Village. We leave the bar. Ariel cocks their head at me and hesitates. "What?" I ask. "It's just . . ." They shrug. "Don't sleep with your roommate. Because you're going to want to." Pointlessly, I wave them away. I try not to blush.

It's a month later, and I moved to California for love. It's two years after that, and Ariel was right: I'm not as straight as I seem. I did want to fuck my roommate. I went so far as to love them, and when push came to shove, I chose them over a boy. Just another bisexual Bay Area cliché. Maybe I'm just like all the other girls after all.

Am I?

I mean, I'm not American. So much time has passed that this can be difficult to remember. I was born but not raised here. I did not grow up in a house with a white picket fence and a lawn. I did not watch *Freaks and Geeks* in the afternoons after school or spread sticks of celery with

peanut butter in order to dot them with raisins. I did not know the bronze of cornfields or the distances that stretch from coast to coast. Singapore was small—my home did not hold a continent's worth of internal difference. My world had heat and humidity and light. We danced outside in our cotton uniforms; we got drenched when the monsoons came. I ate fruit that sweetened itself from having never known the cold. We were taught to rejoice in our tidy sameness, everything jostling and small. When events in my life make the world around me swirl in a haze of pain and shock, the u.s. is not where I find the ground.

I am not American, but I was brought here because my parents believed it would help me attain some better future. I would find new skills to bring home. I would honor them when I returned. But whatever the American dream is, I found it pale and diluted. All I learned from the West was an abstract desire to be free, even if over time, this word has lost its meaning.

Gestalt psychology tells us that the figure and the ground are two objects that, while distinct from each other, still require each other for context. This means that we sometimes see the background as the object and vice versa. No matter which perspective you take, one shape always has to obscure the other even when they exist perfectly together.

Can't I have both—my attachment to my family's history, and the ideal of a liberated future? The longer I'm here, the more these twin yearnings become muddled. Each one obscuring the other, then it retreats.

The story is simple enough. I'm at another poetry reading. This time it's mine. I'm reading from a manuscript I'm working on entitled *Socialist Realism*. It's partly about my family, about the way I've chosen to live. Afterward, people tell me in hushed tones that they like how vulnerable my reading was. When they tell me this, their eyes are round. I'm not sure what they think this means. I'm not sure it means anything to someone who routinely performs, of her own volition, suicide notes she may or may not have written at various points in her life. Honestly,

I'm not sure what it is about writing in general that makes people think they know what feels "vulnerable." I'm not sure what it is about writing the raced elements of childhood that makes them assume the writer must be feeling especially "vulnerable" when it's simply what happened; it's simply true. If I may put it in such terms, I have "practiced" this "specialty" only very seldom. It's true that my response to the peculiarity of my human condition has driven me to the most strikingly extravagant acts of performance, but performing my "Asianness" is not one of them. It is merely one of the circumstances of my life.

The story should be simple enough, but it's not. Does writing about race make my writing "realism," a David Attenborough documentary special? Does it matter? We all know that for such realness to be bestowed upon a work of art, it must first be assessed by an audience that may then deem its raced qualities authentic or not authentic enough.

After the reading, someone points out that just a year ago, they were convinced I was vehemently against the very aesthetic with which I'm currently engaged. Back then, I churned out identity markers with ambivalence. I was cold. This time, I told an alluring origin story. Correctly, I hit an exotic note of warmth. I passed the test. It is fair to say that I have now represented myself adequately and have fulfilled my duty: to gratify my audiences' autoerotic desire to be concerned for and awed by the Other. I am a very pretty ideal, I must say! Whatever. I have never hidden or flaunted my Asianness. It is a fixed symbol. It's just my life.

I'll be the first to admit that I like telling stories about myself, both truthful and not. But perhaps it is a testament to the standardization of white authorship in literature that if race is not explicitly mentioned, if it is not formed into a story that is palatable and congruent with the assumptions of the white reader, then the writer must be betraying their identity. If I have not provided a scenic narrative about my race in the way that readers are used to perceiving it, then I must be denying it. I must be trying to pass for white. What a selfish and perverse provocation—to have given the reader no chance to discover themselves while grasping the encountered object of otherness to their bosom and sobbing! To have not embraced my roots, not unearthed

a new superpower, nor served it all up with a crispy side of multicultural enlightenment, the audacity! The reader informs me the more pronounced my otherness, the greater my passion should be. This way, I am a very pretty ideal indeed.

I'm home after the reading, and I feel defeated. I try to stave it off by making a grilled-cheese sandwich. Staiti and I share it, the surface audibly crunching as I cut it in two. It's delicious because of the provolone, but it doesn't help. I feel as if I am being rewarded for doing identity "right." I realize the extent of my resistance to "performing race too hard," even if it's questionable what that really means. I've harmonized with whiteness. I feel as if a stranger has pressed what they believe is the key to my soul upon me, when they've impulsively flung the real one out into an *Animal Farm*-style field of ideological mud.

Pamela Lu writes, "The trend of irony in contemporary cross-cultural current has, I think, successfully warped the linear narrative expectations of the kind of Asian American novel that became popular in the late eighties to early nineties and prevails to this day, as in: protagonist feels alienated from two disparate cultures, protagonist comes of age by learning Old World wisdom of Elders and New World smarts of peers, protagonist experiences clarity and empowerment as a result."[30]

Has it?

I'd like to believe that my reading accomplished something akin to what Lu describes, but the story isn't simple. The particulates of my own aspirations—who wanted what for me, and why—remain chalky at best. And living between the illusion of reality and the materiality of my desire, it's hard to distinguish the narrative I chose from the one I was given by my family, from what the world assumes me to blindly believe.

Alice Notley writes, "Of two poems one sentimental and one not / I choose both."[31]

I wanted to believe in the possibility of utopia, some fulcrum between our nostalgia for the sordid past and the exciting promise of the future. But it's hard to know where to find yourself. It's hard to know how to

get there when the only constant is how the background tends to fade. When we're all trying to figure out what's real.

A house. There's a dream of a house, like there always is. The house has blue walls.

It's four years ago. I have a boyfriend. He is the only boy I've ever dated that my parents have liked. Mostly it works against him. He's a grad student. His family is Jewish, but he's from Colombia. He is handsome. I think I've fallen in love with him, but now I know differently. It is a pale and diluted sort of love, a vague feeling of something pure and elevated. I am not carried off by a genuinely ardent and inflaming affection. My senses are not completely overturned. The sky is red. It's cold. We're on our second date. I take him out to Brighton Beach on the F train because I like the sea in the winter. We eat blintzes and liver. I try to talk to him about poetry. He isn't a poet, so this is hard. I tell myself it's OK because I believe that Art is only good for suffering. He pets me on the head, and I cough. He leans over to kiss me, but his lips are too thin and I cannot find his teeth.

We walk past a business that takes your photograph and prints it on any piece of china—a teapot, mug, or plate. It's only our second date; it would be creepy if we decided to make an object together, especially one so permanent. We do it anyway. We stand awkwardly in front of a tiny digital camera. A Russian woman belligerently tries to pose us. She insists, over and over, that we move closer together. She insists, over and over, that we hold each other more tightly. "To make you look good!" she exclaims in broken English. I can feel the tickle of his plaid scarf against my cheek. I complain that I cannot find a comfortable position. Eventually we let her manipulate our bodies. I'm stiff and sweaty. Her bony fingers press into my forehead. She bats my head this way and that. I feel as if the meat of my arm is loose, as if she might pull it away from the bone and shred it, then tie it onto the flesh adjacent to mine.

The way we end up standing is awkward and painful. We can't afford a whole plate, so we get our picture printed on a small ashtray. There,

we're wrapped around each other, heads tilted together. It looks easy and natural, as if we've been married for at least five years. We smoke cigarettes and laugh as we stub them out carelessly on different parts of our porcelain bodies. We are a boy and girl, walking together. We are a boy and girl, holding each other. Even partially ashed upon, there is something regrettably marital about the object, so much so that I almost believe it. We are a reasonable representation of "being in love." Typically, there is no suspicion in the reality of such a bond, so I don't suspect ours. It seemed real enough, I guess.

I'm at home, reading and eating a tin of sardines. I'm bored, so I post a photo to an Instagram group Eli runs called @sensualsardines. It's exactly what it sounds like. All of the sardines on this Instagram have been delicately and deliberately posed. Some of the pictures are inspired by Renaissance portraits, tiny tinned fish in profile, framed in gilt, sometimes juxtaposed with pale, luscious girl flesh. Realism is a funny style. It is the continuous resurrection of a blind and arrogant belief that humans are capable of constructing something so lifelike as to truly represent the world. It never dies. It's like the plague. Of course, realism is not always about how an artwork appears visually. Rather, as Victor Shklovsky writes, it is about art that can "impart the *sensation* of things as they are perceived and not as they are known."[32] It's arguable that many aesthetic movements have been, in their own way, a sort of realism, each positing a specific technique's superiority in depicting the world at any particular moment in history. And these techniques of realism do not exclude formal innovation. Even when it explicitly rejected realist ideology, modernism used fragmenting language and image to give a truer picture of postwar devastation. Similarly, nineteenth-century Romanticism was about creating affect at such an intense pitch that it emulated the actual sublime. Either way, when it comes down to it, I think realism's defining quality is just that it's faking.

It's Sunday. I manage to leave the house. I'm on the train, reading Wilhelm Stekel's *Sexual Aberrations*, deep in a case study about a girl, Gerda, who has a fetish for heels. Citing Ludwig Binswanger, who has

conducted this study, Stekel writes "Whenever Gerda hears the word 'heel' or so much as thinks the word herself, she imagines a half-torn heel hanging by a thread to the shoe and showing the nails or tacks; she is simultaneously provoked by the clean, light color of the inside leather thus disclosed . . . She may imagine to herself that a skate has been torn from her foot, leaving some part still attached . . . She produces the phantasy that some man grasps her foot between his legs, quickly puts a skate on her, and then turns the screw clamps. She feels anxious that he might turn the screw up too quickly and tightly. . . . She feels that such a situation in reality could end in nothing else but her fainting. . . . She says: The very worst is to feel the clamps slowly biting into the heel when a skate is put on. She feels as if she herself were being clamped." Stekel writes, "This displacement of feeling from the foot to the whole person is noteworthy,"[33] because fetish is always a metonym.

I'm at home, texting no one. I'm thinking about nothing. I'm playing the game where I delay by seeing how many double negatives I can't help but not put in my sentence, you know, the more I think about it, the more I believe the paragon of realist art is the 1993 Hollywood blockbuster *Jurassic Park.* Recounting a botched attempt to create a theme park of free-roaming dinosaurs cloned from prehistoric DNA, the movie boasts—even now, even after recent developments in CGI and animation—some of the most realistic dinosaur special effects I have ever seen. The reason for this is disarmingly simple. When you see a massive, life-sized *Tyrannosaurus rex* bounding toward the camera, i.e., toward you, it's terrifying. It's terrifying because a large portion of the *Jurassic Park* production budget went toward building a massive, life-sized animatronic dinosaur that could be filmed just like its reptilian counterpart. Sure, if you pricked it, it wouldn't have bled, and sure, it might not have been *sentient* per se, but there's no doubt that this dinosaur existed, materially. It was no CGI nightmare. You could touch it. It could chase you. In other words, it's no surprise that Jurassic Park looks realistic. Jurassic Park *is* realistic because they made *a real dinosaur.*

Like all objects made true to life, though, there are lots of things wrong with this dinosaur. *Jurassic Park* is a movie full of bad weather,

since the rain heightens the suspense of the dinosaur threat. During shooting, water keeps soaking into the "skin" of the robot *T. rex*. It slows the dinosaur down. It interferes with its movement. The directors stop filming every five to ten minutes. They have to. They dispatch large crews to dry off this gigantic fake dinosaur, each crew member armed with towels and a hair dryer. They start filming again. Rinse and repeat.

That's not the worst of it. The robot has one significant flaw. While drying, the robot has a tendency to malfunction: the life-sized dinosaur will, for no reason at all, randomly turn itself on and off. It simply starts moving. It seems to have developed free will, a mind of its own. Its jaws snap. Its head moves from side to side. It becomes common for cast and crew members to scream bloody murder while they're eating lunch or off camera. The dinosaur glitches while a crew member is doing repairs inside of it. He is almost sheared to death by pieces of grinding metal. He narrowly escapes when his colleagues pry the dinosaur's jaws open and pull him out of its open mouth.

I really like the dinosaur special effects in *Jurassic Park*. Part of my pleasure is in knowing the incredible, even life-threatening efforts that have gone into making it seem as though dinosaurs really exist. I really like how the giant machine can function as a real-life dinosaur without actually having to be one. I'm not sure what one is supposed to marvel at here—maybe the mastery of cinematic realism? At the depth of its artistic illusion, at its *craft*?

I don't remember the last time I saw the ashtray we made in Brighton Beach, but I think it was right before the breakup. Neither of us was crying, but the touches between us had become rote and glazed, we already knew. It was spring, and the exhaust fan blowing the cigarette ash out your living room window was half-broken; it spit back sooty chunks. I was sitting on your lap. Ash all over your pink shirt. The yellowing cigarette stub in my hand. It was all turning my stomach. But I looked down at us on the ashtray, smiling and plump, the plaid of your scarf in its bright primary colors, my hair in two sensible braids, and the way my heart sweetened seemed true.

Whatever, reality can never be objective. I'm not sure what *Jurassic Park* says about realism, apart from that it's a prime example of the

lengths to which humans will go to prove their authority over the world. I'm not sure what I know but that realism will almost always be betrayed by the skill in the making of it.

I'm on the train, reading my book. Joey texts me to ask if I've decided to assimilate myself into what he thinks is the predominant aesthetic of Bay Area poetry—what some might disparagingly call *socialist realism.* He's not joking. I snort softly through my nose. The schoolgirl beside me doesn't notice. She's playing Candy Crush on her phone. Her eyes are glazed over, a little too wide, their focus a little too vast. As though she could elide the predestined scripts of her life by the very act of looking. I roll my own.

In the book *Vision and Communism,* the art historian Robert Bird and his co-editors claim that for some artists, socialist realism was not a restriction but an opportunity to demonstrate how "freedom ha[d] become the liberation from having to measure the image against any notion of reality."[34] To Bird, socialist realists were not trying to depict the "communism" they saw directly in front of them. They knew the revolution they wanted to celebrate, no matter what the Soviet state claimed, was not yet within their reach, and therefore was still unrepresentable. That although they wanted to look toward these ideals, the reality in which they had achieved them was still so far in the future as to be impossible to imagine. In other words, these artists might have been charged with producing propaganda. But what they painted or sculpted or created were not idealized versions of their current reality; they were imperfect images that evoked the perfect unknown. A partial vision of the revolutionary future they believed was coming but could barely glimpse. It's about looking beyond. It's about—

—a *metonym.* It's a figure of speech in which an object or concept is referred to not by its own name, but by the name of something intimately associated with it. It substitutes what is small and material for what is grand and abstract. Say *tit* and you might mean *milk,* or even a whole woman. Say *ear,* and I might lend you one or bend it. Say *finger* and I could fuck you. Barbara Browning always talks

about how metonyms are just *meaty* like that. A metonym is an invocation. It's what happens when you take metaphor so far that it becomes performative—it does something in this world. Like when I say the word *shoe,* a shoe could form inside my mouth. And when I say *street,* the whole street could end up in my mouth, and it would be difficult for me to pronounce it. A metonym is partial. It means you never know what might follow. Realism can be beautiful, but metonym is what makes you view a dagger and a hairpin as equivalent and interchangeable. Both might be symbols, but their sharpness is real.

I've left the house. I'm on the train. I'm not sure how anyone is supposed to care about realism qua realism. As far as I can tell, it's the same old shitty world painted out in different ways. Someone once told me a good story about shit. Along with all the fiber and waste that your body needs to expel, shit also contains all the hormonal waste your body has metabolized. When you're constipated and your shit is stuck inside your large intestine, unmoving, your body reabsorbs the fluid from your shit, sucking the hormones it wants to excrete right back into your system, and preventing the body from producing useful "fresh" ones. This is why people who are constipated experience intense mood swings. I'm thinking about what Lisa Robertson said that one time. About how, you know, "utopia is so emotional."[35] I'm thinking about realism. There might be a whole set of visual codes and histories behind its aesthetic, but to me it's just the same old shit, an ideal we're continually reabsorbing into our aesthetic ecosystem, always tied to some universalizing perspective.

I'm on the train, reading *Sexual Aberrations,* and Stekel reports, "It is also interesting to learn that when she walks in the street, Gerda feels impelled to look at the heels of everyone who is walking ahead of her. But she feels quite embarrassed if anyone else looks at her feet."[36] More like sci-fi than any still-life painting, perhaps socialist realism can show us how "profoundly we are haunted by the ghosts of what has not yet happened."[37] The next stop, that is. How it can remain a tense and delaying metonym for what is yet to come. I don't know how to tell if I'm almost there.

I'm staring at a pizza, chewing apart my lip. I don't want to cry. The boy from Brighton Beach is trying to get me to eat more cloves of preserved garlic on my pizza. I don't want to. I don't like this artisanal pizza (which, frankly, has way too little cheese on it), but I feel unable to tell him. It's easy when cruelty is operatic because then you can name it as real. Events that purport to be real garner sympathy because they are authentic and therefore exceptional, but the truth is that what happened was banal. Sympathy is the cruelty of the weak. Easily inflicted, it costs the sympathizer nothing; in fact, it rewards him. She notices in every interaction with this boy that for him, sympathy plays an important role. She notices that when he is on top of her, heaving and thrusting, he experiences moral suffering that he will later lament. When he goes crazy, it is just another event in a progression of events.

The boy destroys all the electronics in the house. He leaves panicked voice mails about how I am collaborating with the FBI and his therapist to surveil him. This is neither authentic nor exceptional. He calls me repeatedly, threatening to kill himself if I don't answer this call, his text messages, he sends a hundred every day. My phone flashes and beeps convulsively next to me as I pant on a stationary bike to the sounds of Taylor Swift. I apologize to the spin-class instructor. I say it is an emergency. He asks me why I didn't pick up, but I say I don't know. The phone flashes and beeps as I walk to the store. My friends ask me about secrets I've never told them. The boy from Brighton Beach is sending them detailed emails about private conversations we had. I do my best to answer my friends' questions. They are sympathetic. They say this is just the way my life is now. I open my mailbox. He's sent me a sweatshirt with Pikachu ears on the hood. He begs for another chance if I will apologize for selling him out to the cops. He threatens to get me pregnant so we'll have to be together forever. He calls my office and won't stop. My boss tells me I have to handle the situation. I agree. I know it is my fault. I accept this. This is just the way my life is now. This is my reality. I get home. There are a dozen roses outside my door. I hate being alone. I spend a lot of time lying on my back, dart-straight in bed. I stop sleeping comfortably on my side. The phone flashes and beeps. It no longer tells me what time it is. I have to handle

the situation. I agree. This is my fault. My eyes are wide. I am trying to look beyond my own fear. I accept this. My life. This is just how it is now. Where I live, there's a house painted blue and red. Here, they knock the fish against a sharp edge so that their necks will be broken. I often watch them do it when I am at the beach. You see, I like the sea in winter.

Either way, when it comes to reality, I've found enough blind spots to know that the next stop's always coming, that it'll never be complete. I've read enough psychoanalysis to know that the ground is never really the ground. All we do is build pieces of our lives on earth that are really shifting in the same way the world is, precarious.

I'm alone at home, reading J. G. Ballard's *Crash,* which is about the erotic possibilities of car crashes, "a new sexuality born from a perverse technology."[38] The protagonists engineer a dangerous accident early in the book purely for their entertainment. On his way home, the narrator slams his car head-on into another vehicle, killing the driver and severely injuring his wife. She is escorted from her car by a policeman, urine dribbling down her leg. The narrator watches. In his pain-fueled haze, he notices tiny rainbows refracting themselves around her feet as the light hits her piss. Reading it, I imagine it makes the ground look like it's hovering somewhere above her ankles.

We might not always know what's real, but the truth is, if we didn't trust false ground, nothing would ever be built. We'd just be somewhere in the dust.

I'm in the car with Staiti because I don't know how to drive. I mostly think it's funny. I like being driven around. They let me put on the music. Even though I usually play what's annoying or aggravating to them, they always remain calm, always practice a tired acceptance. I love them for it. Today, I'm playing the terrible Mandopop songs of my childhood, but it's not having any effect whatsoever. I know if I switch over to Sinéad O'Connor's "Nothing Compares 2 U" or Tracy Chapman's "Fast Car" or Ice Cube's "It Was A Good Day," I'll get the reaction I'm

looking for, but those wins seem too easy. I try something new. I put on a song entitled "Home" by a Singaporean artist called Kit Chan. It's slow and saccharine, full of corny phrases about how we'll "build our dreams together" and how Singapore, my hometown, is a "place that will stay within me, wherever I may choose to go."

Staiti bursts out laughing. I tell them that this is basically propaganda, because it is. Recorded in 1998, it's the first of many yearly Singapore-themed pop songs specially commissioned by the government in celebration of the country's National Day. The song propelled Chan to fame, and twenty years later, "Home" remains one of Singapore's most beloved anthems. "Hey, don't laugh," I tell Staiti. "This song means a lot to me." Once, I performed a solo ballet routine choreographed to this song in front of my entire primary school. I sing along. The song hits its swelling refrain, waxing poetic about how home is a place where my dreams will always wait for me and I'll never be alone. I look over, and my American lover is tearing up. "What the fuck," they say. "I know," I say. I'm crying too. This is extremely embarrassing for both of us. Oh no. We both know it's coming. The dramatic key change. "There'll always be Singapore," the song mindlessly warbles. Nationalism. Its reach sneaks up on you. You can be vigilant, but your feelings betray you nonetheless.

I'm nine or ten. I live in Singapore, a place internationally recognized as the country where they managed to build utopia. I get on the bus to go to school. It comes on time every day. I have a government-issued NRIC (National Registration Identity Card) with my information on it, my name and fingerprints. To keep us in line at school, teachers threaten us with the all-too-believable myth that anyone in any minor governmental position can scan our NRIC and access our full history of school and behavioral records. Until now, my parents have driven me to school because they think it is safer. This is false. We live in Singapore. Everything is just as safe as everything else. My pass makes a beep as I tap it and get on the bus. It is air-conditioned. The roads are clean and paved and beautiful. The shrubbery is green and neat. Each curb is painted with black stripes so you can see it more clearly.

We chug along efficiently. I alight at the stop right by my school. I file in with the rest of the girls. We will attend class until one in the afternoon then separate for independently chosen extracurricular activities. I will participate in synchronized swimming. Each of us wears a clean white-and-navy uniform with a sailor collar, light and airy.

People often criticize the fact that Singapore's utopia is built upon a foundation of acute lawfulness.[39] It's illegal to chew gum. (All Americans know this. I don't know why, but they do.) The penalty for drug dealing, depending on quantity and substance, can be as severe as death by hanging, and if more than five people gather publicly for a particular purpose, for example, to oppose, campaign, or commemorate a group or event, you're required to apply for a police permit. In the nineties a young American man was sentenced by the Singaporean court to six strokes of the cane for several crimes, the most serious of which was vandalism.[40] The case reached international notoriety and punishment was ultimately reduced to four strokes after U.S. officials requested leniency. Caning is still a common punishment for a series of other offences, including sex crimes. Why? Because it works. Singapore is one of the most functional and politically and economically stable countries in the world, but I'm on the bus, on a regular day, going to school, and because I don't know anything different, it doesn't seem special. It just seems like regular life to me.

I went West. I'm in Oakland. I'm curious about the man who built Singapore's utopia because legends are often inflated and rarely true. I'm reading a compilation of interviews with Lee Kuan Yew, titled *Hard Truths to Keep Singapore Going. Hard Truths* documents a rare, no-holds-barred opportunity for journalists to ask the man known as the Father of Singapore tough questions on a range of topics relevant to Singaporeans, particularly younger citizens, in our contemporary moment. Lee tells the journalists he realized early on that he had to be painfully realistic in his governance of Singapore, that he had to face the hard truths. People "assume Singapore is a normal country," he explains, when in fact it exists "in an extremely turbulent region."[41] The story he tells about the country's development is similar to the one I learned in school. In the sixties, faced with sudden independence, few resources, and fewer

allies, Lee saw that political stability and domestic infrastructure for his country would only come with rapid economic development. And this economic development could not come from within the country itself. Singapore was simply too small, too weak. It had to depend on the outside world. It had to rely on a culture of free markets and hypercapitalism to generate investment and demand for its goods and services. It had to depend on foreign investment from multinational corporations to create jobs for its people. As a port, it had to play to its geographic strengths and facilitate international trade. And as the economy matured, it eventually moved away from labor-intensive industries, instead designing incentives to attract high-tech industrial capital. Like Confucius taught us, Singapore had to sacrifice for the greater good. Only then could it improve standards of living and generate jobs and income. Only then could it make a better life for us all. This is what I remember. That is what I was taught.

I try not to ask about my father's political leanings. I know he was more radical in his youth, an economist and professor. I know he's now more fiscally conservative. I think you could call him a libertarian. When he calls me his "idealistic, bleeding-heart daughter," I mostly ignore him, but I have enough leftist friends who worry about what they call "rightward drift" now that they have kids to know that this concern is real. What I never really understood was how my dad went from having these liberal tendencies to becoming a firm believer in the power of capitalism. We don't talk about it because I tell myself he doesn't like to, but the truth is, I'm afraid to know.

There's this artist, Viktor Koretsky. A socialist realist I admire. Even though what remains of his work is mostly propaganda—posters, murals, flyers—it always seems to refuse didacticism. In particular, it refuses representations of an idyllic post-communist world. Gone are the images of endless grain, fat and cherubic children. Koretsky's work is more like an abstract visual yearning for shared intimacy. He's fond of imagery that could provoke viewers to, as Robert Bird and his co-editors write, "join a diverse unseen humanity in its struggles to overcome its own

dehumanization."[42] In other words, he's interested in simple and striking images of struggle. A black person breaking his chains. A man wrestling a snake, his forearms glistening. A woman in a headscarf clenching her fist.

The faces of Koretsky's subjects are uncannily similar. They all look related to each other, like members of the same family. Each person's brow is furrowed; there is not a trace of fear. In his famous portrait of a Soviet Madonna and child, titled *Red Army Soldier, Save Us!*, neither woman nor baby is tearful or afraid. Neither seems to be seeking rescue or refuge. In fact, what's poignant about this portrait is its characters' embedded sense of belief and trust. Both of them gaze forward, clear-eyed and open. As though they fully believe in the material reality of a future yet to come. As though they can already see and touch it. As though they so deeply know that they are on the brink of this beautiful illusion that they would leap into it without even looking. Koretsky's work has been described as metonymic, "a kind of Communist advertising for a future that never quite arrived."[43] It's apt.

I manage to leave the house. I'm on the train, going somewhere. I'm reading *Sexual Aberrations,* this time a case study about a man named Alfred G. He's a thirty-year-old clerk who has a bad case of apron fetishism. He is "so shy and reticent and full of guilt feelings."[44] He was able to accomplish intercourse with his wife only when she would put on a damp and preferably dirty apron. "His mother has often said to him: 'You're a light-headed kid. You ought to be hanged.' Because of this, the idea of becoming an executioner himself had always provoked his fancy."[45] It becomes clear to Stekel that Alfred wishes to be liberated from both his mother and his overbearing wife. He wishes to be released from their "apron strings," which he resents. "He has begun indulging in criminal fantasies to such an extent that he has begun to see them in reality. One of his dreams makes it more or less plain that he is hounded by the impulse to attack a salesgirl in a store, choke her, and then gag her with an apron. He struggles manfully against the impulse, but he is compelled to attempt to play at least the first part of the phantasy."[46] To find a shopgirl in a store, alone, and enter it. To speak to her, even if he can't carry out the autoerotic murder. But without the

murder, the fantasy will always remain incomplete. It has to, because fetish is a metonym, and a metonym is always partial. It will never be entirely real, even if it's connected to a material object, even if the fantasy is rooted within reality. A fetish needs at least one shred of materiality to lurch itself into its imaginary heaven. Somewhere, Gerda runs her hand slowly along the silky leather of a shoe.

I can't imagine that Lee Kuan Yew would have had any patience for metonymy, so partial and illusory. For him, pragmatism seems to have always been the end game. In other words, the Hard Truth. You have to accept whatever you've been given. You have to focus on what is immediately broken rather than give in to some impossible fantasy of the future. You have to do what's necessary, not what you desire. True vision, not ideological fancy.

From what I can see, for Lee Kuan Yew, the situation in front of you might be harsh and disappointing, but swallowing it, clear-eyed and whole, is the only path to an actual cure. No idealism. No illusion. That's the real dream.

It's no surprise that Lee Kuan Yew's dream became reality. He didn't just invoke it, he built it. Utopia. Painstakingly, step by step. In less than fifty years, Singapore has become a capitalist success story. It has forged alliances with both Asian and Western super-powers, forming one of the most developed free-market economies in the world. It's grown from third-world port to cutting-edge manu-facturing hub, international business and financial center. This has sig-nificantly increased the standard of living, GDP, and domestic wealth of the country. Even if there is a large income disparity between the richest and the poorest, taxes mean that Singapore's free-market wealth is ostensibly reinvested in its citizens—housing and health care are effectively socialized. Here's how it works: If I lived in Singapore now, I could apply for public housing. This program makes me eligible for a government-built Housing and Development Board (HDB) flat. The Central Provident Fund (CPF) is a mandatory national savings plan, into which any working citizen under fifty-five has to contribute 20 percent of their monthly salary as "savings," an amount that is then matched by

their employers at a rate as high as 17 percent for citizens under the age of fifty-five. These CPF contributions and matching amounts decrease as you age, providing protections for the financial welfare of the elderly.[47] I can use the funds that I've contributed to the CPF over the years to pay the deposit, or even, if I'm eligible, the mortgages, for my HDB flat, after which I can live in it or sell it down the road for cash instead. Basically, I can use my CPF contribution to buy my apartment. For anyone who cares about material equality, it's amazing to think about. In Singapore, everybody can more or less own their own home without affecting even a cent of their disposable income.

I never understood how my father went from having liberal tendencies to becoming a believer in the power of capitalism. I hate to admit it, but reading *Hard Truths,* this "how" is slowly becoming clear to me.

I'm gazing at my favorite Viktor Koretsky painting, waiting. It's about an hour from when I will leave the house but a half hour from when I should. That awkward almost-space. This image, unlike the captioned, bold posters considered Koretsky's best works, is untitled. Its intent seems somewhat murky: It's a black-and-white close-up of a face, its two eyes staring directly ahead. The pupils feel vacuous. Tears leak from each corner in glistening streams. The entire painting feels flat, even if its style is realistic. There is a single detail that brings the picture dimensionality: a glimmer in each pupil, two small white triangles that animate the stare. The haunting glow of the eyeballs takes up the majority of the frame. But unlike Koretsky's other paintings, there's none of his signature vastness, no open trust in the gaze. Look closer and you'll discover that these animating triangles each contain within themselves two pairs of slanting, demonic eyes. What these giant pupils appear to be reflecting are two tiny Ku Klux Klan members, in the long perspective of their vision.

I'm amazed at *Hard Truths to Keep Singapore Going.* As many foreign critics have done in the past, I'm tempted to criticize Lee's position as authoritarian. There can only be limited political autonomy in a dominant-party

system with fairly stringent free-speech laws. But surprisingly often, I find it difficult to disagree with him. When he's asked why Singapore doesn't adopt a system of Western liberal democracy, he scoffs and asks why he should accept some one-size-fits-all Western system of government. Citing Samuel Huntington, he reminds the interviewer that multiculturalism may destroy the American nation because its liberal democracy was built solely upon a foundation of white "European Christian Protestant English culture"—when in reality, the nation was and is composed of a diverse range races and ethnicities. He cites the historic and continuing inequality of Latinos and African Americans in the U.S. as evidence that liberal democracy is already ill fitting for the very country it was supposedly tailored to. Far from a solution, it is the source of continuing internal conflict.[48]

James Baldwin writes, "The story of the Negro in America / is the story of America. / It is not a pretty story."[49]

What has liberal democracy even done for Americans? Lee Kuan Yew suggests. What could it do for us? Nothing, he says. We Singaporean people are far from American. We have different values. Why would an American system, one that has already been proven to divide its country, work for us, a country of many races? When questioned about the ethics of his People's Action Party (PAP) being the majority political party in most elections past, with little viable opposition, he doesn't balk. He describes how when he was first elected, he promised the people of Singapore every chance at a good life. A good education, better living conditions, more jobs, low-cost housing, clean streets, and health care. "We delivered,"[50] he says simply. Why would the people of Singapore want to vote for anybody else?

In another section of *Hard Truths,* Lee Kuan Yew professes an interest in genetics. Singapore is purportedly a meritocracy and prides itself on giving every one of its citizens the best opportunities. But over the years, he's noticed, despite providing these opportunities for all, performance has varied substantially between different races, as well as within different categories of the same race. Having tried, but failed, to reduce these inequalities through policy, Lee comes to the difficult

conclusion that some people will naturally make more out of what they are given than others—because of the genetic heritage of their social group or socioeconomic class.

For example, he explains, in historical Chinese tradition, the emperor would conduct an exam to determine the brightest and best men in the country. Those who did well on the exam would not only fill high-ranking government posts but would also marry the emperor's daughters, thus filling the royal bloodline with superior genes. According to Lee, this means that the Chinese have a genetic makeup crafted from an ideal set of persons, diverse and strong. Contrary to this, the ancient Indian caste system has isolated certain sets of genes by class. Some lower-caste Indians have genetics that have not been diversified with "good genes" and therefore may be at less of an advantage to excel.[51]

Reading this makes me uncomfortable. I shift in my seat. Despite Singapore's public holidays that are celebrated in the name of racial harmony, despite society's respectful symmetry, I still occasionally perceive prejudice[52] in the way mothers clasp their children closer when walking past darker-skinned construction workers, in the way young students tease their Malay classmates for being "lazy."

In a 1965 interview with Allan Ashbolt, Lee describes the Malay people indigenous to Singapore as "more fortunately endowed by nature, with warm sunshine and bananas and coconuts, and therefore not with a same need to strive so hard,"[53] then confidently asserts that he doesn't consider one race to be better than another. Rather, he seems to point this out in demonstration of his belief that a clear acknowledgment of the differences between cultures—their development, histories, even their original climates—is an important part of establishing mutual learning and respect among the people of Singapore. Only with this understanding, he suggests, can we build an equitable country, unified against those looking to exploit its racial differences.

Lee tells the interviewer in *Hard Truths,* "the problem for the government is: How do you keep a society united when the lower layer can never catch up?" He speaks about a failed government initiative to

offer lower-class women a free flat if they volunteer to be sterilized after the birth of their first two children.[54]

I put the book down. The truth. It's hard to know.

When asked how he would like history to judge him, Lee, ever the pragmatist, responds: "I'm dead by then. There'll be different voices, different standpoints, but I stand by my record. I did some sharp and hard things to get things right. Maybe some people disapproved of it. Too harsh, but a lot was at stake and I wanted the place to succeed, that's all. At the end of the day, what have I got? A successful Singapore. What have I given up? My life."[55]

America's tumultuous and crumbling democracy with its imagined civil liberty and the ever-present possibility of civil war, or Singapore and its stringent, but functional, control—its clinical air, its clipped neutrality? What would I prefer?

It's 2017 and Donald Trump has become the president of the United States of America. When I talk to my dad about it, he only sounds slightly gleeful. He says, "Tell me about your civil liberties now." He says, "Americans are so bloody stupid." Good and affordable education, health care, better jobs—I can't remember an American politician who made good on his promises the way Lee did.

When I tell Chris, one of my leftist friends, that Singapore's benevolent state regulation is starting to look good to me, he tells me sternly not to be seduced by this rhetoric! He tells me I must believe something different could exist in this world. Something separate from the Band-Aid equilibrium found in Singapore's economy, one so deeply mired and complicit in global capitalism. He tells me the kinds of advancements the country made have improved its citizens' quality of life, sure. But like in any other capitalist nation, Singapore's market economy, if unrestrained, could increase the cost of living and solidify economic disparity and inequality for its people long-term.

Perhaps symptoms of this are already starting to appear. In her book *This Is What Inequality Looks Like,* sociologist Teo You Yenn investigates

the structural conditions that lead to inequality in Singapore as a means to better shape solutions for the future. Of the emerging problem, she writes that due to the absence of an official poverty line, it is difficult to determine how much of Singapore's population could be considered poor. "However, if it is defined . . . as encompassing households whose incomes are less than half of the median household income of the population, then roughly a fifth of the resident population could be defined as poor." Not to mention, as she points out, that these statistics do not account for the migrant workers who have come from countries like India and the Philippines to help build Singapore's towering skyscrapers and glittering luxury malls, to take care of the children of the wealthy. These workers numbered almost 1.7 percent in 2016 and their low wages, if accounted for, would likely make income inequality and poverty rates even higher.[56]

Back in Oakland, I groan. Chris laughs. He says, even pragmatism has its limits. What I must find within myself is the belief that we could make something else, something not built from within the ruins of a flawed system and its structural ills. What I must find is the belief that we could break it apart for a different world altogether. I nod and smile. But it's hard to reconcile this notion with reality. It's hard to believe it could someday exist.

Who's idealistic now, Dad?

I'm looking at this Viktor Koretsky image again. I can't stop. It's clear that these twin eyeballs are encountering a true fear—twin Ku Klux Klan members in the distance. But without any context, it's impossible to know if the authoritarian terror in this painted encounter is a vision of the impending future, or a haunting from a banished past. I don't think it matters. In most of his paintings, Koretsky's subjects' lines of sight are so stretched and out of focus that all we can experience is their partial vision—one that could contain any possibility.

But this painting is different. Close up, there is no traditional subject, only a direct gaze. This gaze has an object, and the object is fearful—racist and threatening. Jacques Derrida seems to think that metonyms, because they're partial, are always mourning their lack, always mourning

the wholeness of true name.[57] But this image of Koretsky's is sharp and whole. We're forced into a realm of austere representation. We're fixed in authoritarianism. Koretsky's piece seems to be a warning against political determinism. With the Klan members in sharp focus, with what's in front of us so real, we can't help but mourn the loss of the future we once imagined.

In the warning gaze of the painting, we learn how our political aspirations—once whole, no longer partial—become immutable, no matter how widely we open our eyes or how awake we dream.

The determined realism like Lee Kuan Yew's *Hard Truths* can accomplish a lot.

But why not fetishize an uncompromising fantasy? Why not work for an imaginary universe worth believing in? My beautiful metonym.

A dream. There's a dream of a house, like there always is. This time I'm building it. There's one thing I like most about this house, with its blue walls and red door: a large bell in the middle of the door frame. A doorbell. My father and I, building together on the front porch. I like it, I say. But the bell won't ring. It keeps bumping into the frame. I feel hesitant. I want to figure out what's wrong with the bell before I choose to live here. My father takes a hammer and chisel and goes after the pretty bell until it's all bent and twisted. "You're breaking everything to pieces!" I cry. He becomes angry. He doesn't like that I'm butting in. Finally, the bell is dented and ruined, but it works. It can ring again. When once it was also a charming ornament, the bell now only rings for the house, no more, no less. Ugly and dull, it serves no other purpose.

I'm lying limply on the couch in my childhood home. I'm drinking broth my mother prepared from the shells of hand-peeled shrimp. My mother may believe in sacrifice, but to her, sacrifice is nothing without absolute loyalty. "It doesn't matter what anyone says about how much they love you," she tells me. "It's what they do in the end that matters." You can say pretty words to someone all day long, but whether you can back them up is the real test. Will you sacrifice your own desires

for the good of your beloved? For the good of the group? That's what makes a family.

Sometimes I balk at this, my foreign individualism rearing its head. But in the back of my mind, I remember that, metonymic fantasy or not, this kind of sacrifice is more or less what it'll take to ever manage any sort of utopia, so.

I'm on my way back West after a week home. My mother sends me off at the airport. I'll miss her. I feel guilty leaving. I know it'll be months before I see her again. She tells me she loves me. She tells me she believes in me, in whomever I might want to become, or whatever it is I seek. In my own "better future," even if she can't envision it, even if it hurts her. I believe it. It means the world to the both of us that I do. There's a song by a Singaporean songwriter named Corrinne May called "Fly Away." We listen to it together so we don't have to talk about what the song is saying. Under these circumstances, it makes me weak. I'm listening to it with my headphones as I walk through Immigration. I'm tense from holding back tears. Corrinne May sings the chorus, a paraphrase of her own mother's blessing: "I love you too much to make you stay. Baby, fly away." In this moment, my heart is so soft for my mother. She loves me unconditionally. Because she does, she is the toughest person I know.

It's New Year's Eve and I'm at the kids' table, where we talk about how, for all their criticisms of us, our parents and relatives never seem to mention that they went West too. To boarding school. To college. They got good jobs. They bettered their class status. And then they came back. We stayed. Unlike us, they all actively resisted the kinds of assimilation we fell into. They didn't become "Westernized"—a term they use accusingly, shaking their heads with disdain. To them, it appears we have forgotten our heritage. To us, they seem closed-minded and stubborn, unwilling to see the merits of the other cultures they encounter, unwilling to build them into their world. I tell the table that I think the Confucianism that Asian families so staunchly adhere to is to blame. How its reified values—of sacrifice for the good of the group, of everyone

staying in place—are directly opposed to the Western individualism we were all seduced by. In fact, each directly threatens the other.

According to Confucianism, everyone has an unchangeable destiny. In order to create a harmonious society, everyone should know their place, fill their assigned role. As a child, you have a moral responsibility to your parents, and if you put your own ambitions above returning home to better your family's quality of life, above repaying your debt to your parents, then you are failing to fulfill that responsibility. It's shameful. Everyone else at the table is doubtful—isn't Confucianism just an arbitrary name for the ethical response? To repay in kind what someone else has done for you? I shrug. It's always been more than that to me. Even when it's bitter, I feel the instinctive pull to my family so viscerally it's almost unbearable, whereas most of my American friends barely call their parents, let alone share their lives with them. He said, she said, etc. There's not the same insoluble bond as there is with us.

But maybe everyone else is right. Maybe it's just about class. Our parents grew up poor. We grew up rich. They returned to feed and support the rest of their family. We never had to, so we didn't. How can you blame them for wanting us to do the same? Some days, I wonder if my parents would have preferred to stay West when they were younger, if they simply felt as though they couldn't. But obligation can make it impossible to know if your will is true. That's the difficulty of Confucianism—its imperative is a kind of gaslighting that never ends.

It's New Year's Eve, but our conversation's made us somber. Justin tries to lighten the mood. "I bet your parents have feelings about the way you're raising your son with these soft white values instead of the traditional Asian spankings," he says to Kat, teasingly. "My mom had a bunch of plastic-handled bamboo canes," I say. "But she hit the furniture around us to threaten us; she didn't actually hit us." My sister interrupts. "Mom bought canes in bulk," she says. "But Mom didn't keep a matching cane in every room because she wanted to hit us. She did it because she has a shopping problem." I clutch her arm. We shriek hysterically with laughter.

OK, so maybe my mother doesn't have a *problem,* per se, but she does col-
lect expensive handbags. This is surprising to no one, since for a woman
of her wealth and status, it's a common hobby. Many of her bags are
beautiful, made from rare leathers sourced from around the world, shorn
off the bodies of exotic creatures. Ostrich, crocodile, sheep, baby calf.
Most of them cost more than what I make in a year.

I'm at home. My mother calls me up one day. "I need you to do
me a favor," she says. I can hear the beginnings of a guilt trip in her
faux-patient, coaxing tone. "I need you to go to a store in San Francisco
to pick up a very rare bag for me." My heart sinks overdramatically. I
bite my lip with dread. "I don't have that much money," I say tightly.
"That's OK, we'll take care of it. Charge it to your credit card," she says,
but I remain stubbornly silent.

"I really want this bag," she repeats, to no one in particular. "I really
want it."

"But I'm busy," I whine. "It's so much money. I mean, you have so
many bags, do you really need it?" Now I'm the one who sounds plain-
tive. I'm the one arguing with exactly no one. "It would make me so
happy," she says pointedly. "Think about it as a birthday present for me.
I've done so many things in my life for you, why can't you just do this
one simple favor for me? Don't I deserve it?" I groan and hang up the
phone. Against my best efforts, I cry about this short interaction for
half an hour. We both know that this has been a ridiculous production.
After all, it's not about the fucking handbag, and at the end of the day,
it's not my fucking money either.

When Staiti comes over later in the evening, I'm stressed out.
I'm pacing and yelling. I'm twelve years old; I've regressed. I resent
my parents childishly for their wealth. I resent the filial piety that
compels me to do whatever they ask. I resent that no matter how
much I've read, learned, been to therapy, and emotionally processed,
this Confucian impulse will never disappear. I will remain forever in
its guilty grasp. I sulk. It's unattractive, but Staiti holds me anyway.
Amazingly, they find the whole situation amusing. "I can't just spend
twenty-five thousand dollars on a handbag," I scream at them. "It's
not you. It's your mom who's spending twenty-five thousand dollars.

She worked hard for it. It's not like she doesn't have the money," they remind me, sensibly, patiently. Staiti did not grow up rich like I did, and in this moment, I am becoming rapidly aware that my feelings about my family's wealth are an embarrassing indulgence. I'm being pigheaded and sheltered. They can't stop laughing at my foolishness. They soothe me anyway.

I don't know how to drive. Because of this, Staiti is always having to drive me somewhere. And when they drive me out to San Francisco to pick up this handbag, they make sure we get a good day out of it. We go to the Sutro Baths to touch the sea and to my favorite Singaporean restaurant out on Clement Street. We pick up the fucking handbag. I charge more money to a credit card than I probably ever will again. Later, I take the lid off the orange box and peek at it. The handbag is the size of a shoe box. It is polished and perfect, a beautiful chocolate brown with an elegant gold buckle. My mother is so happy. Against all logic, my heart soars. I tell her it only happened because Staiti convinced me it wasn't a big deal. It only happened because they talked me into it and then got into the car and drove me all the way there. I can hear my mother's approval blaring through the phone. "You know, it's good that you're with someone who's willing to help out with the family, you know, to help us when we need things. That makes me happy . . . ," she trails off. "Even though they're not a man" is what we both know she's left unsaid.

Overhearing me on the phone with my parents, Staiti once told me they really thought I should set better boundaries. I remember peering at them, confused. "This is me having *great* boundaries," I said dully. Back then, they were aghast, but three years later, my mother has their personal cell phone number saved on speed dial.

With this minor sacrifice, Staiti passes my mother's test. From this point on, they are no longer a stranger. They are an ally, someone my mother believes will go to bat for her. One of her own. I can't help but laugh at the irony of it. All of my mother's hurtful, taciturn disapproval at my "inappropriate" relationship that's "not in God's plan for me," now disappeared. All because of one expensive handbag. How stupid and great is that.

It's 2018, and I watch Chloe Kim, a seventeen-year-old Korean American girl, win the Olympic gold medal in half-pipe snowboarding. Her father immigrated to America when he was twenty-six, with nothing but eight hundred dollars and a Korean-English dictionary in his pocket. He taught himself everything about the sport in order to support his daughter. He made mistakes. He fell off the chairlift while little Chloe cruised past him on her snowboard. He tried to wax her snowboard with melted candle wax instead of glide wax. He quit his career in engineering to drive her from competition to competition, training ground to training ground. On the day of the Olympics, he texted her, "Today is the day imugi turns to dragon." I watch Kim land back-to-back 1080s on her final run, spinning lazily through the air with an innate confidence I cannot understand. The first thing she does after she scores a near-perfect 98.25 and wins the gold is to acknowledge the sacrifices her father has made to let her dream come true. Her father tells journalists that these sacrifices are "normal for all parents." He tells them that his daughter, Chloe Kim, is his American dream. Bawling, I text my dad about how awesome she is, how cute they are together. He agrees.

Like Kim's father, my dad has sacrificed so much for me. I text him, "I feel sad that I didn't become an Olympic snowboarder to make u proud."

I mean it.

I might not want a home. I'm not looking for a form.

But I live in America now, the alleged land of individualism and of limitless dreams, and even I know my autonomy is a fantasy nonetheless.

Living in America will not rid me of family, tradition, or loyalty. It doesn't make me free.

Yeah, I got the memo. Unfortunately for me, I don't feel at home unless I'm buttressed to another. I'm addicted to connection. Staiti is away. I panic. I'm scrolling through Tumblr in a bid to find an anchor. I'm lashing myself to a network of varying avatars. I am frantic, thin, and immaterial. It is questionable whether I will ever have a definitive impression

of the shape of my life. It is questionable whether I will ever know what category to fit myself into. I track my fingertips on the keypad as if stroking my clit, with desperation. Jeanne has posted a quote from Rob Brezsny's horoscope for Cancer: "Didn't you perversely nurture the ache that arose from your sense of not feeling at home in the world?"[58] I'm not a Cancer but it's true, I did. I built a house from my lack of belonging. I stayed there. What is a home if not a void, at the end of the day. An ache.

I'm with a friend at a café, getting updates on her life with a side of coffee and a croissant. She's recently become unmoored. She and her partner have broken up because he "doesn't really do intimacy." "That doesn't mean much," I say. She doesn't say it, but as she talks around it, I fill in the blanks. Her partner has broken up with her because he doesn't think intimacy is politically viable—because communism! Because he "doesn't want to take advantage of her unpaid emotional labor." Because no ownership, no property. Because fuck the couple form. Because no lovers before the revolution. I get it. Intimacy really can fuck with any person's ability to visualize a nonnegotiable liberty or politics. Caring for another person more than yourself—that nagging impulse to put them first, above any loyalty to principle—can really mess up your ideological blueprint, the stakes you've decided upon for how you want to live. It's a dilemma.

I keep trying to figure it out anyway. The possibilities, that is. It's a year ago. It's now. It's five years later, I mean three. I'm in Oakland. I'm in New York City. I'm alone. I'm with Staiti, touching their skin as though it's gauzy, like a dream. I'm at a bar, everybody is. We're yelling about art, no, politics. It doesn't matter because we're really yelling about *The Wire*. What is the origin of the phrase *where is home*? But more important, what is its sharper, truer meaning? Something simpler, like *what do you want*? If there's any answer apart from "Something better than this." Dress it up however you like. Sorry, what I meant to say was, "Hey, how'd she get a literary agent?" No, "When the revolution _____." Whatever. We end up making out anyway, everyone pressed against the wall with the wrong person and their shattered ideology. Every

reiterative question a performative facade against the breakdown of a pose. I'm a comrade who strongly believes in the power of communism. I've been easily seduced by fashion and decadence. I'm lost. I'm over there, in the next moment, thirsting after capitalist dick, hell, every time I move my body through different registers, places, times, I go to a different reception hall. I give them my coat. They give me a name tag. I don't try to read it because I don't want to know, which script. I figure it out anyway. I look at the people around me. They all look the same. We speak in the same tone. We all talk small. He said, she said, etc.

The story is simple enough. We are in end-times and it is stupid to even think about the future. But Robert Glück writes, "The idea that a future exists startles me and reorients me to the present. The recognition of a future is the beginning of a kind of sanity."[59] The truth is, I can't help but think about the future in order to remain here with you. I can't help imagining beyond our not-yet apocalypse. It's decadent not to resist it. It seems depraved to fall into it. But I let myself; I do. After all, if there's no future, why live for dogma. If we only have fifty years to live, I'm not sure I want to live with principle. I'd rather steep myself in the luxury of hope.

Most people take that as a cue for an argument.

I don't like to argue.

Sometimes, it feels like all the books I want to make are about love. Is that an argument? Can that be an ideology? I know it's adolescent, but I am young. And when you're young enough to know nothing, everything becomes an ideal. You commit to ideals because it's how you find your shape. You think your resolve gives you power. You begin to believe that power is equivalent to sacrifice. Sacrifice is a way you can prove anything, especially commitment or devotion, both of which are difficult to prove. Other people are often the easiest sacrifice. But when sacrifice is involved, what you're practicing is belief. Belief can be akin to religion. And religion often breaks more hearts than one. It's funny how ideology becomes both more and less flexible when you start to really care.

I'm at brunch with someone who knows me well even if we haven't seen each other in a long time. I catch him up; I tell him about all the friendships I have broken during the five years in which we have not seen each other. He laughs. He tells me that when he thinks about me, he has this image of me walking toward him. I'm crying, but my face is stoic. Behind me, in the background, are a hundred bridges—burning.

I laugh, but I retch inside just a little. It's hard to let someone go. I have never ended an intimacy purely because of ideology, even if that's the excuse I might have used. As much as I hate to admit it, I've mostly done so out of convenience. This makes me feel as if I am a hypocrite. I am guilty and immoral.

But, as another friend reminds me, sometimes, the most loving thing two friends can do is let each other walk away.

My ex-boyfriend Thomson is one of the most intensely moral humans I know. I believe this because he is able to see starkness in the world and act on it with a confidence I do not possess. I am jealous of that ability. There's a story he once told me that I like. I like telling it to people because it makes me feel as though I could share his same ability even when I do not. Unlike him, I am not ever able to believe I am making the correct decision. Thomson is at a frat party. He's skinny and wears tight pants and a plaid shirt. Another boy is aggressive toward him. Thomson is polite. He remains calm. He backs away. He knows the other boy is wrong. He goes into the kitchen. He gets a bottle of bleach out from under the sink. He fills a red Solo cup with a quarter cup of bleach and tops it off with beer. He tastes it gingerly. He doesn't want to hurt himself, but he needs to make sure the taste of bleach is not quite detectable. He knows that if someone takes more than a sip, it is more than likely to kill them. He knows he will give the other boy this poisoned drink because he believes he is wrong. Thomson is with a girl he loves. Before he can do anything, the girl takes the cup out of his hand. He doesn't blink an eye. He acquiesces because he loves her. I believe he is intensely moral without being naïve or uncomplicated, which is a difficult thing to be.

I'm at the café again, this time alone. I'm reading chapter six of Shulamith Firestone's *The Dialectic of Sex* because it is the bible and will change your life. She lays it out plainly: "A book on radical feminism that did not deal with love would be a political failure. For love, perhaps even more than child-bearing, is the pivot of women's oppression today. I realize this has frightening implications: do we want to get rid of love?"[60] But maybe that's always been the question: How can we position ourselves in relation to desire, or care, or loyalty, or aesthetics, or love? And what do these concepts have to bear on moral imperative, or the task of capital-L Liberation?

We live out our lives in a series of endless rooms. Each room represents a set of feelings, thoughts, beliefs. Even then, every room feels the same. It's hard to tell which or whose room you're in. It doesn't matter which or whose house you've witlessly wandered into either. You can move from one room to the next, but you are not allowed to leave entirely, not ever. Sometimes, there are crowds in each one, jostling, but sometimes the room is empty, and you're the only one waiting. You encounter other people in these rooms. You spend a lot of time staring at them. You spend a lot of time staring at the walls. In these rooms, like the audience in Mike Kelley's account of the strip house, "each person's behavior reveals a strange double bind at the interface of intense fantasy and overt restriction."[61] Even without the trappings— the leather cuffs, the St. Andrew's cross—there's a whiff of s-m in how these other people interact with you, and one another. A deliberate slowness unique to staged power dynamics, each person's scripted position made too firm from the outset. The garish clarity that only one can come out on top.

But the rooms we are sitting in are never simply rooms, because a decision has been made. We have *chosen* to sit in these rooms, and choice, whenever it occurs, makes whatever happens afterward seem important. There is little emotion or interaction between the people in these rooms. In small, private moments you might see a few pats on the back, or hugs, but these gestures are restrained and secretive. Kelley writes, "as if drugged

in a dentist's chair, [each individual] sits frozen and immobile. . . . Their stiffness of demeanor reveals the intense concentration, the incredible will to block out all that is going on around them, all that is trying to impose on and destroy their fantasies,"[62] all which might destroy the illusion they want to sustain. Like sex, the work of imagining utopia in each of these rooms is lonely and recursive. It does not allow for the intrusion of worldly problems. "The seats on either side of [each person] are empty."[63]

It's years ago, in 2011. I'm still a smoker, often sick, so I'm lying in bed trying to determine if I've cracked a rib from my persevering cough. Someone I've now burnt bridges with calls me, but she keeps talking like she doesn't care what I'm actually doing. "Hey," she says, "Sophie Calle's doing this performance uptown, at the Lowell Hotel?" "Yeah, I love her," I respond, sitting up immediately. "Yeah, it's called *Room,* but it ends tonight, at midnight." "It's just a hotel room?" I ask. My fingers are hopeful; they think my body might provide some scaffolding for my impeding frailty, but no dice. The space between my ribs is troublingly gelatinous. "Yeah." I sit up gingerly. I say, "meet you there in forty-five if the 6 train's being kind."

Sophie Calle's installation *Room* is located in a tiny hotel room at the Lowell Hotel on the Upper East Side. At the front desk, you ask for her name and room number, as though she's a friend or a lover. You are then let inside. The room is a display of ephemera. It's lived in, rumpled and careless. Each item is labeled with a number and a short blurb. It's a crime scene to be deciphered; it's touched and handled as much as pristinely embalmed.

Sophie's world contains:

A typewriter, a taxidermied cat, photographs, sheets that have been slept in, beautiful dresses, a banana.

Letters to and from Sophie. Notes from her ex-husband to his lover. Black crosses scrawling out another woman's name. *S*'s left behind after its violent elimination.

A bed that has been set on fire. Blackened edges and cobwebbed holes in the quilted mattress. No reference as to who caused the disaster.

Hotels are usually transient, characterless, soaked medicinally in their own neutrality, but Calle finds in the blank canvas of the hotel room a place to build an intimate dream state. At the threshold, she hesitates, then invites you in.

Kathleen Hanna sometimes talks about the first Julie Ruin album as something produced out of what she calls "bedroom culture": just a girl, in her room, with a tape recorder. The ability to shut yourself in and create a world where you're safe in your aloneness. Where you have control of every shape, every curve. I love the record. Its tape loops are stitched carefully over drum-machine beats, a dreamy self-containment in its melodic repetition. A lot's been made from the material of confined womanhood, from its potential or its idiosyncrasy.

Give a girl a room of her own and she can produce a whole world, we've been told by many. She can write her own zine, find her own band, create her own blog, all that bullshit. But sometimes a room isn't safe at all. Sometimes imagination can be its own prison. Sometimes, trapped in my room, watching my feet float against the wall by my bed, the only worlds I can imagine building are the bleak, solipsistic ones. Worlds where insecurity emerges to tear me to shreds, one delicate peel of skin at a time. I finger the edge of Sophie Calle's angry scrawl, the smell of burnt sheets in my nostrils. Rooms have a way of betraying you, especially when what you've built in them is so entirely yours. Your solitude can consume you, a bed that sets itself on fire over and over again.

In *The Poetics of Space,* Gaston Bachelard sees that houses are not simply houses. He writes, "Sometimes the house grows and spreads so that, in order to live in it, greater elasticity of daydreaming, a daydream that is less clearly outlined, are needed."[64]

Sophie's room, it wasn't just hers. It wasn't alone. When I stepped into it, it stretched and heaved. I was delirious. I was drunk from illness, and

I sat on the floor of *Room*, knees to my chest as the room expanded around me into a world. I felt chunks of my own life engorging its walls and warping its windows. It animated itself with me. I was Catherine Deneuve in Roman Polanski's *Repulsion*, illusory claws grabbing at me through the walls. I was Mia Farrow in *Rosemary's Baby*, the house and its architectural traditions gnawing at my body. I became part of the room. I stilled. I equated Sophie's secrets with my own. I felt myself becoming a fiction at the precise moment when I was faced with the monsters of her reality. I touched her shoe. I didn't want to be in front of strangers.

Sophie's world, realer with you in it.

I'm in the *Room*, which, as Bachelard writes, can be "alternate security and adventure. It is both cell and world. Here, geometry is transcended."[65] To inhabit *Room* is to be realigned with the core of someone else's affective force, destructive and prolific. To torque it with your own gravity as you encroach. I eye her dirty bra, slung over the shower railing. I can't stop visualizing my own, trussed to the edge of my bed frame. *Room* tessellates with each new inhabitant into infinite and alternate narratives.

I was in it. The room. I was lying in the bed before it was set on fire. I tried to get out of it, but I couldn't. The door opened, and a smaller girl, about three or four years old, came in and wanted to get in the bed with me. I let her come in. But then I collected myself and pushed her out from under the covers. I got up and went into the dining room to talk with my mother. She was packing away the silverware. I took a piece of coffee cake, and then, because she did not speak to me, I tried to leave the room. I realized I didn't want to. I got back into bed. I shared the cake. The closer two people are, the more intimate the topics they talk about, and the more closely their fingers entwine when they are shaking hands. *Room* itself could have shut the door and reopened itself to another. It could have split the space when instead, it held it, gridded open. It could have let its inhabitants in, one at a time. It would have been different then. But it wasn't. Instead, it forced us in together,

strangers all. We exposed ourselves to it. We became, for a moment, one coherent fiction.

My ex-boyfriend, Thomson. We break up and get back together, and break up and become friends and still love each other and talk sometimes and want to, or don't, but never do, make love to each other. We still feel parallel even though we are not. It is uncomfortable, a grief that has not yet become a loss. He and I, together, we share a time and space outside the present—we share a possibility. We've become a separate cosmic tangent, a fictive point in some unknown future. On Gchat, on a day when my yearning is hard to bear, he tells me that any theoretical physicist's advice in dealing with suffering would surely be to take comfort in the fact that there will always be a fixed place in space-time where an event or situation is located. There, the passage of time is an illusion. In other words, if you build a home somewhere in space-time, it will always be there, even when you think it's gone. There is a place where the floorboards will always be sturdy, and the kettle that is whistling will whistle on forever. Somewhere certain, unlike the neither-nor space of the present.

Thomson finds this comforting. I do not. His ability to be intensely moral also means he values a temporal constancy. In other words, this happened. I was here. I *know* it. The veracity of my experience is a fact that will never change, because there exists a place in the universe where it will never be questioned; it will never disappear. On the contrary, I find the idea that there's a fixed point of thought, an unchangeable emotion or belief, to be frightening. It means that attitudes can never change with circumstance or desire, that there's no room for flux. It feels to me like the beginning of dogma. Anyway, we're on Gchat discussing fixed points in space-time, and he says, "I mean, this [theory of space-time] helps w/ loss but of course it makes guilt/shame basically intolerable."

The thing about fixity is, it gives you certainty about who you are and what you stand for. From then on, events seem clear—who wronged whom and how. From then on, you always know what to fight or

forgive, what to struggle against and why. For me, this can be hard. Some things are unforgivable. But otherwise, I prefer sitting in my own murky muddle. I prefer owning up to the contradictory demands of my proliferate identities, racial or political or otherwise. And without knowing which single category to place myself in, I can never fully know whose side I'm on. If there's a crime against me, I'm likely to still be partially to blame. I can't ever determine the outline of an enemy—if there's a truth to them, or how; and if so, where they or I might end or begin.

It's dark, and I'm upset. This is not new. I remember the room. I remember there was carpet; I was annoyed by how green the walls were. We were young. It was packed. There was a band playing, and all its members had long, curly metal hair and black glitter leggings. It was a great show. Someone ripped his jack from his amp and sucked it as if there were no air in the room. The room shivered and exhaled in response to the aridness of his screech. It was the night that we had refused to let anyone go upstairs to our bedrooms. (It was every night.) The crowd was tight. My eyes were so dry I couldn't blink. Wide and dark behind my eyelids. A stranger got hit in the head by a crowd-surfing cymbal. The stranger went up the stairs. We tried to stop them. They screamed, "I have AIDS!" There was blood everywhere. Their forehead was in your face. Ivy tried to hit them. You held up your hands, your palms were wide and stark. You said, "Whoa, can I get you some help? I just want to help you." Your eyes were very light. You had blood streaked down the side of your face, across your right cheek and close to your mouth. I reeled.

Suddenly, the world felt very taut, like if you shifted one element, others would follow. We thought we could change the world. We thought we could take everything and hold it by throwing our bodies sense-lessly together. We were a perverse Venn diagram turned into collective belief. We were some form of cross. I said, "It's OK," and we saw it come true. You held the bleeding stranger in your arms. I had an urge to see the cymbal. I wanted to know what instrument it was that created this scene. When I remember it now, it resembles a puzzle.

The pieces fit, but the edges are wet and sanitized by my romanticism. There was still blood streaked down your face. I wanted to kiss it off your eyebrow. I washed it out of Ivy's hair. That's what I remember. Was this every show? No one wants to go back there, but it doesn't mean they're not nostalgic for it either.

When I was a girl, I wrote a book. It was about being doomed; it used death as a weapon. But I'm realizing that dying can be easy. These days, it's harder to learn how to live.

It's years later, and I'm back. I'm at the Kelly Writers House in Philadelphia. The room is comfortable because it is familiar. I went to college here. I did my homework in the rocking chair by the kitchen table. I'm here to give a reading of my first book, but something is terribly wrong. I deal with it by being avoidant. I'm extra giggly. I show off a new tattoo. I put on more blush; it's too much. What's wrong is this: a boy has just killed himself. His name was Ezra. He was barely twenty-one. He was young and beautiful and shy. He went to college here too. He did his homework at the kitchen table. He joined the same DIY organization I was a part of. His friends knew mine. We listened to the same music. We read the same books. We believed in punk rock. We spent our Thursday nights in the basement of the same dirty house, its walls painted bright with beer and color and youthful aphorism.

I was too old to be at school with Ezra, but it feels like I was. I tell myself that I didn't know this boy, but it feels like I did. I tell myself I shouldn't have these feelings. It doesn't help. It's minutes before the reading. When I start sobbing, it's sudden, a geyser. The world breaks apart. I can't find the floor. Nick is there. We dated in college. We were the same age Ezra was; he loved me then. We had friends together. A group of kids who found a style to live in, something that kept out the world. He catches me and clutches my head to his chest. He used to be smaller, but he's a big man now, Italian American. His long hair in my face. I can't breathe. Someone else tries to touch me, but I recoil because they weren't from the fiction we lived together back then; they can't find me here. I don't want them to.

I'm at the Kelly Writers House; I'm here to give a reading. My book is a collection of suicide notes, even if I managed to stay alive. I did it out of spite. When I start reading, my voice is dull. Did Ezra think these thoughts? Did he write them down? When my voice finally breaks, toward the end, I feel in that moment my fiction graft itself onto his reality. He wrote the book. I died. I feel our worlds double. I become his future. He is my past.

We are sitting in the same familiar room. Through the first fifteen minutes of the movie, you looked at my neck as though you wanted to twist or kiss it. I flipped my hair because I could. You remember resorting to violence, what's called "being polite." Vivid dream of crushing my eye socket into the banister. Yeah, it was every show. Sometimes the blood wasn't real, and sometimes he was a she or it was drugs instead of cymbals and sometimes we weren't polite, but it was every show. One of us still wants to kiss it off, as long as we're playing.

There is a fixed place in space-time where an event or situation is located. I can't help but return to it. Here, the passage of time is an illusion. I'm in my room, with friends, wrapped in a pink blanket. It's comfortable. There's a march going on outside—I can hear the looming whir of the helicopters—but I ignore it because my friends are beautiful, talking, laughing, dreaming together.

I know I should leave, but I don't. I put Svetlana Boym out of my mind. I relinquish my critical thinking for emotional bonding.

It's no utopia. But it feels like it matters.

I watch a YouTube video of Ezra dancing to indie pop. He's awkward and unselfconscious, his face alternately shuttered and open, turning with the mood of the moment.

Anyway, it matters to me.

It's morning, so I'm on the internet. And like any other morning on the internet, a bunch of people are arguing on Facebook. So what's new;

it's just another day. Just another poet who's published a piece online that everyone's all up in arms about. This time, the culprit is an Asian American woman. I don't know her well, but there's an affinity there. I like her work; I respect her. Even so, when people put us next to each other, it's the way they go about it that irks me. Like, OMG, you're both Asian and you both write about complicated girlhood? Wait, so you guys must know each other, right, like you're basically just the same person! Her poem appears on Buzzfeed, the font large and trendy against the white background. The subtitle reads "it happened to me: / I dated a white anarchist / who made me do all the dishes / while he crowdfunded his trip to Rojava."[66] A caricatured account of the Bad Anarchist Boyfriend archetype, the poem is a too-easy criticism of the left, sure, but I also know men who fit that description, so I don't think much of it. I click out of the screen. But by the time I get to work, there's been a minor internet scandal, and I can't help reading every word: the poem, the related commentary, the outraged Twitter threads, the multiple tags. No coffee, scrolling on my phone.

It turns out that this poem is based on the real-life story of a Bay Area punk activist who went to fight in Rojava. It's a loosely fictionalized account, written from the point of view of his partner, of him behaving like a misogynist fuckboy, even though the poet doesn't know either of them. It seems little of it is true. To say people are upset about this poem is an understatement. Some things I read about it from friends, and on social media:

It's irresponsible, hostile, and unethical.

It's liberal red-baiting under the guise of pop-cultural feminism.

I mean, it's dangerous how it's erasing the work of queer anti-capitalist activists of color while repeating clichés about how radicals are all sexist straight white men.

It's honestly so boring that its critique is just based on "gender stuff." I mean, implying that radicals are uniformly ignorant of these sorts of feminist struggles might score you a bunch of points with the "I'm with Her" crowd, but the point of writing about the personal is to actually do something about it and not just complain.

Like, if your boyfriend's telling you to do the dishes, then just don't fucking do them, just get off your ass and leave him, you know what I mean, like who cares, she's just after the fame anyway, she's just in it for the glory.

OK, so I agree with some of this and some, not so much. But by this point, I've mostly lost track of which side I'm rolling my eyes at anymore.

Because aren't the stakes always just so high? If the internet is a microcosm of real life and its microcosmic issues of race, art, and politics are doubly intensified, we just *have* to have something to say about it. People trade witty barbs that are as full of camaraderie as they are potentially vicious. Others accidentally reveal their understated affiliations with power. We all get lost on a tangent. We're all still online. It's all in the "spirit of the discourse," duh, and if you're going to make problematic art, you have to be willing to take it, but even though I hate this fucking poem, too, it starts to feel like everyone's just making sure they don't get caught not joining in.

I hear my mother's voice in my head. "Americans are not like us," she admonishes. "They're only watching out for themselves."

When I point out to people that some of the critiques of this poem seem low-key racist and misogynist, I'm told I'm just splitting hairs. When I point out that any statement suggesting a woman just "leave her abusive boyfriend" isn't exactly validating victims of domestic violence, I'm told that the accusations leveled in the poem were fictional in the first place, so they don't exactly count—after all, they're more incriminating to the punk activist whose experience is being appropriated. Either way, I can't seem to coax my opinions into an allegiance with either side. And when I get upset, I wonder if it's just because, like Oki says, this Asian American woman is acting as some presumed mirror of myself, and I feel implicated. But honestly, it feels pretty shitty that people keep assuming I'm defending

this poem when I'm not. I'm just trying to critique the *responses* to the poem as well as the poem itself, I want to be mad at more and not less.

I'm looking at this poem and it mostly feels shitty because when I get upset, I know it's not even about the fucking poem. I'm upset because it feels like you can't write the personal without it fitting neatly into some larger cause. These days, there's no room to make art unless its loyalties are straightforward, like how we want identity to be.

I'm at the kids' table with some of my oldest family friends, and it's nice, but the conversation has turned, unfortunately for me, to politics. They remind me that we all come from extremely wealthy families. Surely I can't really be as politically left as I purport to be. How could I be so unappreciative of my parents' hard work as to betray it all? Surely I can't be so cavalier about how shameful it would be to pay out all their hard-earned money in taxes, or to simply give it all away. "All right, Malcolm X," Jacob teases when I get a little riled up about what he's calling the "fascist left." I wave him off. I feel like picking a fight. Casually, I say, "When the revolution comes, I'll be the first to throw myself upon the guillotine." Despite my tone, I'm not really joking. They laugh with me, but I feel as if I'm the only one.

What could I even align myself with besides? My racial affiliations? My aesthetic investments, my nationality, my political ideals? These loyalties, like how my mother taught me—unconditionally, inflexibly—each twisting around the other into a rope I could hang myself with.

After all, I am not American, and yet I stayed. But not because it was the land of the free. I stayed in America because its bloody claim to liberty birthed communities to whom freedom was promised, but who knew it wasn't their own. Who continue to forge a culture together with practices of resistance, who teach us how to make survival synonymous with art. From punk to antifascism, there are movements in America I had never seen, could barely grasp, whose language was not permitted to me back home.

In 1987, twenty-two people were detained without trial in an event known as Operation Spectrum, conducted by the Singaporean government to, as local paper the *Straits Times* reported, "nip communist problems in the bud."[67] Several detainees made televised confessions implicating themselves and their friends in a supposed Marxist conspiracy to establish a communist state. These were then broadcast to the entire nation. In a joint statement released in April 1988, nine of the released detainees categorically denied the government's accusations against them, instead asserting that they were a mixture of students, social workers, and Catholic laity who had "advocated more democracy, less elitism, protection of individual freedoms and civil rights, greater concern for the poor and the less privileged," and had no subversive intent.[68] Most of them were subsequently rearrested. By 1990, all detainees were released.

I stayed in America to learn from those willing to embrace a common metonymic fantasy. Those who insisted on looking beyond, who were willing to forsake this country's colonial promise for something else altogether, something uncertain but true. For those who were willing to imagine something worth fighting for. That's why I stayed.

I'm at home, in Singapore. in my bedroom, alone. All I've done this week is write and read and go to the gym. Have I truly tried to confront my heritage? Have I too quickly written off its promise of clarity and direction? If I'm trying to find some salvation in it, then why am I bound to some foreign fantasy?

When I ask some of my fellow artist friends why they returned to our home country, they tell me that moving away from Singapore permanently would feel too much like losing or giving up. Too much like abandoning the possibility of what our country might become. After all, these days, Singapore is exceptionally stable and wealthy. Local artists and writers, literary publishers, and independent galleries have emerged, and the government is trying to invest in the humanities. From a beautiful National Museum to off-site campuses of major Ivy League schools, it finally feels like a time and place where the arts could flourish. A time for a younger, more politically engaged generation to come to the fore. For my friends, leaving would be betraying this opportunity to create a

different culture together, a culture other than the safe complacency of censorship, the security of order. So they choose to return to Singapore, our beloved, benevolent homeland.

But I shake my head. I can't help but be suspicious of the Singaporean government's recent interest in investing in the humanities, even if it makes me sound like an asshole. If America's any example, state-sponsored art isn't something to aspire to anyway. As Jarett Kobek writes in *I Hate the Internet,* "The writer of this novel gave up trying to write *good novels* when he realized that the *good novel,* as an idea, was created by the Central Intelligence Agency. This is not a joke. This is true. This is church."[69] Love them as I might, books that hate the president, exquisite close-up photographs of genitalia, murals that urgently proclaim the need for equality, and other "transgressive" works are often funded by government grants or private foundations whose executors have other political motivations. These days, art could become a government-funded product that proclaims the state's benevolent tolerance of all subject matter and ideologies. A product that helps create the illusion of America's cultural and philosophical freedom, yet forms a clever distraction from the material reality of life in the u.s. How it remains as crushing as it's always been. The truth is, if any material attempt were made to implement the ideologies professed in any of these transgressive artworks, if they were ever to pose a real threat to the state and its status quo, they would never be allowed to exist. The FBI's investigation of radical artists and writers, from James Baldwin to Jean Seberg to Judy Holliday, its massacre of radical groups such as the Black Panthers, tell us so.

Often, I find myself at that disappointingly obtuse question: What good can art really do?

The weekend that I'm upset about the Rojava poem debacle, Staiti drives me to the Fort Mason Center for Arts and Culture, out by the sea, to see Sophie Calle's show *Missing.* We get there late. It's a cold and cloudy day, so we panic when we realize the pieces are spread out in different rooms, over a large area. Composed of documentation and ephemera

from some of Calle's classic performances, *Missing* is a wide-ranging exhibition that feels casual and intimate in its dispersal. We power walk from gallery to gallery, sweat streaking the smalls of our backs, turning clammy in the salt breeze. My favorite of the pieces we see is titled *Voir la mer*, and aptly, it's installed in an old fire station by the ocean. The wall text explains simply, "I went to Istanbul, a city surrounded by water, I met people who had never seen the sea. I filmed their first time."

We find ourselves in the middle of a dark room. We're surrounded by screens on which bits of film flash intermittently—depicting close-ups of Turkish strangers whose faces change as they encounter the ocean for the first time. A woman who breaks into a joyful smile. A man whose brows furrow slowly, overcome by its watery immensity. As viewers, we're voyeurs to this intimate experience. We're reminded we're in distant America, made too aware of our physical location, our privileged circumstances. We become subject to a simple dilemma: we cannot watch one person's experience without turning our backs on another. The questionable act of looking at the Other, pulled apart: a torturous dissection that happens so gently that when its consequence hits you, its force is winding.

I love Sophie Calle because even if her pieces are easily categorized as "performance of the personal," they are never contrived or theatrical. Even if they're staged, their framing is merely incidental; they've grown spontaneously out of what's already in her life. A single gesture tacked on to what is already occurring. Sophie finds an address book and calls the numbers, she sees a handsome man and follows him, she goes to bed and invites others to join her. In other words, if Calle's art doesn't appear to serve anything beyond herself, it's because it's not intended to; it's usually simpler than we think. To me she is less capital-A artist or inventor of self-as-critique than curious and incisive curator of her very life.

Seeking the last exhibit in the show, Staiti and I climb a series of steep stairs, we careen around a grassy knoll, we follow a strange path into a cul-de-sac full of dumpsters. It's a while before we find the tiny chapel,

high up on a hill, where the installation is. Stepping in is a bizarre experience. Entitled *Rachel Monique,* it's dedicated to the memory of Calle's mother, and projected on the wall above the altar is a video of her dying moments, Calle's own aging hands arranging beloved stuffed animals next to her wizened face. The rest of the chapel is haphazard—lace curtains etched with her mother's last word: *souci* (French for *worry*), giant photographs of tombstones set into the floor. Pages of her diary are printed out on flimsy paper, strewn across the floor, and pinned to the walls, their amusing aphorisms recited over tiny speakers installed in the pews. Her mother's namesake, a taxidermied giraffe head that Calle purchased right after her death, hangs awkwardly on the wall, an ungainly transitional object. Its face is bemused. After we leave, Staiti and I sit on a park bench. It's drizzling. They hold me, and I weep.

In an article for the art publication *Momus,* Sarah Burke writes, "*Missing* successfully illustrates Calle's enduring ability to rend our hearts, like the composer of a well-written pop song. . . . And at a moment when it's increasingly necessary to be invested in a collective reality, the performance of the personal can appear like an unconscionably saccharine escape."[70] She makes a good point. I don't disagree, but there is not much more I can say in defense of this show apart from that it lacked pretentiousness. It was a modest intimacy, it moved me.

Sometimes, I hear people say that after the revolution, there will be no need for art.

Do I really believe that? I don't know.

What I do know: some parts of the revolution are not so unlike art.

What I do know: it's too delicious to love art so simply.

I hesitate to compare art to direct action or even to revolution in the abstract, especially when the latter affects people's lives in real, empirical ways. And even I will admit that art may just be a compulsion, a reiteration of tired forms that we know can produce pleasure. I might not have any belief in art apart from its power to move me.

But I can't help but think that both art and action can produce effects in their participants that, although decidedly different, can in fact serve the same function: to give us some belief that we are sharing in something that is happening, whether internal or external. A recognition of, or recognition by, something bigger than ourselves.

Yeah, those are pretty words, and I'm good at them. As my mother likes to remind me, though, you can blow hot air all day long, but the real test of integrity is whether or not you can make a difficult choice. And despite all my arrogant talk about collectively imagining something worth fighting for, I'm back home, arguing with my friends about whether it's possible to create a free culture of the arts, an activist community in Singapore, and I mumble, "Nothing works. There can be no autonomy," when I don't really mean it. The truth is, I haven't tried. I haven't kept in touch with most of my childhood friends. I haven't tried to see or learn about or make art in the context of my hometown. The truth is, I've shirked my responsibility to those who returned, believing they could build something better. Cowardly, I didn't come home. I've refused to play my part.

I try to comfort myself. After all, it's true that options for protest and resistance are more limited in Singapore than in the U.S. It's true that at home, LGBT people still lack many legal rights, censorship laws are still in place, and Reporters without Borders lists Singapore as 151 out of 180 on its World Press Freedom Index.[71] From the withdrawal of state funding for Sonny Liew's exceptional graphic novel *The Art of Charlie Chan Hock Chye*[72] to the prosecution of activist Jolovan Wham for his involvement in "protest without a police permit,"[73] critique of the state is not taken lightly. Instigating lawful change in Singapore is difficult. But does that mean I shouldn't try? What's sadder than being trapped in this liminal space alone? What's with my misplaced sense of superiority? If I really believe in collective action, in a future I could participate in forming, then why can't I get up off my ass and go home?

Often, I tell myself that I must live for the good of mankind. But now I realize this is an excuse, nothing but a roundabout expression of my

egotistic self, a rationalization. I've hitched my wagon to a star. I'm ambitious and would like to excel all men. My daydreams are identical to my night dreams. I have fantasized that I could fly high without a machine above all men, without wings, without even so much as the movement of my arms. I possess a magic cap with which I can fly through all of space without being seen by anyone, giving orders that must be followed. I dream. I, the criminal who would forsake home, who wants to destroy her parents and sister, her own flesh and blood, who wishes them death in moments of passion, simply for the sake of her own paltry, egotistic ideas about what it means to liberate herself, what it means to make a better world.

Some way for my life to feel selfishly better.

I turn my face into the wet pillow.
Potato.

The truth is, I do have a chance to fight for something in the place I came from. Something akin to what I continue to fight and hope for in America. Something bigger than myself. And yet, I stay. It's a decision I continue to make, one that continues to haunt me. And even if it is a choice, there's no weight in it. It's meaningless apart from its selfish intent.

It's years later. I still haven't gone home. I've made another selfish choice—to move further West, out to California. I'm on a porch with Alli, watching the sun go down, pasta sauce simmering on the stove. As Ariel and I talked about, Alli is recalcitrant, but it's sexy. She has nice tits. She's in a long-term relationship with a cis man, but they're open and she sometimes has affairs with not-men. When we hang out, I'm friend-zoned immediately, but that's OK. We're both Scorpios so talking is easy, and our confidences run easily, like water. I tell her about how I had a girlfriend in high school. How after that, I messed around with girls and queers but have mostly been in relationships with men. This is not a lie; it is a fact. This is a fact at which people roll their eyes, because they feel entitled to let you know they think you are lying. To them, "having a girlfriend in high school" is a statement that's been

founded on a common lie. To them, you're a cliché. "A girlfriend in high school?" they say. "Sounds like a phase."

Maybe that's fair. The right to love and fuck whomever you want, without inhibition or oppression, has been hard-won over the years, which is why I don't like to identify as gay—it feels disrespectful. The truth is I'm only gay sometimes, so I prefer to be called bisexual. I'd rather code-switch between identities. I'd rather be gay or straight depending on who I'm dating, whether I'm in a queer relationship or not. This is not a popular preference. From the sixties' Summer of Love to poly-amory and twenty-first-century queerness, there are those who fervently believe freedom of sexuality to be utopic. After all, it promises the best of all worlds. You don't have to choose. You get to try a little of everything, some people say, as though you're a greedy customer at some fucked-up buffet of differently hot people! But I don't believe that existing in this world can be some amorphous soup of sexuality, not with the structures that undergird our living. Being a code-switching bisexual means I'm aware; I can parse out which privileges I'm afforded in which situations and when. Because no matter what anyone says about queerness, you can't have it all. It gets too contradictory. The way the world operates means you can either function as one identity or the other, nothing in between. You can't demand your queer cred alongside the lack of scrutiny that comes with your straight white boyfriend. You can't have the luxury of assuming your safety at a remote gas station alongside your nonbinary lover. You can't hold it all. And if people tell you that you can, they're lying.

Alli tells me her high school girlfriend ended up dating a super-out queer artist in college who performed at wild gay parties. "That's cool," I say, even though "cool" is not a real descriptor; it doesn't mean anything. Coming out into an identity is just easier for some people, even if coming out is never easy. It's not better or worse, just different. I ask Alli why she never came out of the closet in that classic way, the way that entails an utterance, a statement of identity. Maybe we both think about it the same way. That our sexuality didn't feel that simple to us, but it didn't mean our desire wasn't true. That just because our desire was true didn't mean we needed our sexuality to be simple.

I'm at home, reading the latest issue of local queer nihilist journal, *Bædan 3: Journal of Queer Time Travel.* There's a piece on Samuel Delany's essay *Coming/Out* by an anonymous author. They write, "The closet, in its moral hue—as a shameful space of betrayal—is an invention of gay [not queer] militancy . . . if not the closet, then what one came out of was *straight society.*"[74] I feel kinship because I've been thinking about the closet too. It's only recently that we've begun to consider the closet a negative space, one of defensibility and repression. It's only since the emergence of gay rights and identity politics that coming out has become compulsory in order to be "true to yourself." A performative utterance to demonstrate how you're *really* gay, as though your sexuality has to be recognized by someone outside of the closet in order for it to be true. And these days, with gay rights on the legislative table, coming out of the closet is not only a burden of proof, it's also the promise that if enough people join you in doing so and claim this identity together, we will one day attain an egalitarian utopia. One where every citizen is endowed with the same rights and is accepted by the state for who they are. A democratic wet dream.

It wasn't always like this. In *Gay New York: Gender, Urban Culture, and the Making of the Gay Male World 1890–1940,* George Chauncey describes how in 1920s New York, "coming out" was common terminology in the underground cruising scene, even if gay rights weren't yet on the agenda. At the time, "coming out parties" for gay men were not uncommon. Intended as a knowing play on women's culture ("in this case, the expression used to refer to the ritual of a debutante's being formally introduced to, or 'coming out' into, the society of her cultural peers"[75]), coming out parties were not an occasion for gay men to claim a calcified sexual identity. Rather, parodying the extravagant debutante masquerade balls fashionable among upper-class women at the time, these enormous drag balls knowingly celebrated the fashion and decadence of gay culture. "Gay people in the prewar years [pre-World War I] . . . did not speak of *coming out of* what we call the 'gay closet' but rather of *coming out into* what they called 'homosexual society' or the 'gay world,' a world neither so small, nor so isolated, nor often, so

hidden as 'closet' implies,"[76] Chauncey writes. Coming out was a practice of openness and acceptance rather than of shedding shame. The interior of the closet was not considered secret or isolated in the way we now understand it—one came out of the closet not to escape its darkness, but rather dressed in the most beautiful ornaments from within. One came out of the closet in order to *show its contents off* to everyone else.

It was only later in the century that the closet became a symbol of clandestine sexuality, such as having a "skeleton in the closet." Perhaps it's worth considering that the space within the closet is not simply a space of self-hatred and repression. It can also be a space for fantasy, a space of unformed and flexible sexuality. A space for desire, unconstrained and uninhibited by any identity classification, where there are no restrictions on how you explore your behavior or how you name yourself. Could the closet be a celebration of difference rather than any imperative toward homogeneity? It's true that one might wonder whether any argument for the closet's appeal can ever be defensible to a queer community as anything but romanticized nostalgia.[77] But it's worth remembering that the process of "coming out" of the closet is a contradictory *societal* fantasy. Rather than the erotic flexibility within the closet, this societal fantasy envisions democratic equality: it would prefer an individual emerging from the murky depths of their unshaped, enclosed desire as a fully formed, functional, and enlightened citizen. Coming out is a process that makes you legible and classifiable to the state. And over time, it is this recognition that produces a static category, populated by persons who we then automatically assume all possess a common set of characteristics, even when that's not really the case.

Often, like when it comes to sex, we're told our experience isn't that complicated, and so we assume it's true. Reality can be an imperfect solution. It's why we have identity.

When my mom asked me if I was gay, I don't remember what I said, but I know she ignored it. I let it go because I felt relieved. Because saying out loud to her "Yes, I'm gay" would have felt like telling a lie. If I had said it and repeated it—"I'm gay"—if I had been forced to face it, then

perhaps events would have turned out differently, because repetition is what makes things real. But in that split second, it felt as though there were only two options available to me. Gay or straight. Stark and binary. And whichever choice I picked would have dictated my path, scripted the rest of my life. Would have become something I would never have been able to deviate from. Inflexible.

In that split second, it seemed fucked up to make a choice that didn't feel 100 percent true. It seemed fucked up if later I might change my mind. I didn't know what was real to me. I still don't. But try telling that to a scared sixteen-year-old. I defaulted to what was easy. It would form me.

Queerness is supposed to be utopic, but all it meant to me was an excess of ill-fitting choices. I didn't pick an "identity," per se, but identity forced my hand. I dated boys because it was better for everyone. I chose which path didn't seem most wrong. Sometimes I think that's like choosing what seems kind of right, but I know it's not the same thing.

I'm trying to remember what I ate for lunch yesterday—maybe I've repressed it? Not important, but let's face it, that's apt. I'm in Hampstead, London, in Freud's old home and office. An unremarkable cottage that's been preserved by the city of London, the office is all country charm and loud patterned curtains decorated with maroon roses. It's cozy, the dark wood furniture gleaming in the yellow light. In the corner of a large room, a half-spun rug sits inexplicably. Freud's antique collection is there in its entirety; relics and figurines from different times and contexts line the mantels and shelves, from busts that seem like Roman and Greek replicas to partial Buddha statues. Austere portraits and photographs hang on the walls. And opposite the cluttered desk and the imposing desk chair is the famous leather couch upon which he treated patients in repose, bedecked with lusciously colored rugs and cushions.

The architect Richard Neutra was influenced by the popular Freudian psychology of the the early twentieth century. He was fascinated by the way objects in Freud's office were arranged to aid free association during analyses. It's no surprise that patients found, among the rows and rows

of tchotchkes and talismans in Freud's office, plenty of objects to cathect upon, aiding him in the process of delving deeper into their psyches and unearthing the roots of their repressions. Inspired by the way these objects could alter mood and affect, Neutra went on to develop architectural designs based on psychoanalytic surveys he sent out. He sought to develop a relationship with his clients not unlike the transferential relationship between patient and analyst. He believed that these intimate relationships would help him create a tailor-made environment for each inhabitant's individual emotional needs. They helped him calibrate the psychic valences of the buildings he designed for restorative effect.

Many of Neutra's clients, like Freud's, were unhappy women who believed his custom curative environments could fill a void—women who wanted to feel, in their own homes, that they were enveloped in the embrace of a lover, or that their surroundings would be conducive to conceiving a child. A Neutra house became an empathetic mirror, something that gave a woman's life form.

Freud's cottage remained in the family after he died in 1939. In fact, it went to a woman, his daughter Anna. Throughout her life, Anna remained slavishly devoted to the psychoanalytic foundations Freud had constructed. She followed in his footsteps, becoming a psychoanalyst specializing in childhood behavior. When asked about her work, Jacques Lacan once scoffed dismissively, "Well, the plumb-line doesn't make a building. . . . [but] it allows us to gauge the vertical of certain problems."[78] Anna Freud built no house of her own. Her scaffolding was weak. She preserved her father's office. She built her practice of child psychology within it, literally. Her toy building blocks in the middle of the rug. She toed his calibrating baseline. Sketched her life's form by tracing his. The Oedipal–industrial complex. The thing about Anna Freud is, she never left home.

I'm back. I'm in the gag. Home—I think we all know it's a long-term facility. It isn't a space that's easy to enter—or to leave—but when I return, all my stuff is still where I left it. Home has a force that leaks, like bad radiation. And memory doesn't serve me well enough to know—where this

force came from, which organs were assailed, what circuits were meant to be tripped, was it an accident, and how does it persist? Sure, I might have decided against a future or a past, but architecture is still a repository of events, automatically accessed each time you reinhabit a space, and somehow this means I'm trapped here; it means I can never leave.

It's Saturday. I'm at an s-m waterboarding workshop, in a basement somewhere in Chelsea. I'm nostalgic, so this space could be any other—the black hallway, beer stains on the floor, the faint whiff of detergent masking the lingering cigarette stench, the dull glossiness of a bad paint job, the matte marker of graffiti. We sit in rows and watch as a woman chokes and retches under the soaked cotton of a drenched t-shirt, as she has fizzy Mountain Dew dripped slowly into her nostrils so her airways can never clear from the sugar. The workshop covers all the essentials: the history of waterboarding in a specifically s-m context, what to tell your tsa officer if your carry-on luggage is full of waterboarding equipment, the physiology of oxygen deprivation, how to emergency-respond if something goes wrong. The man doing the demonstration is obviously hard through his tight black jeans; he's stroking his cock with his zipper half open while he tells us this information. Occasionally he giggles, nervous and high-pitched. His wife burbles under the cloth and jerks feebly before he removes it and spits in her face. I recognize the dazed look in her eyes, and it might not seem like it, but I know she feels delirious and relieved, the world turning green and torn apart as though it were dispensable, as though it were no longer hers. Her knees jerk up. I see the wet cotton worm its way into her mouth and pucker.

The workshop is two and a half hours but feels like forty-five. I feel dampness spreading uncomfortably into the mesh of my tights. The girl next to me can't stop sneezing from the humidity. Occasionally, she swims into my field of vision, wide-eyed and lovesick through her hay-fever tears. The collar around her neck reads "Daddy's Little Slut."

I'm in Freud's old office in Hampstead, London. These days, they show art here. Today it's an exhibition of works by the artists Tim Noble and Sue Webster entitled *Polymorphous Perverse.* Built on both Anna and

Freud's formulations of childhood sexuality, the sculptures are excessive and obnoxious, composed of mechanized tools and broken toys that move as you walk past. The centerpiece, *Scarlett,* is bursting at the seams with severed doll parts—burnt limbs rotating on a barbed wire carousel, a jerking baby head trapped in a dirty plastic bag, everything encircled in dribbles of cherry-red blood. It's so coded with shock value as to be sarcastic—an aesthetic I personally like to indulge in—so I feel mostly at home. I walk past a small but austere etching of Moses hanging on one of the walls. In this portrait, he looks furious. He's holding the Ten Commandments above his head, about to smash them at his feet. There's a ragged tin can perched on a small wooden table directly beneath him. It has no label or lid. It's open, so I lean in to take a look and let out a noise between a sob and a screech. As I move my head, a single hot dog with a lone baked bean balanced on its end emerges vertically from the can—a juvenile insult to the life-shaping influence of Moses and dads everywhere. It makes a loud, mechanical whir. It's baldly pink and erect. It's cheerily impotent. I can't help it. I lose it, I'm laughing.

There are crawl spaces in my life where I begin to feel again. There are mind-numbing boxes that are difficult to leave. Sometimes they're the same. I hope it's OK that I'm stuck here for a while. I'm sorry I didn't write back sooner. I started a Word document, but it didn't really come. Something I liked about you was how your politeness was always a snarl. Something I knew was that your courtesy was really armor. We were in love. Was this every show? Say anything out loud and you'd hear the contempt in it. Say anything and I'd have agreed. The memories started small, like wisps nailed against my temples. When I shook my head, they defined themselves against where I thought they were supposed to go. I've listed them below; maybe you can verify.

It's Saturday. I'm at an s-m waterboarding workshop. It's hour two and there's equipment set out so we can experiment on our own. The workshop leaders watch. It's my turn. I'm no stranger to asphyxiation, and the cool drip of the water is starting to make the intensity in my chest

burn from lack of oxygen even as it calms me, but suddenly, the towel is ripped away from my face, an unwelcome gasp of air screeching through my lungs. And amidst my gasping, the woman who's helping me screams, "Oh god, stop, you're a breath holder!" as though it is some terrible accusation. I'm confused. As it turns out, what makes for successful waterboarding is our body's instinctive urge to inhale when denied oxygen. What makes it so painful is the convulsive gasping that comes from trying to suck in life-affirming air but finding in its place only damp, suffocating moisture.

Waterboarding is no match for me. Years of training as a synchronized swimmer have dulled my urge to inhale when deprived of oxygen. Instead, I hold my breath stubbornly until I can't help but pass out. I don't suffer as dramatically, but it also means that my body doesn't express any symptoms before I move swiftly on my way to permanent brain damage. "Most people kick or struggle when they're waterboarded, you know, from the panic, which is part of the enjoyment," the woman explains. "But if you're holding your breath, you'll just be still as a rock, and how would we know—how could your partner know then—if you're," she pauses, looking confused. "Well, if you're already dead." It's cold under the air-conditioning, and I can suddenly feel the slime of water and snot and saliva dripping down the back of my throat. It's warm and alive. I feel subliminal. I'm overcome with a sense of relief or disappointment, I can't quite tell. The woman grabs my arm and shakes it once. I'm jolted to the present. She says firmly, "It's just that you don't know how to struggle correctly." "I know," I say back. I can't help it. I am going to die in disgraceful circumstances. The air-conditioner whirs.

I'm walking around the exhibition. I'm walking from room to room in Freud's cottage, and it becomes clear that the artists Noble and Webster don't intend to cast aspersions on Freud's theories. They don't intend to question the way his psychoanalysis became the foundation of our understanding of the modern human subject, the basis for our valuation of individuality. But they want to highlight how absurd and arbitrary his theories can seem as well. There's a sculpture entitled

Black Narcissus in front of the bookcase. I stop before it. It's a dark mass of rubber-cast hands and cocks, entwined and gesturing to each other, melded into a friction of attachment and acrimony. Some fingers are curled into or they're gracefully draped, some cocks are flaccid or bent or aggressively erect. But there's a spotlight shining on this black mass, so it casts a shadow. And what we see on the wall directly behind the sculpture is the perfect silhouette of Noble and Webster's conjoined heads, sitting perpendicular to a cast bust of Freud's own. Both shadows are exactly the same size. In this piece, identity, ideology, semiotics, and sexuality—all crudely reduced to cock and hand, sensation and sensation received, desire and desire fulfilled. Not to be dumb, but god, just facing this fact, so literally. How funny and awful is that?

In an interview, Tim Noble and Sue Webster are asked how they managed to make so many plaster casts of Noble's erect penis. It was a struggle, they say, to make such a cast. They tried everything, from plastered gauze to modeling clay, but everything was too cold or too hard or too unbecoming for such a fragile event as erection. They landed on materials used for dental impressions, the gooey alginate still warm before it's set, a comfortable cocoon for a bald, pink member. Easy to mold and compress, easy to turn out hundreds of different casts of his wrinkled organ from which to construct the contours of a face. Noble and Webster, in their Freudian parody, create a space, not to discover the truth about our "real identities," but to reveal what is soft, or flexible, or comic, or pathetic about how we mirror these ideations in our lives. Some farce of our utopian desire to know ourselves. I think of Noble's cock set in colored goo, each iteration a smaller and smaller stage of erection, a fainter and fainter silhouette. Something that delivers a perfectly reflective but damning portrait, one's silhouette is always already the shadow of one's departure. I left—

—home. It happens because we're human and our fantasies are narrow. We can only collage utopia from what we know of our empirical universe; it can only be a bricolage of pleasures vividly recalled.

I'm tilting my face toward the blinding spotlight, letting some patterned Morse code of cock and finger imprint itself on my eyes.

Some days, I wake up weak. I don't know how to struggle correctly. I am going to die in disgraceful circumstances.

Whatever. You can make utopia out of almost anything.

It's Friday morning, my day off. Claire texts me and asks if I want to go to the Martin Wong show at the Berkeley Art Museum with her, maybe after we get bagels? I do. When we meet, Claire is carrying a very gay tote bag with pornographically realistic Tom-of-Finland leather daddies on it, each of their tiny cocks straining through their pants. The server at the bagel shop clocks it and casually mentions how much he regretted not going to the Folsom Street Fair this year. I'm reminded of the time Claire went out with one of the bagel girls and then promptly ghosted her, meaning we couldn't get bagels for months after. You don't shit where you eat, I say. But we're in the gay Bay Area, so that's what happens—and I can't help but love it.

I'm at the Berkeley Art Museum, learning about Martin Wong, a queer Asian American painter raised by immigrant parents in San Francisco's Chinatown. He was active in the Lower East Side arts scene from the eighties through the nineties. Refusing to adhere to traditional ethical limitations—in fact, refusing to adhere to the racial themes of his own Asian experience—Wong instead employs a wide range of identity markers in a way that betrays his own psyche's complex and problematic web of cathexes. Some of the paintings combine the influences of graffiti and sign language with Chinese calligraphy. Others employ kitschy stereotypes of Asian culture in a series of glamorized and distorted tableaux, calcifying it into a style that subtly critiques the way Chinese culture has been grotesquely adapted in America, from yellowface in Hollywood to the lurid red buildings of Chinatowns in every state. In an oddly naïve style of collage, Wong's paintings manage to locate, even celebrate, the romantic ideals embedded at the heart of each identity category while simultaneously exposing the artificiality of any assumed qualities associated with them.

Perhaps the most compelling paintings in the show are the eroticized portraits of young, muscular black and Puerto Rican men in

prison. They're reclining in their cells, wearing gleaming tighty-whities. They stand shirtless next to heavily barred doors and metal walls, alongside placards that proclaim prison names such as "Paco" and "Cupcake." Painted in a style reminiscent of Mexican religious icons, these portraits fetishize rough trade along racial lines, and are beautifully difficult to encounter. Claire tells me she had invited someone else along to the show, but reading the description of the show made her hesitate. Didn't it seem a little fucked up? "But I love problematic gay art," Claire laughs. "I know, me too," I say before I go back to tearing up at a video of Martin Wong's white-collar parents caring for him as he is dying of AIDS. The three of them laughing with his friends, crooning off-key at a karaoke Christmas party in Chinatown, the green and red tinsel piercing the stage.

In writing about early Soviet artistic culture and emergent forms of socialist realism, Robert Bird and his co-editors also state that "aesthetic strategies for fostering revolutionary intimacy over distance and across national borders" were the priority in a system that wanted to engage comrades across the world. That if revolution was going to happen, it would come into being "not through its amplification, but through its repetition in countless intimate gestures, not as a totality, but as a series."[79] Socialist realists were interested in communicating not the tenets or historic nuances of communism, but rather what revolution could look like, sound like, feel like. As Dudley Andrew describes, "those realms of preformulation where sensory-data congeal into 'something that matters' and those realms of post-formulation where that 'something' is experienced as mattering."[80] Revolutionary art was not about theoretical piety or the starkness of the world as is. It was about stigmata, something that could push through. About transforming a material politics into an ethics *as intensity*.

It would probably be more than a stretch to call Martin Wong a "revolutionary" artist. But in his portraits, we find no way to see beauty without confronting essentializing assumptions about ability or race. There's no way to fall into their romance without being turned off by

their fetishizing bent. To love Martin Wong is to acknowledge that our desire is necessarily shaped by our own fucked-up histories, our contextual and constituent parts. Loose and dreamy, barely composed, Wong's contradictory collages tend to collapse inward altogether, into a place where identity and fantasy are forced to rub up against each other, to hurt and confuse and oppose. In their shredded, affective intensity, they do. Struggle, that is.

To me, the best pieces in the show are the most understated. They're life-sized, realist depictions of closed doorways and shuttered storefronts in the 1980s Lower East Side. Gray and dreary, they're imposing nonetheless. Unyielding ciphers that obscure colorful queer histories past, these paintings are a melancholy memorialization of a moment wherein gentrification has not yet arrived, but looms forebodingly, clinging sickeningly to the devastation of the AIDS crisis. Effectively, they're mausoleums. And against all instinct, they feel utopic.

Honestly? There's no art that makes me feel more than a steel trap approximating some vision of heaven.

I'm at dinner, picking at my food. An acquaintance is telling me about a LARP (live-action role-play) scenario he was engaged in a few months ago. Day one involved everyone developing their character through group exercises. A new persona that can be as separate from or as similar to your IRL person as you'd like; the only condition is that it is not entirely yourself. On day two, they set the scene. You're at a party. It's the seventies and the music is amazing. Donna Summer, Sister Sledge. Some people are dancing, or taking drugs, or hooking up in small groups or large ones. Everyone is the best version of who they want to be, everything queer and free and beautiful. Or is it? Day three: they set the scene again. You're at a party. It's much like the one before, but this time, it's ten years later. After yesterday's role-play, several people have been given paper slips at random, indicating that over the ten years that have passed in this fictional universe you are all inhabiting, they have died. On day three, they may only interact with the players as ghost characters, returned to haunt the living. It's ten years later.

You're at a party. So many of your friends have died. You're crying and sharing stories and memories. You're holding each other, you're gently kissing, you're loving each other through the pain.

What my acquaintance is describing is a fictional re-creation of the AIDS crisis in the form of a role-playing game with sexual gratification at its center. I try to staunch my initial reaction. It is one of unmitigated horror. "How could anyone participate in a situation eroticizing the AIDS crisis?" I ask them. It seems as though its purpose is to find a more interesting sexual experience, entertainment, or some contrived and false emotional catharsis. "Well, part of what you say is true," they say. "Yeah, it's pretty icky." But they also point out to me that the people who choose to take part in this kind of role-play span a diverse demographic and include a significant number of actual AIDS crisis survivors—survivors who participate in order to relate their experiences to younger queer people and resolve their own trauma through erotic play. Some think that as an activity, this LARP can be a form of education to help people understand how painfully banal the threat of death was in the eighties, how much it was part of the fabric of reality. Others think it is inexcusable, a rosy, sex-tinted version of gay existence in another time that doesn't include, for example, the terror of having your party raided by the cops, that doesn't account for the true hardship and oppression suffered by so many at the time. But it seems to do some good, for some. A vivid closet fantasy, I don't know.

We tend to depict the resident of the closet at extremes, either walled in against their will, desperate for escape, or cowering in their shelter in shame and self-denial. But is the outside of the closet so beautiful? Is it truly as free as it seems? Is it so heavenly, its clouds cotton-candy fluff against the glossy blue weight of a better sky?

Perhaps if its surfaces look like a simulacrum of liberty, we can never find its walls. Perhaps if we believe it's real, we can never recognize it for what it really is: a trap, a room within a room within—

—a house. There is a dream of a house, like there always is. The boy and girl have gone to a movie together because this is part of a progression

that ends in a shared dream. A domestic ideal. The house has blue walls. It has a little red door and a little white fence. There are plants growing around the house, haphazard with flyaway fronds to provide an image of fecundity. The boy reaches for the girl's hand, but his reach is half-hearted, his fingers dry. He asks her about the movie they watched together recently, because his father has told him that small talk can calm a woman the way a firm grip around its body can calm a rabbit. The mother of the girl desires for her to become the mistress of this home. The girl agrees to make this dream a reality. But the young man. A neurotic. Irritates her. The boy is the symbol of her conquered sexuality, which is half dead now, and that makes her a little sad. Sometimes she goes to the sea to watch the seagulls pick at the bones of fish the fishermen have strewn across the sand.

The house, the one with the blue walls and red doors. It has antique crown moldings that have been painted white. Inside, it has covered itself in mint-green wallpaper with a mist of baby's breath. It's pretty, even if it's old and has begun to peel a little. Despite herself, the girl is succumbing more and more to her fantasies of life with the boy. She is succumbing, slowly, to this domestic image of living and working with him. In her heart, she knows she is ambivalent, but she does so like to be paid in love. He asks: Would she prefer tile on the kitchen floor to linoleum? Does she have a position on mosaic? She averts her eyes. Ignores him. No matter. She likes the sea in winter. Somewhere on a distant shore, a seagull's beak bangs away.

Amour is a movie about an aging couple. They live happily together in a charming Parisian apartment. They are still in love. That's why the movie is called *Amour*. The couple is played by French New Wave legends Jean-Louis Trintignant and Emmanuelle Riva, who are almost unrecognizable with age. One day, Emmanuelle has a stroke while they're eating breakfast. Time stops. When it starts again, she is bed-ridden and incapable of speaking. She blubbers. She is transformed from elegant pianist to invalid. She is a formless mass of flesh that cannot care for itself. Her fluids leak out onto the clean floors. Her living decay begins to contaminate the regal antiques and charming

ornamentation. Her husband tries to take care of her. He degenerates from loving spouse to cruel, resentful caregiver. He has dreams of drowning in icy water in the basement of his own home. His wife refuses to eat. She can no longer stand. He becomes so tearfully frustrated that he slaps her, hard. A rigid part of him dissolves. The situation gets more and more difficult. Despite the entreaties of his daughter, he refuses to send his wife into care. Jean-Louis becomes increasingly reclusive. The different rooms of the apartment begin to deteriorate from disuse. He covers the craftsman furniture with dead plastic sheeting. He goes out to the shop to buy fresh flowers. He seals the entry to Emmanuelle's bedroom with tape. Their home becomes a dusty and beautiful tomb for the two figures within it. He is trying to preserve the gently rotting vestiges of their life together.

Bachelard writes in *The Poetics of Space* about how a house is not so much an architectural structure as it is a series of repetitive gestures that coalesce in a space. He writes, "The word 'habit' is too worn a word to express this passionate liaison of our bodies, which do not forget, with an unforgettable house."[81] In other words, houses are not simply what contain us. Their layouts and structures are what dictate the repetitive actions and gestures of the people that live within them. The way a hallway moves, the way furniture is placed: these elements subtly script our actions and plot the trajectories of our bodies, forming a collaborative choreography between people and objects. Stepping over the creaky board in the floor or not seating too many people on the lumpy couch produces muscle memory; actions become routine. Routine is comfortable and safe, and so it creates the effect of a home. Routine, like repetition, is what makes fleeting actions concrete. It makes things real. Bachelard illustrates how our domestic environments play a large but often invisible role in the ways we come together. The ways we relate to each other, or refuse to.

A house may seem solid, built of concrete and brick, but it's flexible, its ghostly tissue sustained by a series of tiny dramas playing out between people and objects—objects that affect people, people who affect each other. Because of this, interior design has become a microcosm of

the modern family's dysfunctions, a museum of banal cruelties inflicted on us in miniature. A man drops his keys heavily on a perfectly placed counter just inside the front door. He has a study in such a position that he can access it without having to go through the kitchen. It is out of hearing range of the bedroom. Its doors are heavy and repellant. A woman places the foldable dinner tables in the living room. They are light and flimsy so any trace of the family coming together for dinner can be erased when it's time for television. The comfort of a house is nothing but the restriction of routine, confined within four walls.

The boy. The girl submits to his schedule. More and more she is becoming bashful and reticent. More and more she suffers from a feeling of inferiority she will never overcome. More and more she is retiring into herself. Where would she be today if she had not been burdened with the weight of her own imperfection. She seems to live in a dream, and life is passing her by. She cannot find an explanation for this strange bit of conduct, her lashing herself to another. She has acted under the stress of an irresistible impulse. The boy and girl step into a storefront together. The whir and heat of the furnace from the back. An ambient glow within the frame. It scalds their skin as they enter. She steps across the threshold, her footsteps light with familiarity. The smell of pizza and garlic in her nostrils. After this, they will return home. All her thoughts are wiped blank. Friday-night routine. Nothing matters now.

There is a house with blue walls and a little red door, a little white fence. There is not much to separate this house from any other type of closet. The plants have begun to spill over the walls and doors and windowsills so no one can enter or exit, but the overall effect is still charming.

In the 1950s film noir *In a Lonely Place,* starring Humphrey Bogart and Gloria Grahame, Bogart plays Dixon Steele, an alcoholic screenwriter whose career is failing. After a late-night visit to his apartment, a young lady ends up killed. Steele is suspected of the murder. His alluring neighbor, Laurel, unexpectedly provides him with an alibi, getting him off the hook. They're taken with each other. They begin to see each other romantically. Their flirtation turns dark, a dangerous mirror of

the circumstances of the young lady's violent death. The police continue investigating. There is no other evidence. I love *In a Lonely Place* because it is a movie about how one's desire is inevitably thwarted by one's distrust of oneself. Dixon's erratic temper makes Laurel doubt his professed innocence. Laurel's fickle beauty makes Dixon doubt her fidelity. Her ability to destroy his alibi makes him paranoid that she's toying with his future. The possibility that he is, in fact, a murderer makes her anxious for her safety. Their suspicion of each other takes hold. They alienate each other as these shared circumstances revive their individual ghosts. More than anything, *In a Lonely Place* is a paragon of doomed love. But that love is not superficial, or magnificent, or obvious. It hovers in the undercurrent like decaying jasmine, sick and sweet. It's suspended in the way Grahame's eyebrow arches and in the tremor of Bogart's hand before it finds itself around her neck.

In the whole movie, there's only one love scene, a few moments imbued with that sense of clarifying, unfiltered delirium, untainted by the rest of the world. It comes right before the final betrayal, making the couple's fall even more wrenching. *I love the love scene. It's very good. They're not always telling each other how in love they are. Good love scenes should be about something besides love. Like this one, me fixing grapefruit, you sitting over there, dopey, half asleep. Anyone looking at us could tell we were in love.*[82] Like this one. You on the couch, me making coffee by the stove. Cookies on the side table and your hand absently on my belly, my fingers combing the stiff product out of your hair. Or this one. Me reading over your shoulder while I'm pretending to look at my phone. Your breathlessness in describing a new project to me, my fingernail caught between your teeth in an anxious moment; you'll bite my nails for me instead, you say. Or this one. My hand batting the cat away from the wilting flowers on the dining table. A puzzle purchased together from Games of Berkeley, depicting six long-haired cats and a bouquet of flowers fanned out in a haze of colors on the desk—a fractured, loopy caricature of life. You, soft in the morning from sleep, my pupil tracking your eye as it flicks past words on the page. A strange electric arc from some sixties experimental film strewn across the wall,

my foot resting in the corner next to the bed. The left edge of my mouth pulling up in a half smile; I'm soupy like a kitchen sponge, saturated and swimming. You look up and notice my face. Your eyebrow twitches; you're jealous. You think I'm texting someone else, but you don't say a word, and I'm shy, caught in the act of watching you. I suffer your gaze; I flush red. You bite your lip and look away. I kiss you on the shoulder. I reach toward you, but you get up anyway, the couch too warm from your departure. I'm bereft, sitting in a thin T-shirt and no pants, a draft up my back and the cat stalking lazily into the other room. I roll over onto my side, my face into the back of the couch, my posture slack and sad and submissive. It works, you feel guilty, you give in. You grab my waist, and I pull away, moving over. You sit next to me on the couch. You hand me my coffee cup. You find your book, buried deep within the cushions. The wind outside is changeable, blowing softly through the window screens. *I love the love scene. It's very good. They're not always telling each other how in love they are.*

People seem to think that desire's path must always be straight. And it's a bad joke, but I like to say that it's too straight for me. The same way we choreograph routines in our rooms to sustain the feeling of "home," we behave as though there is but a single trajectory desire must tread, over and over again, because this repetition is what makes things real. But that's not how it works. Today's compulsion might not be tomorrow's. And it doesn't help that whatever our desire pursues, whichever object, will inevitably be changed by the pursuit, just as desire itself must change in order to continue its pursuit of the changing object. We think we know what we want, because people who don't know what they want are loose and dangerous. We choose people to take into our lives who claim they know what they want. This makes their love seem certain. We convince ourselves we are secure. But at the end of the day, we can't ever know.

Adam Phillips writes, "Suspicion is a philosophy of hope. It makes us believe that there is something to know and something worth knowing. It makes us believe there is something rather than nothing. In this sense, sexual jealousy is a form of optimism, if only for philosophers."[83]

I think good love scenes should be about something other than love.

I want to value our nebulous not-knowing. I want to eschew the routine of home. I want to walk the suspicious spaces we stake out between desires. Our inconstancies as they are formulated, processed, abandoned. Is this possible? Or is the compulsion of identity too severe—the way it anchors us within our material reality?

It's June 12, 2016. At the Pulse nightclub in Orlando, a man massacres forty-nine people. Most of the victims are queer people of color. We're mourning. It's a spectacle on Facebook. For the first time, I post a statement online. I feel like I have some abstract permission because I'm not in a heterosexual relationship. As though I'm allowed. It makes me queasy. Other people post statements too. Some take the opportunity to remind others that even though they're currently in straight relationships, they are queer or bisexual. Visibility is important, sure. It's good to let the world know queer people are not, in fact, alien monsters, but friends, colleagues, family. I know this. It doesn't matter. I'm irked nonetheless.

At dinner, another bisexual friend and I are complaining about this gratuitous and incidental flood, everyone taking the opportunity to come out on Facebook. We wonder together how and why "permission" operates at moments of collective trauma such as this—whose pain is it anyway? Who's allowed to feel and what, who should remain silent and why? I tell her that I think it's sad, but it has to do with suffering. Suffering offered up as evidence that you are a worthy bearer of the relevant identity marker. Could you, too, have been a victim of the current event of the day? Your potential suffering is quantifiable, instantly transformed into permission to speak publicly as a representative of the identity group of the moment! Been queer bashed? Congratulations, you have been awarded +10 suffering points. Accosted in a bathroom? +5. Told off by old ladies about the not-boyfriend on your arm? +2. Femme lipstick? -3. Pass as white? -6. Lesbian haircut? Level up.

Stephanie writes, "what didn't kill us / didn't kill us."[84]

Sympathy is the cruelty of the weak. We all know the sensitively furrowed brows, the impotent trembling lip. The empathetic pat on your

arm that seethes with "understanding" but provides no actual aid, shirks from investment in any real change. The tears shed that co-opt someone else's pain in order to shift the world's attention to your own.

It's no wonder, as Wendy Brown points out, that suffering has always been the barometer of authenticity, and authenticity has in turn become proof of identity. Your bleeding wound is the evidence that allows you to name yourself part of a group; shared wounds have historically been the impetus for political solidarity. Movements are brotherhoods of suffering that gather numbers and grow, forming the bonds that are the basis of our politics, our shared homes. But for Brown, this increased focus on the shared wound also yields the compulsive policing of membership in any given identity group. It can become an unnecessary distraction. It can prevent us from focusing our energies against the *process* of the wounding. It stops us from detecting and addressing the structural and historical elements that harmed us in the first place.[85]

I think Brown is right when she points out how suffering, as the basis of identity, can curtail the possibilities for intersectional politics. It means we may end up forming movements that are exclusionary to those who cannot sufficiently prove themselves part of our identity groups. Often, this comes at the expense of building a true coalition with significant numbers. Svetlana Boym may warn us against letting emotional bonding outweigh our critical thinking, but what if this moment of emotional bonding is exactly what we need for collective activism, a platform from which critical thinking will become relevant across difference? After all, when push comes to shove, one of my leftist friends of color reminds me, we might have more in common with the white kid standing next to us, masked up and holding an M18 smoke bomb, than the Asian cop in riot gear, or the Mexican border patrol agent.

But the power in belonging, in professing sameness, is still some-times the only power afforded to the oppressed and disenfranchised. Denying it is perhaps irresponsible in a moment when white national-ism and grievance politics are at an all-time high. When the effects of structural racism are obvious in the lives of many. So I itch my wound. I share it with pleasure. I show others where I hurt. I make them press

on the wound. I air out the secret places where I break. But on National Bisexual Day, when Staiti sends me a little Valentine, I play it off and ask if I can trade my identity marker for cake.

Some days, I wake up weak. Some days, I wake up when other people have died. I am going to die in disgraceful circumstances.

I don't know how to struggle correctly. Do you?

Someone else who I know has never had a gay relationship, has never had to deal with the dread and anxiety that their lover might be assaulted on their way home, who has never had to bite their tongue and remain silent under someone else's hostile gaze, who has never feared a gas station bathroom, comes out as queer on Facebook amidst a flood of lurid social media emotion and rainbow-heart emojis. Despite my best efforts, I feel myself prickling, though who am I to judge? In real life, there's no escape from desire. It changes in the moment, even if identity can't always bend with it, doesn't always allow it to. But of course by this logic, even if you identify as queer, maybe the reality is that right now, in this moment, you're just as straight as you seem. I'm no exception.

The scene in *Amour* I like best: In it, the air seems cold and blue from all the dust. Ambient particles swarm even though there are protective sheets draped over everything. The room is stark, stripped of all the character the couple once lovingly embellished it with. One window is open, the light streaming through hesitantly, as though it has forgotten that it is no longer permitted to enter this apartment, this home embalmed in layers of grief and plastic and imminent rot. A pigeon flies in. The husband tries to catch it so he can let it out. He is old. You don't hear his knees creak, but you can feel them in your bones. He chases this pigeon, slowly, clumsily; for what feels like a very long time. When he finally catches it, he is panting, gasping. He grasps it firmly in his two gnarled hands, as though he's afraid it might leave, when in fact he's trying to calm it. Holds it so tightly we don't know if he will crush its bones. It looks like he will. Like he wants to. He holds it for long enough that it feels as if the decision will never be made. As though

he's smothering it so slowly we can barely see it happening. It is an eerie echo of how moments before, he has smothered his invalid wife with her pillow. He caresses the pigeon. The camera cuts away. Later, in a letter, he writes, "A pigeon has returned, but this time I grabbed him. In fact, it wasn't difficult at all. But I released him."[86] I like this moment in *Amour,* not because there is joy in the pigeon's release. On the contrary. I like that it's reluctant; I like that it's a question. I like even more the fact that we barely know it happens, Trintignant's hands clutching the bird, trembling, not from ecstasy, but from hesitancy, as though he's unsure if the life-sustaining gesture is the ethical action to take. As though at any moment, he may decide it's more humane to wring its neck instead. The cruelest moment in *Amour* is when we realize he has let the pigeon go free.

Despite our efforts, our ideals of freedom seem to inevitably end up bound in normative values. We want to be free. We seek civil rights that only have merit in the eyes of the state. We want the ability to claim domestic or marital bliss, which can look like heaven but trap you like hell. We find a prepackaged ideology to believe in and march toward. We strive for material successes, we work hard to enjoy wealth and decadence. We seek ourselves in the mirror of our friends and lovers. We give in to the urge to wrap ourselves in a blanket, far outside the world. We find our way back home.

Whatever. You can make utopia out of anything.

It doesn't matter if you're inside or outside the closet. Either way, it's impossible to know if you can ever really be free.

It's Monday. I'm at work; it's cold. I turn on the space heater, and it smells like burning dust. Someone's randomly sent me an email about the Zika virus that's going around. I'm freaked out. I mean, who wouldn't be? These viral infections. The natural warfare of mutating biology against humankind. I remember taking communion at church during the height of the SARS epidemic in Singapore. It felt dangerous because it was. Each

dose of wine measured out in little plastic cups, latexed fingers placing wafers gingerly on tongues, hazardous waste bins standing by so any lingering organic material could be collected and destroyed. We were quarantined from school. We rotated between each other's houses so each of the moms could catch a break from having the kids home 24-7. My mom snuck us out to the park one day even though she wasn't supposed to. I tasted the air like it was guilty. From this email, I learn that one can be a carrier of the Zika virus but remain asymptomatic. In these cases, all that happens when you catch it is that it really fucks up any kids you might have. There's no cure. There's no solution.

I think about how this virus is analogous to so many other insidiously expanding problems humanity has made for itself, from capitalism to the patriarchy to heterosexuality. Perhaps the queer nihilists are right, and non-reproduction has become the only ethical response to the conditions of our world. Perhaps freedom could only become a reality then—the moment the world ends, when the structures all fall away. I think about how tender it would be if there were just some worldwide agreement for humans to stop having babies. An agreement for our species to die out, slowly. Just a gentle apocalypse.

I'm at an MLA panel on poetry and pleasure, and my friend Joey is presenting a paper about extinction. Joey tells us that in 2016, it's imperative to remember that one day, the earth is going to be eaten by the sun. He asks, *When the end of our species is so near, why would we bother with pleasure? Why would we bother with art, let alone poetry?* All of Joey's questions are rhetorical. It's what makes him so funny. It's also what makes his nihilism utopic. Rather than come up with a complex set of solutions or refine a political theory that might solve the numerous problems in our current universe, Joey takes the Occam's razor perspective: apocalypse. For Joey, human existence has become so entangled with the structural flaws of the world that we no longer have any freedom, any autonomy to resist or fight what we have become entrenched in. And with everything we know too degenerate to fix, the world would be better off, fuck, we would be better off, if it were simply destroyed. He finds plenty of impertinent delights to be had

in not having to structure the future at all, because you know, WHO CARES, WE'RE ALL GOING TO BURN.

In the Q&A, an audience member is suspicious about Joey's view of autonomy. He finds it difficult to believe that it's impossible to find a point of resistance, even if by the panel's formulations, pleasure is always related to aligning oneself with a master or machine. What if we began by denying ourselves pleasures altogether? Wouldn't that in itself be a form of resistance we could engage in? Wouldn't that be at least a start?

Joey's answer: He tells us to think about the compulsive pleasure of swiping on Tinder. The way we touch the tiny glass screens of our iPhones, over and over again. He reminds us of all the natural resources that have been consumed in order to make this action, swiping the glass screen, possible: the creation of the phone, the construction of the server, the children who mine lithium for its battery. There is a small ooze of consumption every time we touch the screen. But we already know this, Joey reminds us. We already know that each scroll on our phones correlates to an expenditure of natural resources. Will contribute in some small way to humanity's continuing demise. Each swipe, another shuffle toward the end of the world. And yet, knowing all this, Joey asks, When you leave this panel, are you going to check your phones? Fuck yes, you are. What autonomy? We're all slaves to pleasurable compulsion. I check my phone, the little pads of my fingers lapping at the screen. I can't help it. I'm scrolling, but I don't feel anything, not anymore.

Fredric Jameson writes, "It is easier to imagine the end of the world than to imagine the end of capitalism."[87]

I have a friend whose father was a part of the Summer of Love in the sixties. With the Vietnam War raging and his generation swimming in the afterbirth of the Cuban Missile Crisis, he was certain it was the end of the world. He sank into the decadence of the time, tinted his world with drugs and alcohol and sex. He wore flares and grew his hair. He found no sense in caring, because he thought he was going to die. His belief was genuine. He reveled in it. But the world didn't end. The apocalypse didn't come. And he found himself suspended in a terrible

stasis, stuck existing in a body he had maltreated with demons he had assumed death would obliterate.

As much as we might wish it, the world has not ended. Time continues to pass, stretching on like an endless, indiscernible ream of paper, blank and menacing. Some days, I wake up weak. I don't know how to struggle correctly. I find myself in rooms instead. Sometimes I move from one to the other, but the rooms are all the same, and they seem small and not enough. Utopia—I don't know where that is these days. But I want to feel free in our searching for it. However it is we're moving. However it is I'm coming to it, especially if it won't ever arrive.

Thomson likes to remind me how theoretical physics means there will always be a fixed place in space-time where an event or situation is located. There, the passage of time is an illusion.

At a televised Q&A with famed physicist Stephen Hawking, an audience member asks a curveball question about the cosmological effects of British pop singer Zayn Malik leaving famed boy band One Direction. Stephen Hawking said, "Finally, a question about something important! My advice to any heartbroken young girl is to pay attention to the study of theoretical physics. Because one day there may well be proof of multiple universes. It would not be beyond the realms of possibility that somewhere outside of our own universe lies another, different universe. And in that universe, Zayn is still in One Direction."[88]

The positive spin on this theory of space-time: with each of our choices, we not only preserve multiple pasts, but also create multiple futures, yet unexplored.

I'm back in New York, and it's hot. I'm wearing a black dress that's cut very low, off the shoulder, with thigh-highs and sparkly silver eyeliner. I look about ten years younger than I actually am. I check my phone. Appropriately, I'm at the opening night of the One Direction documentary movie, *This Is Us*. I'm waiting for my friend Michael Tom to arrive. He's got poppers and a bottle of Jack. Apart from a few harried parents, we're two of the oldest people in the theater. We watch the movie. We're misplaced in a sea of pubescent-girl bodies, shivering with

the weight of a collective libidinal energy. Every time a shirt comes off one of the members of the boy band on-screen, a synchronous gasp is emitted from the crowd. The air isn't moist, but it seems like it should be. I feel dirty. Michael Tom cackles at the screen. I take another sniff of the poppers. My world liquefies.

I learn a lot about One Direction at the movie. A typical English–Irish boy band comprising Harry Styles, Zayn Malik, Niall Horan, Louis Tomlinson, and Liam Payne, One Direction came in third place in the British talent show *The X Factor*. They were cute, but they couldn't really sing. When they lost, everyone wrote them off. Maybe they'd get one or two good songs in the charts, or a decent manager, but no one anticipated that they'd eventually become one of the most popular musical acts in the world, surpassing even the Beatles both in the size of their international fan base and their total album sales. One Direction's success wasn't just luck. It's arguable that they were the first boy band made by teen fans *for* teen fans. It took an international Twitter campaign launched by fans across the globe to generate enough popular demand to get the band worldwide distribution, bigger tours, more appearances. It was teen fans who demanded from the world the melodic, bubblegum love of these beautiful teenage boys.

I sometimes like to lie with my head partially underwater in the bathtub, turn the lights off, and close my eyes. I imagine how during rehearsal one day, Harry is violently horsing around for no apparent reason and hits Zayn, who is number two in line to him. There is a struggle. They roll around on top of each other. There isn't much to do about the resulting injuries except take care of the flesh wounds. I imagine I'm in the library during the Columbine shooting, and the One Direction boys are with me. Suffocation creates the most vivid hallucinations, and sometimes, if I'm really lucky, I can imagine myself fucking them one after the other in the midst of the chaos.

I'm reminded of how José writes, "We must strive, in the face of the here and now's totalizing rendering of reality, to think and feel a then and there." I take another sniff of poppers. What if imagining an alternate universe—if imagining utopia—was a way to actively destroy this world, to make it disappear, if only for a moment.

I'm home. My body slack and comfortable. I'm boiling water for tea. I'm wearing a large, soft gray sweater. It's too big and I scald the sleeve by accident, swiping the fabric through the flame. The air smells like burning, but I'm insulated; I'm OK. I'm reading a book entitled *Starve and Immolate: The Politics of Human Weapons,* a critical treatment by Banu Bargu that explores techniques of self-destruction—hunger striking, death fasting, self-immolation, suicide attacks—as tactical modes for radical political action. The book is dense, but Bargu's text is thorough and balanced, based on hundreds of interviews she conducted with death-fasters in Turkey between 2004 and 2005. She has great empathy and respect for the strange logic of sacrifice, the existentially finite gestures of those who have chosen the path of martyrdom. In the beginning of the book, Bargu describes the funeral of a young woman who was a death-faster. It's touching; her forehead is decorated with the signature red headband of the movement. Torches flame against a backdrop of night, searing hot against her cold, emaciated body. She's a tapered pinpoint in the crowd's attention. They bear her high above their shoulders. She has become immortal, a revolutionary martyr.

In *Starve and Immolate,* I learn that those who choose to become death-fasters are mostly political prisoners. Without many resources at their disposal, they resort to weaponizing their bodies as a method of resistance. In October 2000, hundreds of political prisoners in Turkey went on a hunger strike against the inhumane "F-type" high-security prisons they had been forcibly transferred to. Overcrowded and unhygienic, some of these prisons were only partially constructed and lacked basic amenities, such as running water and proper heating. This strike turned into a collective death fast, groups of prisoners catalyzing or delaying their inevitable deaths tactically, synchronized with their particular demands in order to most efficiently pressure the government into complying. By January 2007, when the effort was called off, the fast had lasted a total of 2,286 days and claimed the lives of 122 martyrs, a remarkably choreographed effort involving thousands of prisoners and activists.

These protests initially garnered a healthy amount of public support, but it eventually waned. The movement's everything-or-death mentality, as opposed to a slower process of ongoing reform, alienated

its liberal base. It didn't help that through a series of propaganda efforts, the government managed to paint the death-fasters in a negative light—as crazed militants with unrealistic goals and ideals who should be ignored, or worse still, as domestic terrorists who, if negotiated with, would threaten national security. It became easy for the public to turn a blind eye to the people choosing to die in prison. Their cause was out of sight, out of mind—a faded, unfashionable issue of the day. And ultimately, this hunger strike had little to show for itself, only temporarily stalling the development of the F-type prisons it was working to cease.

I'm at the One Direction movie, and I begin to see something else in the sloppy mess of selective documentary and publicity gaslighting I'm watching on the screen. One Direction gets trapped in an athletic store after two fans spot them. The girls promptly tweet the band's location to the world. Other fans show up, each armed with a smartphone and camera. They text their friends. More are coming. They won't stop. One Direction is mobbed. The staff locks and bolts the glass doors of the athletic store. There is a crowd of teen girls pressed against the windows. The band can't leave. Time passes. Bored, they start playing basketball among the shelves. And even when additional security shows up so they can finally escape, the boys are almost torn apart in the small distance between the door and the van—by the crowd's rabid hunger to touch, to taste, to get a glimpse of even a single part of them.

Rachel Monroe, in an article about fandom, teen girls, and revolutionary potential, writes, "Intensity without an outlet is a dangerous thing; it is also sometimes where revolution comes from."[89] Beatlemania was not unlike the One Direction fandom, but it emerged earlier, in the political moment of the sixties. Monroe cites it as an example of how teen girls instinctively felt that there was something wrong in the world, but lacked access to a vocabulary or knowledge to accurately describe it. Instead, they performed fangirlishness as a socially acceptable mode of resisting and expressing their frustration, their dissatisfaction. Monroe quotes Barbara Ehrenreich and her coauthors, who see the hysteria and projective violence of extreme fangirlishness as a sublimation of an emergent revolutionary spirit. They write, "To abandon

control—to scream, faint, dash about in mobs—was, in form if not conscious intent, to protest the sexual repressiveness, the rigid double standard of female teen culture. . . . It was the first and most dramatic uprising of women's sexual revolution."[90]

Back at home on Tumblr, my dashboard is flooded with images of leaking, bloody cuts, a never-ending scroll of gore and emoji and internet acronyms screeching uncertain outrage. There are gifs of broken hearts, cartoon doves shitting themselves with trails of glitter, banners sporting large text in dripping, horror-movie font. A member of One Direction has announced he is engaged to Perrie Edwards, another teen celebrity of British girl group Little Mix. The internet has code-named the pair "Zerrie." Furious that their imaginary future husband has been stolen from them because of the intrusion of his real life, a small group of teen fangirls launch the social media campaign #cutforZerrie. They tweet images of self-harm inflicted as protest of the engagement. They claim that they will continue harming themselves until the engagement is called off; they refuse to stop. Pandemonium ensues. Other fans are horrified that their wholesome fantasy has been tainted. Parents become anxious and concerned. It turns out that a group of internet trolls are responsible for at least some of the posts, but hoax or not, #cutforZerrie means the engagement is a PR nightmare. It is not what was promised. It is an unspoken contract between fan and boy band that the boys are not allowed to grow or develop. They have to live out the narrative that their fans have prescribed. They should never be allowed to have girlfriends. They should subsist as static, living representations of picture-perfect heartthrobs. This is part of their job. And with the engagement, the contract has been broken.

In *Starve and Immolate,* Bargu writes that death fasting is still controversial for being "opposed to our conventional notions of instrumental action because it renders difficult, if not altogether impossible, the achievement of political ends through means lesser than death."[91] In other words, why do it? Can literally dying for a cause be more effective than direct action, with its continual pressure, its achievable goals and specific demands? Can sacrificing one's life achieve any real

change when its only cost to the state is what it already has a surplus of—human capital?

Bargu notes that if the state's sovereignty is based upon its ability to confer the status of life or death, then to assert our individual agency over our fates is, in fact, to interfere with that power. Sovereignty becomes "wounded by those who threatened to die rather than submit themselves to the state."[92] Instead of hungering for the life the state confers, death-fasters choose death in order to undermine the very fabric of the system that has put them in prison. And in doing so, they choose a different humanity. One that proclaims a higher spiritual belief in a justice system, their *own* justice system, that "gives [a different] meaning to life and death,"[93] not the state's mandatory conception and control of it. What's efficacious about death fasting is that it happens on terms *other than what it has been assigned.* It manages to reject the sovereign system of the state, even while still existing in its grip.

I'm at home getting ready for a party. It's a nineties-prom theme, so I put on a turquoise spaghetti-strap dress and gloss my eyelids with a thick coat of light-blue shadow. I purse my lips as though getting ready for a kiss. My ghostly celebrity suitor. I'm adolescent again, nebulous and unformed.

The thing about any loop of fannish puppy love is that, even if its intensity can be violently expressed, even if this intensity contains within it the seed of revolution, it will still desire what it's been told to desire: the perfect husband, a utopian princess romance.

Adam Phillips writes, "Our utopias tell us more about our lived lives, and their privations, than about our wished-for lives."[94] Trapped in our reality, teen fandom tends to stay limited to the heterosexual domestic bliss society has taught it to seek. Because of this, it's possible that if the One Direction revolution did ever arrive, it would be no revolution at all. But naïvely—crucially—it continues to hope. And even as it remains in the iron grip of heteronormative societal expectations, in its excessive kicking, screeching, squealing, violent potency, teenage fandom is always already destructive to social expectation. An absolute refusal, it unwittingly demands more from the world than the life it's expected to live.

In my favorite scene of *This Is Us,* the mothers of the boys are at a merchandise store before One Direction's big Madison Square Garden concert, perusing products decorated with images of their now-famous sons.

"You know the cardboard boys, the cardboard stand-ups? I want a Louis one and then at night, I can just go and say good-night [to him]," Louis' mom peers around excitedly, looking for a life-sized cutout of her son to purchase. Helpfully, the clerk brings out some packaged versions featuring the One Direction boys for their moms to look at.

Adoringly, Liam's mom points to her cardboard son. "That's my favorite hair on Liam. I just love that one. Just shed tears just looking at him," she says. "You've only got the images—"

"—that's all you've got," Louis mom agrees.

"—they become like, um, someone in a newspaper or a magazine to you," she sighs.

An artificial substitution. Each boy turned into a mass-produced pop-star paper cutout, all shy grin and swagger and glossy printed paper hair. Liam's mom is besotted with her new replacement son. "He goes away so long," she cries, tearing up on screen with missing him.

I mean, it's sad because without projecting our impossible illusions upon our objects of desire, without a constant falsification of the world through other human beings, we probably could not live. If we gave up our utopic fantasies, it would, in fact, amount to a renunciation of life, a denial of life.

I'm at home, reading *Starve and Immolate.* I'm hungry, so I make myself a sandwich. I appreciate the irony even if it makes me feel guilty. I take a bite. I learn more about how death-fasters do not simply starve to death. Instead, they often prolong the process, rationing their intake of salt, sugar, and water in order to stay alive and resist, in the process draining the resources of state penitentiaries. It's easy to dismiss political fasting as a form of suicide, but this would obfuscate the political motivations and the collective organization of the underlying movement. No, death fasting does not believe in the possibility of reform in the present, nor does it work gradually toward a realistic resolution between the state and the people. It accepts the futility of resistance.

Bargu writes that, for these prisoners, "it is not worth living life if you are forced to live a mere existence that is predicated on renouncing or not living up to your political cause."[95] So more than a readiness to die for conviction, their actions demonstrate a commitment to living. In fact, they go one step further: they create *a different form of living.* They open up a space of potentiality, however small, in which the state can no longer operate in the way that gives it its power.

At the end of the day, death fasting insists on operating as though that utopic future we desire has already arrived. A future in which the state has been destroyed. And by opening a window into a separate and abstract existence, it reveals the impossibility of reforming the state as much as it pronounces a desire to *hope*—for something, anything, other than this. The insane elegance in the logic of death fasting as resistance is: all you need to do is believe. All it needs to do is occur.

Here's a parable. I'm in church with my mother. It's Christmas Eve in Singapore, and it's packed. I'm wearing a starched white shirt with a Peter Pan collar, buttoned all the way up; a tight leather skirt; and the blackest tights I own. It's hot. I'm sweating. Despite my efforts, my thigh tattoos show through the translucent fabric and as I walk past the pews, the congregants' glances begin to travel nosily down my legs. The pastor tells a story before his sermon to wake us all up. "A contemporary parable," he says, "if you will." He tells us about the invention of the "chicken cannon." The audience is doubtful, but he insists it's true. The chicken cannon is exactly what it sounds like. Each chicken cannon makes use of a pressurized air chamber in order to discharge your standard-sized, whole, and defeathered supermarket chicken from its barrel at a reasonably high speed. The pastor tells us that these cannons were most commonly used to test the strength of jet-plane windshields. Chicken after featherless chicken was shot at a high speed toward the planes in order to simulate in-flight collisions with birds and ensure that the windshields would not shatter.

When the train industry heard about these tests, they thought they should do the same. Trains had been around a lot longer, but the engineers thought it best to be cautious, just to be sure that a bird flying at

the windshield wouldn't cause any major damage to the train. To their utter horror, when train mechanics lobbed the first chicken at their newest train, it shattered the glass. In fact, the chicken went directly through the windscreen, cutting the driver's seat in half before lodging itself firmly in the back wall of the driver's cabin. The mechanics were appalled. Panicked, they sent a telegram to the jet-plane company, asking them for any advice that might help their windshields stand up to these vicious flying chickens. When the response returned, it was a single sentence: "Did you defrost your chicken?"

I laugh, but I don't get the lesson. Then: "It doesn't matter what you believe in," the pastor says. "What matters is that you accept what God has given you and remain open to His plan. What matters is that you encounter life with a defrosted heart. That you encounter God like a flabby chicken, soft and supple with belief. If you stay hard and frozen, like the chicken flying through the train windshield, it will be destructive toward everything around you. Believe, and God will massage your soft, chickenly flesh into His image. Have hope for what is to come in your future, and His will, through you, will be done."

My grandmother has a favorite sister. Her sister is a little younger; I'm not sure how old. I've always been extremely fond of her. We used to have dinner with her and her husband when we visited Hong Kong. He was tall and lean with a wrinkly, serious face and a body like a string bean. He had a very deep voice. She was soft and plump, like a steamed bun, with a gentle voice and twinkly, kind eyes. They both snored. We would always bring them a bottle of hot sauce made from dried scallops and whiskey from Singapore. It would make my granduncle's face crumple with pleasure; he would turn kind around the eyes. My granduncle liked the races. He taught me how to read the broadsheets while he drank his Chinese medicine or a tumbler of strong black tea. Because my grandfather was already dead by then, he would often help my grandmother out around the house. I would sit on a stool and watch him while he played handyman.

While he's changing light bulbs, I ask my granduncle to explain the difference between the two ways of saying *thank you* in Cantonese, a

grammatical idiosyncrasy I had never been able to understand. "Well," he says in English, "You should know this! There are two ways to say *thank you* in Cantonese, which is one more way than in Mandarin, so they probably don't teach you this in school." "Well, yeah," I say in Cantonese, childishly exasperated. "But what's the difference?" He laughs, screwing the bulb in. "It's actually hard to explain. *Mm kuoi* is more casual. It's what you say when you are just thanking a friend. *Duo che* is the formal term you use when you are providing someone with a service." "Wait, I'm confused," I say. "So you have to use the formal one like when a waitress serves me my dinner?" He pauses for a moment, then tries to explain again. "Maybe this is a good way to think about it," he muses. "You use *duo che* when you are especially grateful—when someone patronizes your shop, or when you receive a gift. *Mm kuoi* is just for regular life, when everything's normal, like when I give you a slice of apple." This doesn't make that much sense to me, and I still get the two mixed up, but I accept it. When we leave the country, at the end of our visit, they say good-bye. "*Duo che!*" I yell. Everyone laughs because it's the wrong usage. I blush, but it's true. I'm grateful for them.

A little over a year ago, my granduncle passed away. Since then, my grandaunt has been unable to speak even a word. Something happened in her brain. Only little strings of garbled syllables. Sometimes a little sound. She's been struck dumb by grief. When I was a child, I thought she and my granduncle had the sweetest voices in the world. Complementary to each other. One soft but firm, sometimes melodically shrill, the other deep and mellow. They loved each other. Now, she says nothing. It breaks my heart. She sits on the couch while my mother and I talk to her. I know she recognizes me even if she doesn't make a sound. I tell her I like her shirt. Collared and pink with black stripes and little black flowers. My mother holds her two gnarled hands with her own small ones and stares her directly in the eyes. She tells my grandaunt that she understands the pain she is feeling even if she cannot articulate it. That she knows how much she must miss my granduncle, how sad she must feel because her son has a family of his own

and doesn't have much time to spend with her, or to bring her grand-children around to visit. My mother tells my grandaunt that life can feel both very long and very short, depending on how you want to live it. "But you have time left," she says. Obviously, this time isn't ideal because she is now without my granduncle, the person she loved most in the world. Life now seems long. "But that's OK," she says, "you have to live for yourself."

My mother tells my grandaunt that she has to accept what is hap-pening in her life now rather than mourn what she has lost. She has to accept what is happening rather than pine for the dreams that, with the death of my granduncle, have now become impossibilities. She has to let go. This acceptance will give her hope. It will help her live. Maybe then, even without her husband or her children, time can be new, sharp and short, not thick and slow and murky. Tears roll down my grand-aunt's cheeks. She doesn't make a sound. Tears roll down my mother's cheeks. She prays for my grandaunt. She holds her hands tight. She begs the Lord to expel the darkness from her thoughts. She begs God to help her to see not despair, but hope. She prays that if God takes my grandaunt to heaven to be with her beloved husband soon, it is His will. But if she remains on this earth, alone, it is also because He has a plan for her. She will accept it, even if it's the harder path.

My mother holds my grandaunt to her chest like a child. They are crying together.

Is it tragic that the best place for us to find hope might be in the passive acceptance of our circumstances? In understanding that despite all our efforts, these circumstances will not change? Is that just giving up? Or might this acceptance help us find something else—openness to what might come when we let go of the limits of what we most desire, when we give in to what's truly unknown. Something we might call realism. I reach up and touch my face. I can't help it. It's wet too.

I'm alone, lying in bed under the gold-framed portrait of the Virgin Mary. I idle with my rosary because even when it's lapsed, even when it's tired, belief helps me move through the world. I'm at the gym, the

thud of meat against bag dulling my senses. Slow on the quarter turn, I take a punch to the jaw, and I'm panting, but the breath scraping my lungs calms me. This suffering I forced upon myself is temporary; remembering it means I can better accept what comes my way.

It's hard enough to wade through time; it's difficult to face what's real.

But at the end of the day, we're just trying to get through it together. At least we still have flimsy, temporary escapes. I switch on the TV. I walk to a nearby bar and while away the time with friends. I order a Shirley Temple. The bartender gives me four cherries; I don't even have to ask for extra. I put Etta James's "At Last" on the jukebox. Intuitively, people at the bar start to sway. I'm biking home, and some kids in a car reach out the window and try to grab my ass. I fall off the seat, screeching obscenities. They shower a bag of cold McDonald's french fries over my head as I lie in the road.

Things pass. They won't stop. We have no choice but to bear it.

On Gchat, Thomson wants to tell me about a video game he's playing that's consuming his life. He's too excited to wait, so he starts to describe it before I can respond, and I can't help but laugh, because frankly, it seems less action-packed and pleasurable than psychologically torturous, and what would you want that for? I roll my eyes fondly. I say, "I'll listen."

TG: part of the game i'm playing is that the character you play
is called THE NAMELESS ONE
and he begins the game dead
on a slab in a mortuary
and wakes up
and can't remember his life
but you eventually discover, in navigating the world, that you're an immortal who has died over and over again
forgetting more and more of your previous lives each time
and you recover your memories gradually
and patterns start to repeat

and i think the game made me think of past lives/iterations of me
TG: one of the first things that happen in the game is that
you meet a ghost in the mortuary
who is the ghost of a former lover of yours
and she either attacks you in a vengeful rage for abandoning and
deceiving her—she claims you never really loved her, that you used
her—or, if you play as a charismatic character
you can convince her that you do still love her by lying to her
even though you have no memory of this person
and she leaves you alone
and lets you pass
TG: the game is about uncovering the truth of who you are, so the
people that join your party are, in a real, game play sense, just tools
on your quest to self-discovery
but sometimes they call you out on that in the game and
it gets weird
indictment of the player for playing the game

Total escapism has never held much sway for me. Usually, I find that for a movie or book or even a game to be compelling enough to absorb me, it must also contain some measure of familiarity. In any case, from the romance, the thriller, to the dark comedy—the fact is that most genres play on our deepest desires, providing a saccharine version of what we wish to see, or a violently reductive literalization of what we fear. Ironically, our tools for escapism usually end up as allegories of what's true.

In other words, when push comes to shove, you can't escape reality.

People expect me to like French New Wave, but the films are too uncanny and veneered for me, simultaneously too little and too much like real life. My favorite French director didn't like the New Wave either; in fact, he was its rival. His name was Maurice Pialat. He was known for pioneering a particular brand of French realism that ran contrary to the whimsicality and high aesthetics of the New Wave. Pialat's films are simple slice-of-life stories. A child who is abandoned to the mercy of the

foster care system by his mother. A young girl's sexual coming-of-age in a fraught and difficult home. In each of his movies, experimental filmic techniques are applied with intense restraint so the simple stories *feel real,* even if they are not accurate or real-time representations of their events. In *Loulou,* for example, a young woman, Nelly, falls in love with a handsome drunkard. She realizes that he's accidentally gotten her pregnant. Shit, she thinks. Oh, but wait, he's excited; he wants to do the right thing, even if ham-fistedly. He brings her home to meet his family so they can start to build their own. Ironically, this celebratory visit becomes a devastating realization, where Nelly finally accepts, in this moment of ecstatic familial welcoming, that her boyfriend is not capable of being a good father to her child. He's too drunk, too clumsy, too aimless. This impossibility is, of course, punctuated by a series of fateful events ending with her brother-in-law-to-be losing his mind and firing a shotgun—incontrovertibly driving home the point.

But Nelly's epiphany occurs much earlier, and when it does, it's unexpected and jarring. Nelly and her man have just arrived home, and everyone is outside, eating and talking together in the indigo dusk. During this meal, conversation is charming. Everyone is radiant and laughing, but the film fades from sharp to muted and grainy. The sound buzzes in and out, the voices becoming a clamor. Rather than focusing on whoever's speaking, the camera meanders, the trailing visuals mimicking Nelly's faltering mind. Nothing much happens on-screen, and yet we feel as torn as she, caught between this celebration of what could be and her abrupt knowledge that she can never let it come to fruition.

To me, though, Pialat's masterpiece is *The House in the Woods,* a seven-episode television series following the life of a young boy who is evacuated to the French countryside to live with a groundskeeper and his family during World War I. What I find most stunning about this work is that throughout the entire series, there is no visual or literal trace of the war or its violence; it is only implied. Mostly the story is told through the young boy's perspective, so even things that are war related still seem entirely innocuous as they occur, hazed by his youthful innocence. The groundskeeper gets caught stealing cans of food from the

soldiers' barracks, but it's depicted as comedic rather than threatening. The family has to pack up and leave their house because the threat of battle is looming, but Pialat doesn't show what happens during this time; we cut to them returning, cheerfully, to their beloved cottage and its surrounding woods. It's through these everyday events that the picture of wartime France sluggishly begins to build. Rather than being *about* the war, *The House in the Woods* is a subtle depiction of how many families *experienced* the war at the time: as a trickle, banal rather than bloody and dramatic. It's nothing like the bombastic pain-porn of war movies like *Braveheart* or *Apocalypse Now*. The real tragedy of war here is how quickly its deprivation becomes as daily as life was before it.

When the boy finally has to leave the woods to return to his Parisian family, we say a tearful good-bye. We think this pain of parting is over, but it's not. The boy runs away from Paris, back to the house in the woods, but what he sees is different from the joyous countryside he remembers: his foster mother is dying, his foster father is gray and sad, and the house is ramshackle from disrepair. Unlike in Hollywood movies, he doesn't get to save his foster mother and live happily ever after. He doesn't even get to say good-bye before she dies, doesn't get to stay to help his foster father. No, he has to leave; he is snatched, sent back to his icy Parisian family without any closure. He has to keep saying good-bye to what he loves, over and over again. Exactly like how it happens in real life.

Pialat's great talent is for showing the deep emotion that any mundane happiness or triviality can obscure. His movies are so intricately crafted, so subtle in their experimental technique, that their events appear exactly real—even if this "reality" is indebted to filmic fabrication. It's not often we notice Pialat's directorial hand; it's only when you look closely for it that you see its heft. His humility, his refusal to make ostentatious his craft, is a form of submissiveness to the film's demands. It's what makes his movies so seamless. The fact that he often plays bombastic, patriarchal characters within his own films—the schoolteacher, the priest, the father—only serves to emphasize this irony: it's a sly and joking counterpoint to his directorial subtlety. To me, Pialat has designed an aesthetic weaving affect so true that it makes it seem as though artifice could become entirely powerless to reality. I could live in it.

I'm at a poetry reading, again. I'd like to pretend I'm here against my will, but that wouldn't be the truth. This one's a marathon; it spans a whole weekend. There's a writer here whose work I really like. I don't know him well, but gossip tells me that he might be like me, maybe has a few wires crossed in his brain. In other words, maybe he's also a total masochist. After the reading, I talk to him even though I'm shy. It turns out I'm right, although he's less into pain than he is into humiliation. He'd rather cede his power, leave himself vulnerable to the whims of another. "Fair enough," I say.

Somehow, in the course of our very entertaining conversation we end up lingering upon the topic of human furniture. I'm reminded of Bachelard. How furniture itself may not be alive, but it's designed to anticipate ways to make everyday life more convenient and comfortable for us human masters, to draw our invisible paths. An interesting literalization of the idea that furniture can "direct" our actions, the fetish of human furniture mainly involves experiments in objectification and objecthood: being bent into the shape of a footstool, someone's stilettos resting on your back. Your body supporting the weight of a few books, a coffee carafe, a mug—becoming a functional table for an exacting mistress.

Over the next few months, the poet and I exchange a series of emails about what masochism means to us, how it structures our experience as well as our intellectual interests. It's enjoyable, even if we do mostly end up disagreeing. Either way, the breadth of difference there can be in understanding and sharing a singular mode of eroticism is compelling to me, and having someone with whom I can discuss my experience is refreshing. In our discussions, we get intimate very quickly. It's no surprise. I become enamored. I can't help it.

"I would switch for him," I groan to a friend, flinging my hands over my face. "What, *you*? You'd want to top?" They look up from their computer, eyebrows raised. "I never thought I'd see the day." I pull up an email from him and scan it quickly. I hesitate. "Maybe not? It'd be service topping. I mean, I won't know. Not until I try." My friend laughs. "Do you *want* to try?" they ask. I shrug. "Definitely not," I say. "I just like the fantasy."

In another email to me, the poet retells a story he read that he thinks is relevant to our ongoing correspondence. It's Honoré de Balzac, titled *La Duchesse de Langeais*. A revenge story, one that he describes as "very hot rather than classically cold—their revenge is always emotional and always mixed up with several conflicting feelings." He's right. Reading it, it's honestly difficult to tell if love is being mutually expressed or if the two characters are just maliciously fucking with each other. The duchess is being a tease to start. She rejects her lover, the general, over and over again, in increasingly strange and cruel ways before she disappears. In response, the general threatens to brand her as punishment for being such a terrible coquette, for eluding all of his advances. The way this poet retells the story is seductive; the general holds the red-hot iron in one hand. The thumb of his other hand traces an outline of the mark he intends to sear into her forehead. Flesh on flesh. She leans into his thumb. Her eyes are defiant. "My forehead burns hotter than your branding iron,"[96] she says.

s-m practitioners generally like to emphasize the safety of their activities. They believe that getting explicit consent before any act can engineer a reversal of power between the sadist and the masochist, wherein the latter then has total control—the ability to say no. But I disagree. Masochism is about passivity. It's about being forced to reach a limit of physical exhaustion so intense you're left with absolutely no control over what you're being subjected to. And ultimately, what's sexy about masochism is nothing to feel safe about or good about or consensual about. An acknowledgment of how impossible it is to escape the power structures that hold us, the pleasure of masochism is in unconditional *letting*.

The Duchess of Langeais, in consenting to accept the branding iron, exemplifies this precise paradox. "My forehead burns hotter than your branding iron," she says. But if her forehead were as hot as she claims, it would destroy the iron itself, and the iron would no longer be able to hurt her. This is impossible, of course, since iron doesn't melt that easily; flesh can't burn that high. Nonetheless, she says it brazenly.

The poet tells me that he finds in this story a beauty and nobility in submission.

I'm at home, trying to make a needlessly fancy dinner, and I find myself on YouTube. I'm looking up videos about how to debone a whole duck; my dad's too lazy to talk me through it on the phone. He says he can't remember, that it's been a long time since he did it, but he knows you have to begin by cutting straight along the spine. You have to carve the flesh away from the rib cage. Go slow, he tells me, because if you make one wrong cut, the whole carcass might fall apart. He tells me to use dental floss instead of butcher's twine because it holds the meat together better and won't burn in the oven. And that it's not a bad idea to buy a . . . backup duck. I groan. He laughs. By now, I'm tired and nervous, and I definitely don't have a backup duck.

I end up watching a documentary about the AIDS Coalition to Unleash Power (ACT UP), a direct action advocacy group founded during the AIDS crisis, instead. Titled *United in Anger,* it contains original footage not only of direct action filmed by participants themselves, but of rare propaganda videos from AIDS Community Television as well as interviews with activists. The documentary feels uncommonly intimate, a window into the heart of a movement that cannot be divorced from its time, context, or tragedy. A moment when everyone didn't just believe they would eventually die but knew it was likely to happen soon. Everyone together, and the world falling apart. Everyone fighting, creating, and falling in love in one frenzied, swarming mass. In this moment, no piece of art could afford not to have a political function; every direct action couldn't help but be imbued with the ingenuity of any work of art. The end of the world as they knew it. The end of a world they were ultimately unable to outlive. Watching this documentary, I can't help but cast my mind back to the time-warp AIDS crisis LARP my acquaintance was describing, because as fucked up as it might be, it's still hard to deny that this moment, exquisitely singular and devastating, is sexy.

The most striking part of *United in Anger* comes later in the movement, when ACT UP extends the reach of their activism beyond young artistic communities to those who most need resources—poor women of color, the homeless, the differently abled. Initially, it seems curious that ACT

UP is not as demographically diverse as one would expect, considering the vast impact of the AIDS crisis. But soon, the activists realize that this is because those most affected are the ones who can least afford to participate. It's a crucial moment, wherein the young activists become aware of the privilege that sits at the root of their anger. As Ron Goldberg notes in the documentary, there is nothing that makes people angrier than denying them what they have always assumed they are entitled to. What they have always felt they deserved—life, the possibility of success, the fantasy of being able to shape one's life, to make it better—"when this entitlement is taken away."[97] For the young and AIDS-stricken, the utopia they once glimpsed but that became so jarringly truncated was reason enough to fight those who would take it from them—the FDA, the government, the church—to the death. But ACT UP also learned that those who were most impacted by AIDS not only died faster, but were rarely diagnosed. Perhaps it's unsurprising that these people were significantly less angry than the activists themselves, that they were less stirred to resist. The fact is, they simply didn't expect any better. They had no reason to fight. They were dying. So what? They had already been dying.

In any case, the end of the original iteration of ACT UP was no surprise. They didn't become superheroes. They couldn't save everyone they loved. ACT UP changed more than a few policies, but it fractured in the nineties like most movements do, in a tangle of bad feeling and lack of unity. After that, the world didn't end. It simply went on. It continued, as the world is wont to do. The world, plodding sulkily into today, where we still find ourselves stymied without solutions that address every problem or see every angle. The world we're stuck with—a fucked-up Rubik's cube we compulsively sigh about, and call *late capitalism*. But this world—it wasn't that different back then from how it is now, and yet this didn't stop the people in ACT UP from striving tirelessly to change it, however slightly. Even when they saw so clearly that their concerns would barely be addressed. Even if they were dying. The world—it didn't deter them from *trying* either. It doesn't stop contemporary chapters of ACT UP from continuing to fight, well into today.

Masochism isn't a fantasy. It's not some shallow performance. It's about acknowledging our lack of choices in the face of power, about recognizing our ultimate helplessness. It's about defying it nonetheless.

Masochism is not being able to struggle correctly. It's about choosing to do it anyway.

At the Berkeley Art Museum, I'm with friends watching Jean-Pierre Melville's 1969 film *Army of Shadows,* which is screening in 35 mm. An account of French Resistance fighters in World War II, the film is far from a glamorized depiction of espionage. Rather, it's a desolate account of several ordinary citizens willing to subject themselves to gut-wrenching difficulties for the sake of resisting the German occupation of France. From sabotage to surveillance to small-scale guerilla raids, the film focuses on the activities of a single Resistance cell composed of a group of diverse ages and genders. Through the entire film, however, we never get to see the consequences of their valiant actions. There is no satisfying climax, we do not see any enemy defeated, we do not see children or loved ones saved. And as for the Nazi-free future they're working toward, it never arrives. Those who make up the Army of Shadows are merely soldiers. They slog through seemingly nonsensical, life-threatening orders and trust, blindly, that those above them have a greater plan. One man escapes the Gestapo only to be captured again in a raid. Another turns himself in, in an attempt to infiltrate a prison and rescue a comrade, but finds his friend has been tortured and is too close to death to save. Together, they take cyanide pills to ensure that they won't betray anyone from their cell. Two brothers play a prominent role in the Resistance, but they never realize they're working together toward the same cause; each hides his clandestine activities from the other until one of them dies, anonymous and alone. When one of the Resistance members discovers a young traitor in a decrepit safe house, no one has a knife, and they are forced to suffocate him with a tea towel. Danger is the new normal in this film, where around every corner lies another betrayal or attack. Nazi Germany remains a ubiquitous enemy, one far greater than themselves. And what's left unspoken yet known to all is the fact that the Resistance

cannot vanquish it—defeat, and death, for them is not frightening so much as it is an inevitable reality. They are proud to accept it.

Roger Ebert writes that *Army of Shadows* finds itself, touchingly, in "that place in the heart where hope lives with fatalism."[98] Each character rarely knows the purpose of his mission and yet always carries it out. Each readily sacrifices himself to a greater good that he does not have the luxury of understanding. Remaining nameless and invisible, their silent deaths or disappearances are apparent only to their comrades, those they fight steadfastly alongside and with whom they cannot risk sharing their real names. In *Army of Shadows,* each person is willing to die for a future they know they will not live to see, that they cannot ever know. But so long as what's coming is *any future but this one,* they will continue to resist. So long as what's coming is different, the sacrifice is worth it.

I'm supposed to meet Claire at the protest, and she's late. But when she shows up, she's wearing a denim jacket and carrying a large picket sign that reads "GOD HATES COPS" in big, black capital letters. It makes me laugh. I can't stop. When we get to the broad middle where everyone's gathered, I don't see the boy I'm dating at the time, he's somewhere on the front line documenting the action. A series of smoke bombs go off in the distance. I'm worried about him. Claire notices; "Which one is he again?" she asks, trying to calm me. Honestly, it's nice of her to make the effort, since she has zero facial recognition when it comes to straight white dudes; to Claire, they all look the same. The truth is, right now I can't tell either, and that's kind of the point, so I shrug. Someone else will watch out for him. We keep moving.

I'm rushing to the protest from the tattoo shop where I've gotten "CASS" permanently printed in the middle of a fat heart on the back of my ankle as a tribute to my friend. I put on my sneakers, the cling film and ointment wrapped around my leg sweating moisture. I get a text, and someone sweeps me up in their car. Someone else inside of it offers me nettle tea, like a good protest mom, and fixes my hair as I pull a sweatshirt on. I refuse the tea and get out when the car stops. Running up a slope, I trip on the crawling ivy, but someone grabs my hand. They're much stronger, so they drag me up, then give me a boost

to the road with their hands. I yell my thanks, and when I pop up into the crowd, the streetlights are blinding and beautiful. I see stars. I let myself get swept up in our outrage, even if I know it's futile. Even if this sublimity is temporary.

After the movie at the BAMPFA, my friends and I exhale, sitting back in our chairs. We're still anxious and unsteady. We laugh nervously together. *Army of Shadows* is based on the writer Joseph Kessel's account of his real-life experiences with fighters in the French Resistance. We are awed by the bravery of these ordinary people. If the time came— and it might—none of us are entirely sure we would have the courage to do the same.

In the movie, there's a tense scene in which a Resistance member fights his way out of Gestapo custody. After killing a guard, he makes a break for it and sprints down the street. He's out in the open. There's nowhere to go. He steps into a barbershop, trying to look nondescript, but he is panting and sweating. He'd like to get his mustache removed. He tries to slow his movements down, but it's obvious he's on the run. The barber doesn't smile but gets the job done silently, his question-able customer sitting still in the chair. The razor flashes at his throat. There is a poster of the marshal of France during the occupation, known Nazi collaborator Philippe Pétain, on the wall of the salon. It's quiet and tense, light shining through the lace screens. Whether it's regular traffic or police, no one can tell. When the Resistance member finally gets up to leave, the barber says nothing but hands him an overcoat of another color to aid in his escape. This gesture leaves me stunned.

Elaine and I, when we march together, form a good partnership. She's quick and passionate on her feet, and I'm slower and more cautious. We're hand in hand near the lake; we're moving fast, and she pushes forward to stare a line of cops in the face. I pull her back urgently, worried that the dispersal order is imminent. She bursts into tears of rage. When she turns, she finds herself in front of an African American reverend. He doesn't know us, but he hugs her tightly to his chest.

Later that night, when the crowd starts to swell, I take a glass bottle to the head and get the breath knocked out of me. The world turns red, I feel my eyes widen but can only see a blur, I double over instinctively, panting and clutching my stomach. I hear everyone else in the protest raging around me in a cloud of humidity and noise. I don't know the person who threw the bottle, but they're next to me suddenly, clutching my shoulder so hard it's painful. They hold me up. "You're OK," they say. Then, "You OK?" they repeat uncertainly. "I'm sorry." I nod wordlessly. They don't leave. They stay with me until I catch my breath, their body tough and rigid against mine. I trust them. When I finally get to my feet, when my vision returns, they tap me twice on the shoulder, lightly and reassuringly, before they disappear.

In the book of critical essays *All Art Is Propaganda,* George Orwell writes, "The real objective of Socialism is not happiness. Happiness hitherto has been a by-product, and for all we know it may always remain so. The real objective of Socialism is human brotherhood. This is widely felt to be the case, though it is not usually said, or not said loudly enough. Men use up their lives in heart-breaking political struggles, or get themselves killed in civil wars, or tortured in the secret prisons of the Gestapo . . . because they want a world in which human beings love one another instead of swindling and murdering one another. And they want that world as a first step. Where they go from there is not so certain, and the attempt to foresee it in detail merely confuses the issue."[99]

I want that world too.

But I have to go home. Back in Singapore, my mother prays in a group sometimes, led by a pastor named Richard. The members of her prayer group share their visions out loud. These visions sometimes come true. They see miracles. They're gifted that way. The suspicious part of me wonders if Pastor Richard is some Tom Ripley, some kind of con man intent on extorting money or favors from her. To my mind, these visions seem implausible, or questionable at least, but I trust my mother. I believe her. I close my eyes. We clasp our hands together.

Pastor Richard prays with us. In his vision, he sees me young, as a baby. I'm crying, so hard. I'm reaching for Christ, and he picks me up. He's carrying me. The minute he touches me, all this water sloughs off my body. Pastor Richard tells me that I am crying and wet and drowning in it, but Christ is still lifting me up. The water streams away from me. The sun rises. Christ, He has now accepted me as His daughter. The atmosphere in the room changes. I stiffen. I feel coerced toward something forced. I feel myself flinch.

We like to think that doubt and questioning are crucial to finding one's faith, but it's our blinder belief that's the basis of any action. It's belief that's the fragile lynchpin of any resistance.

I open my eyes. My mother has tears streaming down her cheeks. There's something about it I can't access. There's something here I can't understand. I feel a twinge of jealousy. I want—I don't know. In the face of everything, I'm small, like a child. I feel weak and powerless. I want something to save me. Will it? Will anything? I haven't started crying yet.

I fall asleep, dreaming. In my dream, it's the end of the world, just like it always is. But it's not like usual, where it's dark and damp and cold and the sun has gone out. No, it was the opposite. In my dream, it was hot and sandy, a wasteland I could taste right in the core of my teeth. Nothing smelled of anything, everything was very granular. There was a lot of walking. We walked everywhere. I kept asking about people, but they had all disappeared. Alli and Brandon and Lindsey and Steve. You and I, we weren't lovers, but we were walking together with strangers, a little girl and a big man who was tall and brusque but had kind eyes. You got impatient with me because I kept asking about our friends and the little girl kept asking you, "But what's a friend?" She didn't know what it meant. The man snapped. He said she would have to learn the precision of language. He said the world was so broken it wasn't possible for its words to have meaning like they used to.

In my dream, there were a lot of rooms. I don't know what the rooms were like because they were so plain they didn't even seem like

rooms anymore. You held my hand while I coughed blood and sand out of my lungs. I said I didn't know where all this was coming from. You said it was just what the world was made of now. I said it felt as if my body were dissolving from the inside out. The man told me that our bodies all felt the same, that I wasn't special. He told me I should stop complaining.

We had to travel. There were policemen, and a giant arc had been drawn in the sand. There was a long stream of people waiting to cross the line. Everyone we were with crossed the line before me. Once you crossed the line, you disappeared, but what you were wearing remained. There were little piles of clothing left where each person had vanished, like my mom had told me would happen during the Rapture. When I got to the policeman, he told me there was something wrong with me. He didn't like that I had underwear in my bag. He took me away and put me in a small box that was exactly my height and so narrow that I couldn't even lean forward to press against its sides. I stayed there for a long time, but I wasn't sure how long. I stayed there for so long that it felt as though time was a big mass, a block you could cut into, chip away at, rest upon.

I can't remember how I got out, but I did. I can't remember how I found you, but it was in one of the rooms that didn't feel like a room. You touched me softly, in disbelief, and told me I had been gone for four years, for a long time. One of us was trembling, and I thought I didn't know which, but the truth is, I knew you'd always been steady, and it had always just been me who'd been lurching from side to side. The big man was still there. I think you were married, but I really couldn't tell. The little girl hadn't grown, so I almost said, "It's not been four years," but then stopped myself. It must have been, because our circumstances were different, even though they weren't. Now, it wasn't just us. Now, everyone knew how bad the world had gotten, even though the world itself hadn't changed much from before. You kissed my forehead. You made me eat a piece of toast. You told me you were with the man now. You said, this is because of necessity. You said, this way, we can keep moving. We can keep going on. I ate the toast, and then I woke up.

It's true that when our sentimental attachments to one another out-weigh our ability to critically assess what's good for us all, we run the risk of dogma, even fascism. Because of this, we cannot be seduced by our desire for the comfort of a home. We could embrace some kind of realism instead. We could accept the fact that any blissful utopia we might imagine is not only false but will also likely never arrive.

But there is something to be said, too, for choosing to fight while understanding its futility. Something crucial about the trust we develop between each other in making this choice together. How this trust might help us with the difficult task of continuing to believe—in whatever unknown future we're blindly working toward. Something better that might yet come.

There is a fixed point in space-time where the struggle is always happening. Where the passage of time is an illusion. You just have to be willing to go there. You just have to be willing to leave.

It's time to go.

I want to, but I can't. Can I?

I was going to struggle, finally. If I could. I wanted to try. You knew. You told me so. You said, "I hope that, for the sake of the rest of you, you find an oasis that isn't a mirage."

I didn't.

I did everything I possibly could to make you happy.

NOTES

1. Christopher Isherwood, "California Is a Tragic Country," in *American Culture: An Anthology*, eds. Anders Breidlid, Fredrik Chr. Brøgger, Øyvind T. Gulliksen, and Torbjørn Sirevåg (New York: Routledge, 2008), 203.
2. Elfriede Jelinek, *The Piano Teacher*, trans. Joachim Neugroschel (New York: Grove Press, 1988), 23.
3. Ibid., 23.
4. This was Miss Louisiana, Miss Patricia Brant. My parents modified the name to their liking.
5. Marcel Proust, *Remembrance of Things Past: Swann's Way* (New York: Random House, 1941), 442.
6. Kathy Acker, *Eurydice in the Underworld* (San Francisco: Arcadia Books, 1997), 9.
7. Judith Fryer, *Felicitous Space* (Chapel Hill: University of North Carolina Press, 1986), 64.
8. Richard White, interview in *Ken Burns: The West*, episode 1, PBS, 1996.
9. Roger Ebert, "Chris Burden: 'My God, Are They Going to Leave Me Here to Die?'" Roger Ebert Interviews, RogerEbert.com, May 25, 1975, accessed September 20, 2018, http://www.rogerebert.com/interviews/chris-burden-my-god-are-they-going -to-leave-me-here-to-die.
10. T. H. Watkins, interview in *Ken Burns: The West*, episode 1, PBS, 1996.
11. Isherwood, "California Is a Tragic Country," in *American Culture: An Anthology*, 203.
12. José Esteban Muñoz, *Cruising Utopia: The Then and There of Queer Futurity* (New York: New York University Press, 2009), 1.
13. Jenny Holzer, *In a Dream You Saw a Way to Survive and You Were Full of Joy*, 1984, text on cast aluminum plaque, 152 x 254 mm, London, Tate Modern, https:// theartstack.com/artist/jenny-holzer/dream-you-saw-way-su.
14. George Orwell, *The Complete Works of George Orwell: I Have Tried to Tell the Truth, 1943–1944* (London: Secker & Warburg, 1998), 42.
15. Robert Bird et al., eds., *Vision and Communism: Viktor Koretsky and Dissident Public Visual Culture* (New York: The New Press, 2011), 41.

16. PEN International (@pen_int), "Home is not where you are born . . . ," Naguib Mahfouz quotation, Twitter, December 14, 2017, 6:55 a.m., https://twitter.com/pen_int/status/941335933319827456.

17. Singapore Penal Code, Chapter 224, Section 377A, accessed January 3, 2019, https://sso.agc.gov.sg/Act/PC1871?ProvIds=pr377A-.

18. Hannah Arendt, *Men in Dark Times* (Florida: Harcourt, Brace & Company, 1983), 105.

19. Patricia Highsmith, *The Price of Salt, or Carol* (New York: Dover Publications, 2015), 39.

20. Leslie Jamison, "Grand Unified Theory of Female Pain," in *Waveform: Twenty-First-Century Essays by Women,* ed. Marcia Aldrich (Athens: University of Georgia Press, 2016), 74.

21. "Fascinating facts about the invention of Band-Aid by Earle Dickson in 1920," Great Idea Finder, updated February 2005, http://www.ideafinder.com/history/inventions/bandaid.htm.

22. Sigmund Freud, "The 'Uncanny,'" trans. Alix Strachey, in *Collected Papers,* vol. 4 (London: Hogarth and Institute of Psychoanalysts, 1953). Accessible online at http://web.mit.edu/allanmc/www/freud1.pdf.

23. Svetlana Boym, *The Future of Nostalgia* (New York: Basic Books, 2001), 9.

24. Ibid., xvi.

25. Ibid., 15.

26. Stuart Hall, "Race, Articulation and Societies Structured in Dominance," in *Sociological Theories: Race and Colonialism* (Paris: UNESCO, 1980), 340.

27. Highsmith, *The Price of Salt, or Carol,* 47.

28. David Wojnarowicz, *Close to the Knives: A Memoir of Disintegration* (New York: Vintage First Edition, 1991), 62.

29. Joan Lubin, in conversation with Jeanne Vaccaro, Tumblr, http://whateverjeanne.net, now inaccessible.

30. Pamela Lu, "Report IV," *Clamour 4,* (Spring 1999), 77.

31. Alice Notley, "A Baby Is Born out of a White Owl's Forehead—1972," in *Mysteries of Small Houses* (New York: Penguin Books, 1998), 39.

32. Victor Shklovsky, "Art as Technique," in *Modernism: An Anthology of Sources and Documents,* eds. Vassiliki Kolocotroni, Jane Goldman, and Olga Taxidou (Chicago: University of Chicago Press, 1999), 219.

33. Wilhelm Stekel, *Sexual Aberrations* (New York: Liveright Publishing Corporation, 1952), 87.

34. Bird et al., eds., *Vision and Communism,* 68.

35. Lisa Robertson, *Magenta Soul Whip* (Toronto: Coach House Books, 2009), 19.

36. Stekel, *Sexual Aberrations,* 87.

37. Steven Shaviro, *Connected, or What It Means to Live in the Network Society* (Minneapolis: University of Minnesota Press, 2003), 250.

38. J. G. Ballard, *Crash* (New York: Picador, 1973), 13.

39. Sebastian Reyes, "Singapore's Stubborn Authoritarianism," *Harvard Political Review,* September 19, 2015, http://harvardpolitics.com/world/singapores-stubborn -authoritarianism.
40. Philip Shenon, "U.S. Youth in Singapore Loses Appeal on Flogging" *New York Times,* April 1, 1994, https://www.nytimes.com/1994/04/01/world/us-youth-in -singapore-loses-appeal-on-flogging.html.
41. Lee Kuan Yew, *Hard Truths to Keep Singapore Going* (Singapore: Straits Times Press, 2011), 25.
42. Bird et al., eds., *Vision and Communism,* 90.
43. Ibid., 90.
44. Stekel, *Sexual Aberrations,* 71.
45. Ibid., 71.
46. Ibid., 70.
47. If you're under 55, you contribute 20% to the Central Provident Fund and your employer contributes up to 17%. If you're between ages 55 and 60, you contribute up to 13% and your employer matches that up to 13%. If you're over 65, you contribute up to 5% and your employer exceeds that amount by contributing up to 7.5%.
48. Yew, *Hard Truths to Keep Singapore Going,* 53–70.
49. James Baldwin, "Selling the Negro," in *I Am Not Your Negro,* ed. Raoul Peck (New York: Vintage International, 2017), 95.
50. Yew, *Hard Truths to Keep Singapore Going,* 51.
51. Yew, *Hard Truths to Keep Singapore Going,* 185–193.
52. Charissa Yong, "Singaporeans Respect All Races, but Racism Still an Issue: Survey," *Straits Times,* August 20, 2016, https://www.straitstimes.com/singapore /singaporeans-respect-all-races-but-racism-still-an-issue-survey.
53. Lee Kuan Yew, quoted in *Managing Chineseness: Identity and Ethnic Management in Singapore* by Daphnee Lee (London: Palgrave Macmillan, 2017), 55.
54. Yew, *Hard Truths to Keep Singapore Going,* 197.
55. Yew, *Hard Truths to Keep Singapore Going,* 79.
56. Teo You Yenn, *This Is What Inequality Looks Like* (Singapore: Ethos Books, 2018), 23–24.
57. Jacques Derrida, *On the Name,* ed. Thomas Dutoit, trans. David Wood, John P. Leavey, Jr., and Ian McLeod (Palo Alto: Stanford University Press), 91.
58. Rob Brezsny, "Free Will Astrology for the Week of June 29," *The Stranger,* June 29, 2016, https://www.thestranger.com/free-will-astrology/2016/06/29/24284467/free -will-astrology.
59. Robert Glück, *Communal Nude: Collected Essays* (Boston: Semiotext(e), 2016), 152.
60. Shulamith Firestone, *The Dialectic of Sex: The Case for Feminist Revolution* (New York: Bantam Books, 1972), 126.
61. Mike Kelley, "Empathy, Alienation, the Ivar," in *Foul Perfection: Essays and Criticism* (Boston: MIT Press, 2003), 19.
62. Ibid., 19.

63. Ibid., 19.

64. Gaston Bachelard, *The Poetics of Space,* trans. Maria Jolas (Boston: Beacon Press, 1962), 51.

65. Ibid., 51.

66. Jenny Zhang, "Poem: 'Follow Him' by Jenny Zhang," *BuzzFeed News,* BuzzFeed, August 4, 2017, https://www.buzzfeednews.com/article/jennybagel/read-this-very -short-story-by-jenny-zhang#.ciQaJj3kv.

67. "Govt Acted to Nip Communist Problem in the Bud, Says Dhana" *Straits Times,* June 2, 1987, 1.

68. Detainees of Operation Spectrum, in "1988 Statement of Ex-Detainees of 'Operation Spectrum,'" accessed January 3, 2019, https://remembering1987.files.wordpress .com/2014/04/1988-statement.pdf.

69. Jarett Kobek, *I Hate the Internet* (Los Angeles: We Heard You Like Books, 2016), 24.

70. Sarah Burke, "Post-Confessional: The Aging Intimacies of Sophie Calle," *Momus,* August 2, 2017, http://momus.ca/aging-intimacies-sophie-calle.

71. "2018 World Press Freedom Index," Reporters Without Borders, accessed November 6, 2018, https://rsf.org/en/ranking.

72. Charissa Yong, "NAC Pulled Grant from Comic as It 'Potentially Undermines the Authority of the Government,'" *Straits Times,* June 3, 2015, https://www .straitstimes.com/singapore/nac-pulled-grant-from-comic-as-it-potentially -undermines-the-authority-of-the-government.

73. Fathin Ungku, "Singapore Charges Activist for Organizing Assemblies without Permit," *Reuters,* November 28, 2017, https://www.reuters.com/article/us-singapore -protests/singapore-charges-activist-for-organizing-assemblies-without-permit -idUSKBN1DT0BH?il=0.

74. Anonymous, *Bædan 3: Journal of Queer Time Travel* (Bay Area/Seattle: Bædan, 2015), 20–21.

75. George Chauncey, *Gay New York: Gender, Urban Culture, and the Making of the Gay Male World 1890–1940* (New York: Basic Books, 1994), 7.

76. Ibid., 6–7.

77. Michael Trask, "Patricia Highsmith's Method," *American Literary History,* 22, no. 3 (2010): 608.

78. Jacques Lacan, *Freud's Papers on Technique 1953–1954.* Book 1 of *The Seminar of Jacques Lacan,* ed. Jacques-Alain Miller (New York: Cambridge University Press, 1991), 63.

79. Bird, et al., eds., *Vision and Communism,* 45.

80. Dudley Andrew, "The Neglected Tradition of Phenomenology in Film Theory," *Wide Angle* 2, no. 2 (1978), 45.

81. Bachelard, *The Poetics of Space,* 15.

82. *In a Lonely Place,* directed by Nicholas Ray, featuring Humphrey Bogart as Dixon "Dix" Steele (Los Angeles: Columbia, 1950).

83. Adam Phillips, *Monogamy* (New York: Vintage Books, 1991), 41.

84. Stephanie Young, *Pet Sounds* (Nightboat Books: New York, 2019), 73.

85. Wendy Brown, *States of Injury* (New Jersey: Princeton University Press, 1995), 73–75.

86. In the movie *Amour,* this is written in French—"Un pigeon est entré, mais cette fois je l'ai attrappé. En fait ce n'était pas difficile du tout. Mais je l'ai remis en liberté."

87. Fredric Jameson, "Future City," *New Left Review,* no. 21, May–June 2003, https://newleftreview.org/II/21/fredric-jameson-future-city.

88. Monica Tan, "Stephen Hawking Tells Fans Zayn Malik Could Still Be in a Parallel One Direction," *The Guardian,* April 27, 2015, Culture, https://www.theguardian.com/culture/2015/apr/27/stephen-hawking-tells-fans-zayn-malik-could-still-be-in-a-parallel-one-direction.

89. Rachel Monroe, "The Killer Crush: The Horror of Teen Girls, from Columbiners to Beliebers," *The Awl,* October 5, 2012, https://theawl.com/the-killer-crush-the-horror-of-teen-girls-from-columbiners-to-beliebers-1fc64bdafed9#.oy4xb9dj4.

90. Barbara Ehrenreich, Elizabeth Hess, and Gloria Jacobs, "Beatlemania: Girls Just Want to Have Fun," in *The Adoring Audience: Fan Culture and Popular Media,* ed. Lisa A. Lewis (New York: Routledge, 1992), 85.

91. Banu Bargu, *Starve and Immolate: The Politics of Human Weapons* (New York: Columbia University Press, 2014), 6.

92. Ibid., 3.

93. Ibid., 18.

94. Adam Phillips, *Missing Out: In Praise of the Unlived Life* (New York: Farrar, Straus and Giroux, 2012), xviii.

95. Bargu, *Starve and Immolate,* 16.

96. Actual quote is "my forehead burns hotter than your fire," from Honoré de Balzac, *La Duchesse de Langeais,* trans. Ellen Marriage (Project Gutenberg, 2010), updated November 22, 2016, https://www.gutenberg.org/files/469/469-h/469-h.htm. Paraphrased by Anonymous in email correspondence with Trisha Low.

97. Ron Goldberg, in *United in Anger: A History of ACT UP,* produced by Jim Hubbard and Sarah Schulman, written by Ali Cotterill and Jim Hubbard (2012), https://www.youtube.com/watch?v=MrAzU79PBVM&t=4306s.

98. Roger Ebert, review of *Army of Shadows,* RogerEbert.com, May 21, 2006, https://www.rogerebert.com/reviews/great-movie-army-of-shadows-1969.

99. Orwell, *The Complete Works of George Orwell: I have tried to tell the truth, 1943–1944,* 42.

ACKNOWLEDGMENTS

Portions of this text have appeared on *Armed Cell,* as part of the Post-Crisis Poetics series (April 15, 2017), and in *Through Clenched Teeth* (Triangle House Review, 2017) and *From Our Hearts to Yours: New Narrative as Contemporary Practice* (ON Contemporary Practice, 2017).

It is difficult to write about life, but life itself would be far more difficult without the friendship, support, and intellect of the following people: Alli Warren, Lindsey Boldt, Steve Orth, Brandon Brown, Stephanie Young, Steven Zultanski, Joey Yearous-Algozin, Holly Melgard, Noah Ross, Cassandra Gillig, Julie Buntin, Matt Sussman, Eric Sneathen, Josef Kaplan, Bridget Talone, Ben Fama, Judah Rubin, Rob Fitterman, Kim Rosenfield, Coco Sophia Fitterman, Diana Hamilton, Astrid Lorange, Andrew Brooks, Aaron Winslow, Chris Chen, Andrew Kenower, Elaine Kahn, Grace Ambrose, E. Conner, Nich Malone, Jane Gregory, Ari Banias, Maxe Crandall, Diana Cage, Liz Kinnamon, Jeanne Vaccaro, Joan Lubin, Ariel Goldberg, Allison Harris, Juliana Spahr, Joshua Clover, Aaron Kunin, Sean Collins, Zoë Tuck, Evan Kennedy, Charles Bernstein, Barbara Browning, Patrick Durgin, Lauren Cerand, Kirsten Saracini, Michael Thomas Vassallo, Nicholas Salvatore, Rachel Hauer, Zoë Roller, Coach Jay Joseph, Lottie Bevan, Edward Atkinson-Clark, Désirée Lim Harkins, Wei-Ling Woo, Caroline Woon, Kim-Mei Kirtland, Jeremy Yap, Julian Yap, and Kay Ch'ien. Thank you for being there.

Acknowledgments

Thank you to Thomson Guster, the better writer.

Thank you to Claire Grossman, my Bay Area ride-or-die.

Thank you to my family, who have always been willing to sacrifice everything for me.

Thank you to Ruth Curry, Emily Gould, Lizzie Davis, and Carla Valadez for believing in a better version of this book than I even thought was possible. Thank you to Mandy Medley, Daley Farr, and Nica Carrillo for shepherding it into the world. Thank you to the rest of the Coffee House Press staff for putting so much of your time, energy, and resources into this book. I will never be able to repay you for your generosity.

Thank you to Meg Fransee and Aaron Gonzalez from Floss Editions for designing a cover that will no doubt "make the zine hos crawl."

Finally, to Syd Staiti—without your care, wisdom, and patience this book would never exist. Thank you for continuing to build a life with me. I love you.

LITERATURE
is not the same thing as
PUBLISHING

Coffee House Press began as a small letterpress operation in 1972 and has grown into an internationally renowned nonprofit publisher of literary fiction, essay, poetry, and other work that doesn't fit neatly into genre categories.

Coffee House is both a publisher and an arts organization. Through our *Books in Action* program and publications, we've become interdisciplinary collaborators and incubators for new work and audience experiences. Our vision for the future is one where a publisher is a catalyst and connector.

Emily Books is a publishing project that champions transgressive, genre-blurring writing by (mostly) women. Its founders are Ruth Curry and Emily Gould.

FUNDER ACKNOWLEDGMENTS

Coffee House Press is an internationally renowned independent book publisher and arts nonprofit based in Minneapolis, MN; through its literary publications and *Books in Action* program, Coffee House acts as a catalyst and connector—between authors and readers, ideas and resources, creativity and community, inspiration and action.

Coffee House Press books are made possible through the generous support of grants and donations from corporations, state and federal grant programs, family foundations, and the many individuals who believe in the transformational power of literature. This activity is made possible by the voters of Minnesota through a Minnesota State Arts Board Operating Support grant, thanks to the legislative appropriation from the Arts and Cultural Heritage Fund. Coffee House also receives major operating support from the Amazon Literary Partnership, Jerome Foundation, McKnight Foundation, Target Foundation, and the National Endowment for the Arts (NEA). To find out more about how NEA grants impact individuals and communities, visit www.arts.gov.

Coffee House Press receives additional support from the Elmer L. & Eleanor J. Andersen Foundation; the David & Mary Anderson Family Foundation; Bookmobile; Dorsey & Whitney LLP; Foundation Technologies; Fredrikson & Byron, P.A.; the Fringe Foundation; Kenneth Koch Literary Estate; the Matching Grant Program Fund of the Minneapolis Foundation; Mr. Pancks' Fund in memory of Graham Kimpton; the Schwab Charitable Fund; Schwegman, Lundberg & Woessner, P.A.; the Silicon Valley Community Foundation; and the U.S. Bank Foundation.

THE PUBLISHER'S CIRCLE OF COFFEE HOUSE PRESS

Publisher's Circle members make significant contributions to Coffee House Press's annual giving campaign. Understanding that a strong financial base is necessary for the press to meet the challenges and opportunities that arise each year, this group plays a crucial part in the success of Coffee House's mission.

Recent Publisher's Circle members include many anonymous donors, Suzanne Allen, Patricia A. Beithon, the E. Thomas Binger & Rebecca Rand Fund of the Minneapolis Foundation, Andrew Brantingham, Robert & Gail Buuck, Dave & Kelli Cloutier, Louise Copeland, Jane Dalrymple-Hollo & Stephen Parlato, Mary Ebert & Paul Stembler, Kaywin Feldman & Jim Lutz, Chris Fischbach & Katie Dublinski, Sally French, Jocelyn Hale & Glenn Miller, the Rehael Fund-Roger Hale/Nor Hall of the Minneapolis Foundation, Randy Hartten & Ron Lotz, Dylan Hicks & Nina Hale, William Hardacker, Randall Heath, Jeffrey Hom, Carl & Heidi Horsch, the Amy L. Hubbard & Geoffrey J. Kehoe Fund, Kenneth & Susan Kahn, Stephen & Isabel Keating, Julia Klein, the Kenneth Koch Literary Estate, Cinda Kornblum, Jennifer Kwon Dobbs & Stefan Liess, the Lambert Family Foundation, the Lenfestey Family Foundation, Joy Linsday Crow, Sarah Lutman & Rob Rudolph, the Carol & Aaron Mack Charitable Fund of the Minneapolis Foundation, George & Olga Mack, Joshua Mack & Ron Warren, Gillian McCain, Malcolm S. McDermid & Katie Windle, Mary & Malcolm McDermid, Sjur Midness & Briar Andresen, Maureen Millea Smith & Daniel Smith, Peter Nelson & Jennifer Swenson, Enrique & Jennifer Olivarez, Alan Polsky, Marc Porter & James Hennessy, Robin Preble, Alexis Scott, Ruth Stricker Dayton, Jeffrey Sugerman & Sarah Schultz, Nan G. & Stephen C. Swid, Kenneth Thorp in memory of Allan Kornblum & Rochelle Ratner, Patricia Tilton, Joanne Von Blon, Stu Wilson & Melissa Barker, Warren D. Woessner & Iris C. Freeman, and Margaret Wurtele.

For more information about the Publisher's Circle and other ways to support Coffee House Press books, authors, and activities, please visit www.coffeehousepress.org/pages/support or contact us at info@coffeehousepress.org.

ALSO FROM EMILY BOOKS

The Gift
Barbara Browning

I'll Tell You in Person
Chloe Caldwell

Mean
Myriam Gurba

Problems
Jade Sharma

Temporary
Hilary Leichter

Things to Make and Break
May-Lan Tan

Socialist Realism was designed by
Bookmobile Design & Digital Publisher Services.
Text is set in Adobe Garamond Pro.